love
maps

ELIZA FACTOR

Published by Akashic Books
©2015 by Eliza Factor

ISBN-13: 978-1-61775-273-5
Library of Congress Control Number: 2014919154

Akashic Books
Twitter: @AkashicBooks
Facebook: AkashicBooks
info@akashicbooks.com
www.akashicbooks.com

To Jason, who makes everything possible

Chapter 1

"Mom!"

What did he want now? Whatever it was, they couldn't afford it. It had been madness buying the sole, $17.99 a pound, but Sarah could not stand another night of bluefish. Max ran into the kitchen, all seven years of him, lithe and bright-eyed, waving an old-fashioned airmail envelope. She dropped the fish, knowing somehow. How? She couldn't make out the handwriting from that distance, not distinctly at least. Maybe some part of her optic nerve saw it, just not the conscious part. In any case the fish fell to the linoleum, thankfully still in its wrapper, and she snatched the envelope out of Max's hand. It was him, his letters precise and slightly slanted to the right, pressed so hard as to cause gullies in the paper.

"Is it from my father?" Max was only a couple of inches from her, his chest rising and falling as if he had run a mile. Thank god Philip hadn't bothered with a return address.

"I don't know."

"Well, open it!"

"Not now. It's time to make dinner."

Max gave her a look both steady and accusing. His eyes

were the same gray-blue as Philip's, but fringed with thick eyelashes.

"Sweetheart, just because it's from overseas doesn't mean it's from him. I know other people overseas."

"It's from the Congo. Who else would be in the Congo?"

The Congo? She hadn't even noticed the stamp. She was tempted to open it then and there, but couldn't with Max pressing in so close. She folded it and slipped it in her back pocket. "Honey, if it's from your father, I promise I will tell you what it says. But I am not reading it right now. It's time for me to make dinner and for you to practice your katas."

"But Mom!"

"You promised Sensei. Ten of each."

"Let me see it. I want the stamps."

"Sensei says obey your mother. You'll get the stamps later."

Max groaned, but he was a good kid, by which she meant that he did not bristle against rules. He headed outdoors to the front yard, the only place where there was enough space for him to practice. She put the fish in the refrigerator. Then the eggs, careful not to jiggle them, aware that she was shaking—not her hands, but something deep inside of her. What was she going to do? What in the world was she going to do now that Max could read?

Chapter 2

New York City, April 1981

Greenwich Village. Sarah, thirty-one, sleeping naked under dirty sheets, is awoken by the phone. It is early, very early in the morning, the sky is colorless, on the verge of dawn. The sound is muffled—the phone, somewhere on the floor, is hidden under an assortment of paint-splotched jeans and T-shirts. She squints, fuzzy from that last drink. The phone rings again. The street is quiet as it is only at this hour. She wraps herself in her sheet and starts kicking at the clothes. The ringing gets louder; it's coming from under a slightly damp towel.

"Hello?"

"Sarah?" It's Tori, Sarah's godmother, who must be eighty by now and who lives in proud seclusion in a crumbling West Texas adobe. "Sarah?" she repeats.

"Tori? Are you okay?" Sarah adjusts her sheet. A pigeon swoops down with a loud flap of wings and lands on the fire escape.

"He's done it," Tori says.

"Who?"

"Conningsby—he's gone. Stopped breathing at 2:41 yesterday afternoon." Tori sounds as raw as if he were out riding his horse yesterday, though he had been hospitalized for months.

"Oh, Tori, honey."

"No honey about it."

The pigeon's legs are pink and scaly, its talons expertly balanced on the rickety railing. Sarah stares into its black eyes, grasping for something to say. She reaches for her jeans and pats the pocket for her cigarettes.

"I want you to go to the funeral for me."

"Of course." Sarah strikes a match and inhales. "Where's it going to be?"

"Where do you think?"

"Michigan?"

"Of course with those people. What do you expect? Ah. It's all right. They can arrange their damned funeral. They've already done it. They even have a goddamn date. They know more about death than life, those people. They are the ones who killed him. They did. If they'd just let him stay here, I could have wheeled him outside and he could have gotten some sun. That's what he needed, the sun, Chihuahua. Can you imagine, Sarah, Conningsby, our Conningsby, hooked up to one of those machines? And those people! The nurse said there was always one of them praying over him at every allowable hour—he probably stopped breathing to escape them."

"Are you sure you want to go to the funeral? You guys will be fighting the whole time."

"Me? No! I want *you* to."

"You want me to go alone?"

"Someone needs to pick up his ashes."

"His ashes?"

"I told you last time, don't you ever listen? I sicced my lawyer on them, and everything's settled. Sixty percent to them; twenty to me; twenty to Philip Clark."

"Philip Clark?"

"A kid Conningsby knew back from Terre Haute."

"You want me to go all by myself? They don't even know who I am. Couldn't they just send the ashes to you?"

"Those people? They'll keep them all if someone doesn't go. And it's better you than that lawyer."

"Won't you come with me? Please. You shouldn't be alone down there."

"I'm not alone. I've got my neighbors, my horses, Conningsby's horses. They tried to take those too! They tried to sell them even while he was alive, the vultures. It will be better knowing that he's not tied up to one of those machines. I need a part of him here, Sarah. I do."

Sarah holds the telephone a long time after she's hung up. She hadn't seen Conningsby for ages, not since her parents' memorial, but she had talked to him often, on this same blue telephone, a dumb piece of plastic and wire that still seems to be vibrating in her hand as if it has something yet to say. She thought she had been prepared, but somehow she hadn't realized she would never again hear his voice, his old-fashioned Western-Midwestern accent, his calm diction.

Later she calls Maya. Old Maya. No one except for Conningsby ever called Maya "old Maya." He had done this even when she was a girl, "That's old Maya for you," the word having nothing to do with age, but a certain immutability. Maya, of course, hated it.

"Hey chickadee," Maya says. "You're up early."

Sarah gives her the news, bracing herself for Maya's response, but when it comes, it is a perfect, heartfelt "*Damn.*"

"I know that you didn't think much of Conningsby, but

perhaps you might want to come to the funeral on account of Ma and Max."

"It's not that I didn't think much of him, it's just that you idolized him so. But he was a presence, I'll give you that. Of course I'll go."

"It's in a couple of days, on the twelfth in Tulapek."

"Tulapek?"

"Some little town west of Flint."

There's a rustle of papers on the other side, followed by the sound of Maya breathing deeply. "Oh dear. Do you think they can change the date?"

"Of the funeral?"

"I'm booked on the twelfth. You are too. It's that Cotswolds thing." For some reason known only to her, Maya had agreed to be flown overseas to sing Happy Birthday at some baronial country house. "I really can't pull out on that. Laine would kill me. She's built the whole party around it. Don't worry—I'll get someone else to pick up the ashes. We're not going to let Conningsby founder out there in Tulapek."

Sarah twists the telephone cord, unable to say a thing.

"Don't feel badly, Sarah. Tori's not going either. It'll be some strip-mall funeral put on by people who didn't know him in a town he never set foot in. You don't need to go to that."

Sarah remembers an evening some twenty years ago. Tori and Conningsby, in their sixties then, leathery and handsome, leaning against the railing of Tori's back porch, lit by a desert sunset. Max and Ma were sitting in the only two rocking chairs, like they were the old ones. They were all drinking beers out of green glass bottles, a slight breeze was blowing Ma's hair over her face, and names from the rarely

mentioned past burst out in gusts of laughter. Sarah—nine or ten—sat cross-legged on the floor, listening hungrily. She could see the unfinished floorboards, her skinny legs, the gleam in Conningsby's eyes, all of their eyes.

"I have to go to that funeral," Sarah says.

Maya arrives in a hail of honking, her black town car jamming up the street. "Darling!" She's breathless from running up the stairs. "You're all right?"

"Of course I'm all right. Why can't your driver learn to park?"

The black beast heaves back and forth, the driver trying to get into an impossible spot. One of the blocked taxi drivers gets out of his cab, his arms raised. The boy from the nearby fruit vendor comes out to watch.

Maya stands beside her, talking urgently. She had a terrible dream; Sarah can't go to Michigan.

Sarah cups Maya's face in her hands and tries to look anything but what she is—annoyed. "Let me make you some tea."

Maya plops herself down on the lumpy futon, forgetting that she usually refuses to sit on it. Sarah stands on tiptoes, searching through the cabinets, looking for the stinkiest, weirdest Chinatown brew she can find.

"I know you don't get dreams like that, but I do. I dreamed about the plane, didn't I?"

Sarah finds a brown bag of roots she'd purchased during a fit of insomnia. The kitchen fills with the smell of rotten fish and grass. The hubbub on the street finally dies down.

Maya continues to talk from the other room: "Are you even listening?"

"Yes, of course."

"A man from the West took you away."

Sarah brings out the teapot, and ceremoniously pours Maya a cup. "How do you know that he was from the West?"

"There was this spangly compass in the sky and the landscape was flat and desertlike, with barbed wire and tumbleweed. What do you want from me, Sarah? It was dream logic. He was the Man from the West. I was holding you and he tore you away."

"But I'm here now. You are awake. I am awake. I have encountered no men from the West. Come on, take a sip."

"You're here at this moment, but the first thing I hear this morning is that you're going to Conningsby's funeral. Conningsby was from the West. And he's dead. Sarah, listen. I had that dream about the plane, didn't I?"

Sarah picks up the teacup and puts it in Maya's hand, wishing she hadn't been so diplomatic about Maya's plane dream. Maya sips the tea, too distraught to notice the flavor.

"If your dream was really a prophecy, then I can't escape it. Isn't that the point of those kinds of dreams? Whether I go to the Cotswolds or Tulapek, the Man from the West will come and get me one way or another."

"Don't smile."

"I'm not smiling."

Maya finally notices what she's drinking. "This is disgusting. What is it?"

"I don't know."

Maya squawks with laughter. "I'm not drinking any more of your fucking tea."

"Fine," says Sarah, laughing too.

Maya, suddenly serious, hands Sarah a thin silver chain from which dangles a tiny egg-shaped piece of ivory, finely carved with what looks like Arabic writing. "Wear this at

least. It's powerful and will protect you. I don't care if you believe in it, just do it for me."

"It's cool looking," says Sarah, trying to lighten the mood. She holds her hair up so that Maya can clasp it around her neck. It falls halfway to Sarah's breasts, the white of the stone giving color to her skin, which is ever warmer and pinker as a blush travels through her body.

At the rental car place, Sarah fidgets with the seat belt and frowns down at the pedals, trying to remember which is the gas and which is the brake. She could have taken an airplane, but Tulapek is a four-hour drive from Flint, and to get to Flint she would have to transfer at Chicago, and the travel agent indicated that she might miss the transfer and have to wait seven hours for the next flight. In the end she'd have to rent a car anyway.

She feels weird. It's not just being behind the wheel. It's being alone. She never has time alone when she travels. There's always a crowd of musicians, suitors, business partners. Always people to be organized and placated, names to be remembered, schedules to be met. She presses the right pedal. The car inches forward. Right equals accelerator. Left equals brake. If she can keep that straight, she'll be fine. She pulls onto the road flawlessly, even remembering to turn on the blinker. When has she last been in a car? Not a taxi or a limo, but a car—a private, unpretentious, unmarked car. She follows the signs to the New Jersey Turnpike, both hands on the wheel, enjoying the swerve and sway of her fellow drivers, the sheer number of lanes, the awful stores that line the road. In her normal life, she forgets that this exists. There's Manhattan and there's Europe, and occasionally there's South America or Japan. But not the United States.

Maya doesn't tour the United States anymore. It's because Maya started here, and she wasn't Maya Myrrh when she was a kid; she was a freak, a singing child wonder, playing third-rate nightclubs and funny little concert halls. But Sarah liked those days, Ma and Max at the front of a succession of used cars, the tops of their heads barely visible. They were small. By the time Sarah was fifteen, she was a head taller than both of them. And Maya was even taller. American food, Ma said. In particular hot dogs, all the growing pills they ground into them. The Seminoles had been tall too. The men easily six feet, and they hadn't eaten hot dogs.

The first time she'd seen Conningsby had been from the backseat of her parents' car. It was 1959. They were clunking down an arroyo, looking for Tori's house. Ma was in front, reading the directions for the thousandth time, and Max was cursing the rocks that bumped against the car's underbelly. Maya was sixteen, not yet blond, hair in dark pigtails. She sprawled in the back, eyebrows knit, glossed lips pouting. The trip had been appended onto one of her tours, a detour so that Sarah could finally meet Tori face-to-face.

"Godmother?" Maya said. "What in the world is that? Did God choose some extra mother for her? Why didn't I get one? I don't want one anyway. Ma is good enough for me. I don't need God."

Ma whipped around. "Wicked girl! Don't say that!"

"Why not? Max doesn't believe in God."

"You do not know of what you speak. You don't say anything, you don't say anything until you're old enough to understand."

Maya curled away, her forehead pressed to the window, her shoulders trembling. Maya and God had something go-

ing on between them. Sarah would catch her praying, fingers forming a steeple, jumping up if anyone came into the room as if she'd been doing something wrong. Sarah put her hand on Maya's shoulder and Maya's shudders passed right into her skin. Then she saw Conningsby. A cowboy in a straw hat and blue jeans, riding a black-maned horse. He wasn't galloping or showing off, just clopping across the rocky arroyo, but he did this with great ease and dignity.

"He could tell us how to get there," Sarah said. Max kept driving, as if she hadn't said anything, as if the cowboy did not exist, as if Maya weren't steeped in some sorrow all her own. Sarah turned to the rear window. The cowboy had stopped his horse and was watching their car. He saw her looking and doffed his hat. She waved back.

She met him properly a day or two after, as she was squatting in the sunbaked dirt in front of Tori's house. His horse snorted and pawed the ground. "Where's your apple?" It turned out that Maya had found a worm-bitten apple in her suitcase and wanted to give it to a horse, but Sarah didn't know about this. His question seemed like a code that had to be broken.

"It's *my* apple!" Maya yelled from the porch.

She wore a white blouse tied at the waist and a blue-and-black plaid skirt. She skipped toward them, holding the apple high, a round, red prize cupped in her hand. Instead of feeding it to the horse, she showed it to Conningsby, hiding the wormhole. "Ain't it red?" she said. They weren't supposed to say "ain't," but Conningsby didn't correct her. Maya smiled, then polished the apple on her skirt. She did this slowly, rubbing it against her hip. Sarah and Conningsby both watched, and behind them the horse breathed heavily. Sarah felt a strange stir, which she clas-

sified then as magic, later as sex, a current strong enough
that Ma sensed it inside the house. The screen door opened.
Ma, in one of her dozen black sack dresses, stepped onto
the porch. "Mr. Conningsby!" she yelled. "Don't let her play
with you! She has to learn when she's offstage."

Maya was so angry that she threw the apple right at Ma.
A good, strong spin that Ma might have caught, but she
jumped out of the way and the apple shot through the win-
dow, splintering the glass. Ma clicked her gums and looked
at Maya dangerously. Maya bravely stared back, then some-
thing inside of her broke, and she stomped off to the car.
Sarah got to feed the horse the apple. Conningsby made a
curious, barely audible sound. Sarah eventually realized that
he was laughing, just doing it without opening his mouth.

"A hellion, that one," he said.

"What's a hellion?"

"Someone who likes to stir things up."

She imagined Maya standing over a steaming cauldron,
and couldn't help but smile, although part of her felt badly.
She could sense Maya's humiliation, a sharp stinging cloud
of it rising from the car where she sat slumped before the
steering wheel.

"You want to ride?" asked Conningsby.

Sarah drew in her breath. She'd never been on a horse
before.

Conningsby was already picking her up, helping her
onto the saddle. "Don't worry, I'm coming behind you."

She still didn't understand who he was, but she knew
from Ma's nod that she could trust him. The horse started
moving. She could feel Maya's eyes on her back. Maya had
a plan that when the bomb hit, she would steal a horse
from the stables down on 52nd Street, scoop up Sarah, and

take her over the George Washington Bridge. Everyone else would be stuck in cars, all jammed up. She and Maya would gallop in the spaces between the lanes. Once they arrived at the Palisades they would leave the road completely and crash through the bracken, the bomb-torn world behind them, a whole new land stretching out ahead.

She arrives at the ramp for the New Jersey Turnpike and takes a breath. The cars are going so fast. She accelerates, and her car hurtles into the tightly packed lanes. Their US tours had inevitably started on the New Jersey Turnpike, but back then it had been lined with dairy farms. Now it's a study of gray. Gray pavement, gray exhaust, gray marshland, gray Mercedes with a gray roof rack, gray warehouses, gray tanks of who-knows-what, gray potholes. The rental car flies over one. It had been a smooth road with pretty ladies in the rest stations wearing smart little skirts and giving out road maps. The New Jersey Pikettes. Ma would first send Maya, then Sarah, to ask for a map. They were free, so why not? It's always good to have an extra.

The funeral parlor is indeed in a strip mall. A single-story stucco with a shoe store attached to one side and an office-supply place on the other. Sarah parks the car and sits behind the wheel, staring at the double doors of the funeral parlor, not wanting to go in. Twenty percent to Tori. Twenty percent to this Philip Clark. Sixty percent to Conningsby's biological family. What does any of that mean? As if you can prove your claim by the mass of ash you carry around. She imagines the funeral director standing by a table, and on the table is a scale—an old-fashioned, double-plated one, like the scales of justice. He's wearing a butcher's apron over his

undertaker's black, and he's scooping Conningsby's ashes onto the plate, his glasses halfway down his nose, frowning, shaking his head in holy disgust.

She struggles into her black dress, crouching low to avoid the attention of a gang of kids stuffed into a nearby station wagon. A woman with a feather hat walks purposefully toward the funeral parlor, her lips a severe and distinct plum. Sarah's lipstick is too saucy. She wipes it off, then fingers her collarbone. Where is Maya's necklace? She searches through her suitcase and toiletry bag, panicked at the thought of what Maya will say. The pendant will not be found.

A minister is reading from the Bible as she slips into the back row, unoccupied save for a man who seems to be the only other person under seventy in the room. In the row before them a dozen or so of Conningsby's relatives, pale necks and colorless hair, murmur a prayer. The minister steps down, and the woman with the plum lipstick rises. She makes her way to the podium, heels clicking, the black feathers on her hat bobbing with each step. An uneasy silence settles. She surveys the room. "Marshall was a brave and principled man." Her eyes home in on Sarah. "He would have died for democracy." She says this accusingly, as if Sarah would not die for democracy.

Sarah stares back, wondering if she is being overly sensitive, but no, the woman is glaring at her, accusing her of some kind of, what, lack of patriotism? Does she really think that Conningsby would have willingly signed up to die for democracy? The only person Sarah has known who could do such a thing, at least with any grace or intelligence, would have been her father. But he wouldn't have done it for democracy, it would have been an atonement—no, that was

putting it too grandly, it would have been revenge, sweet revenge, ptchinka.

Feather Hat continues, her voice breaking, talking about the Verdun and the Huns as if the mud was still red with men's blood. The man beside Sarah looks on with what seems to be polite astonishment. He senses Sarah's glance and turns toward her. He has the handsome bland face of an anchorman on the nightly news, and she is afraid that he is going to shush her even though she hasn't said anything. Instead the corner of his mouth lifts into an asymmetrical smile that charms her completely. She is overcome with a desire to giggle, which he seems to intuit, for he shakes his head and turns back to Feather Hat.

At the end of the service, Feather Hat marches over to them. "I assume you're here to pick up Marshall's ashes."

"Yes," says the man, "I'm Philip Clark." He extends his hand.

The woman gives it a cold stare. "Follow me." She turns sharply.

Philip Clark drops his hand and allows himself a slight raise of the eyebrows. "Shall we?" he says to Sarah.

The woman stomps out of the chapel and down a narrow hallway, the feathers on her hat waving as they follow behind her. They turn a corner and go up some steps. Sarah's surprised. The funeral parlor looked so small from the parking lot. They head down another hallway, fluorescent lights sputtering and crosses dangling and the woman's heels clacking sharply against the tiles. Sarah starts to feel dizzy. What are they doing? They're treating Conningsby like a medieval saint, doling out tibias and fibulas, only it's worse—the charred remains of tibias and fibulas. She shouldn't be involved in this. She's a Jew, for God's sake,

Jews don't believe in relics. But she's not a Jew. It's these crosses. They're making her feel Jewish, or at least nervous. Philip Clark walks by her side, confident and oblivious. She wants to grab his elbow, steady herself. No. It would be too flailing.

They enter a sweltering little room, more of a storage closet, and Philip loosens his tie. In the corner, two plastic bags sit askew on an old vinyl armchair. The woman picks one up. "Here you go, Mr. Clark. It's a shame that Marshall didn't have any children of his own." She hands him the bag.

He palms the contour of the container inside. "You must be Mrs. Merriweather," he says. "Conningsby often spoke of you."

The woman opens her mouth. The space inside is terribly black. "Miss," she croaks. Something's happened to her. She sucks in air, gulping it down like she can't get enough. Sarah steps forward to help, but the woman bats her away. "Go."

Sarah points at the second bag. "I need that first. I'm here for Victoria Scraperton."

Miss Merriweather grabs the bag. "Tell Ms. Scraperton that if she had any pride, she'd have come here herself. She's a whore, tell her that. A tramp."

Sarah roots through her purse for the legal papers that Tori had FedExed her. "Here," she says, offering the envelope.

Miss Merriweather, clutching the bag to her chest, won't take it. Philip stands there unhelpfully. Sarah unfolds the letter and holds it in front of Miss Merriweather's face.

"Go away," the woman says.

"Give me the bag," says Sarah.

Miss Merriweather stomps on Sarah's foot. Sarah

gasps, as much from shock as from pain, but the pain is considerable.

"Give me the bag!" She tries to wrest it from Miss Merriweather, but the old woman slips away. With a yowl she darts forward and kicks Sarah in the shin. Sarah makes a fist and starts to swing. Miss Merriweather screams and drops the ashes. Philip grabs Sarah right before her punch lands. Sarah looks down at the floor, trembling.

Philip squats to pick up Victoria's bag. "We're entitled to forty percent," he says to Miss Merriweather. "If you want to dispute it, talk to the lawyer."

Sarah is aware of him leaving, but she's too dazed to move. She almost punched an old lady. She's never punched anyone before. Miss Merriweather collapses on the armchair, sobbing. Sarah feels she should say something. She wavers at the doorway. But it doesn't matter. Miss Merriweather is off in her own world, sobbing arrhythmically. Sarah turns down the hall and limps after Philip.

Outside, the air is cool. Cars stop at the light, and a man with a cake box walks across the street. This is how people are supposed to act, carrying cakes across the street, not plastic bags of ashes. Philip Clark is waiting for her. He gives her the bag.

"Don't worry, you wouldn't have hurt her. It wasn't much of a punch."

"Gee, thanks." She examines her bag. It's not even black. It's a drawstring shopping bag. Inside, the ashes are packed into some sort of metal container. It's not very heavy.

"I'm glad Victoria didn't come," Philip says. "She would have killed that woman, twisted her neck right off."

"You know Tori?"

"I met her once, when I visited Conningsby." He says this as if it is not strange, as if some Republican with neatly clipped hair has every right to know an old circus star living out in the middle of the desert.

"Did you know she used to dance with snakes?" Sarah says.

"No." If he's shocked, he doesn't show it.

"Yeah, she was my mom's mentor, a real star. She had her own tent, her own train car, a step above your normal sideshow fare. She had a real affinity for snakes." She levels her eyes at Philip. "Her tongue, you know, is forked."

Philip raises his eyebrows.

"She might not have shown it to you. It's not so obvious that you can see it unless she demonstrates."

"What about that drink?" Philip says.

"What drink?"

"We're supposed to have a drink. After funerals, you know. People have drinks."

"All right," she says, pleased. They walk down the sidewalk. The town's main street is a four-lane road lined with parking lots, low, flat buildings, mass-produced signs offering nothing you want. His hand touches the small of her back.

"You're limping," he says.

"Miss Merriweather knows how to stomp."

"We'll stop here then. No point in taking a tour." It's a Holiday Inn with a bar called The Good Times. A waitress with braces seats them in a dark booth under a painting of snowcapped mountains. They put their plastic bags on the benches, then slide in afterward. Their knees touch. Sarah lights a cigarette. Conningsby would have enjoyed this; he would be having one of his silent laughs. Why had he never

mentioned Philip? But why would he have? Some kid from Terre Haute. He didn't speak much of his past.

Philip orders them Scotch with extra ice for Sarah's foot. "To Miss Merriweather," he says when the drinks arrive.

"So what's the story there?"

"She was Conningsby's fiancée, before the war."

"And?"

Philip shrugs. "Conningsby broke off the engagement."

"But he still spoke of her."

"I said that to make her feel better. He mentioned her, but mainly to illustrate the difference of before-the-war and after-the-war. Before the war, they were engaged. After the war, he had different ideas."

"Different ideas? What kind of ideas?"

"I don't know. I didn't ask."

"Why not?"

He looks at her patiently. "It would have been digging."

No, it's not a patient look, it's a condescending look, as if she had no tact. She swings her knees away from his. Just because she almost punched an old woman doesn't mean she doesn't have tact.

"It's funny to think of you and him being friends."

"Why?"

She's flustered. What's she supposed to say? Because your face is too neat and square, the face of a man who's afraid to ask questions, and Conningsby wasn't afraid to ask questions. She corrects herself: Philip would ask questions, but they'd be predictable, preapproved. Just the facts, ma'am. It's that TV anchorman face, composed, steady keeled, not unduly affected.

She squirms in her seat. She wants to affect him. Fuck him and his tact. She slides her knee back between his. It's

the funeral. It's her throbbing foot. It doesn't matter what it is. She wants to see him sweat. She wants to get a room. They will, obviously. Why else did they stop at a hotel? She's never screwed in a Holiday Inn—how fitting, a Holiday Inn smack in the middle of the Midwest with a white guy who asks formulaic questions. Why is he looking at her like that? Oh, yes, she's just put her foot in her mouth. What's so funny about him and Conningsby being friends?

"I don't know," she says, "I guess I picture Conningsby alone, you know, out West on his horse."

He smiles, a friendly spread of lines around his eyes. A kind smile. She's being too hard on him.

"He had horses in Terre Haute too," Philip says. "Not in the city proper, in a big house in the woods."

She leans forward, all of a sudden understanding what Philip must know. "You mean his grandfather's house? Alligator's? Did it really look like a castle?"

"Yes. Did Conningsby tell you about it?"

"We were working on a book together. The castle was the project of Alligator's old age."

"I'd love to see the book. Do you have a draft?"

"I wish we had gotten that far—I only have some patchy bits of his essays. They were wonderful, but never completed. And about a dozen paintings." God, the years poured into that book. One of the pictures featured Alligator's castle rising out of the Everglade swamps. She wonders what Philip would make of it, if it would bear any correlation to the place he'd been in. "Was the turret really crooked?"

He looks confused, but only for a moment. "Yes," he says fondly. "It had a tiny, narrow spiral staircase. I'd climb up with a glass of juice and put the glass down on the stairs so I could see the angle at which the liquid settled. There

were so many things about that place. A dumbwaiter you could climb into. A roomful of lances and rawhide shields. And this gigantic basement—god . . ."

"Did it have dungeons?"

"No." Philip hesitates. "No. It was just a big basement. That's all, a lot of space. You forget, living in New York, that basements don't blow everyone away."

Sarah sits up straighter. "You live in New York?"

"Seventy-eighth and Riverside." He fumbles for his card. "Here. You should call me up sometime."

She crosses her legs. They are not getting a room, absolutely not. She won't have another drink; she can't let herself get tempted. People think that New York is big, but not if you sleep with someone you don't want to see again. And she can't see him again. He has a solid decency about him that is lovely, but not for her. Maya would eat him up for breakfast. She wraps the ice in a napkin and presses it against the pain.

"Put your foot up here," Philip says, patting the bench beside him. "It won't swell as much if you keep it raised." He places her ankle beside his thigh and holds the makeshift ice pack to her foot.

"Thanks."

Cold water seeps into her stocking and his trousers. They stare into their drinks. They are no longer on their seconds, but their thirds or fourths. They have balanced the booze with plates of chicken wings and mozzarella sticks and bloated green olives, both of them surprised by their hunger. She misjudged him earlier. They wouldn't have gone to bed; she mistook funeral angst for sexual friction, or something like that. And he's not bland, he's just understated. She likes being with him. It's like being with family.

What a strange thought. He's so emphatically unlike family. Maybe it's just that he likes Scotch. Max liked Scotch. No ice. Straight. He'd stir it around with his pinkie and suck the drop from his fingertip.

"Good lord," says Philip.

"What?"

"It's funny how you can miss people that you haven't seen in years." They are silent. The bar has become crowded with drunken salesmen in matching electric-blue jerseys. They yell scores and throw peanuts at the waitress. Philip shakes his head in disgust. "It's hot in here. Let's go outside."

They head for the lobby, each with a bag in hand. He walks ahead of her, and she feels that something has cooled between them, but then he stops at the door and opens it with a charming bow.

"Where are we going?" she says.

"I don't know. Let's take a walk." Outside it's dark and there are stars in the sky, a particular wonder for those from Manhattan. "I'm sorry. I forgot about your foot."

"It's fine. It's nicely numb at this point."

Philip relaxes and they walk, hips bumping, down the ugly strip. She's happy. She catches herself swinging her bag, its contents forgotten. They pass convenience stores and gas stations, a couple buildings that must have been nice but now are boarded up.

"No graffiti," she says. "This town is hopeless. There should always be kids and spray paint livening things up."

"Graffiti's a blight."

"Don't be square."

"I'm not square. I'm an architect. Graffiti mars buildings." He reaches for her, slips his arm around her. He tells her that he became an architect because of Conningsby.

"That basement in the castle?" he says. "It wasn't just big. It was filled with stuff. We were making a model, Conningsby and I, a model of an entire town, a French country town with a Gothic church. We had a sunlamp, soil beds, chisels, whetstones. The details were exact and historically correct; there were bonsais in the orchards and stained glass in the church windows. We worked on it for years. A perfect model."

"Conningsby never mentioned that. Why France? Where's the model now?"

"In the historical society of Terre Haute. I'll take you there someday, if you want."

Sarah grins so wide her cheeks hurt. Maybe New York is big enough. His fingers curl around her waist. She plays with his thumb, squeezing it gently.

But she can't. He is not the sort of man to bask in the pleasure of a good love affair. He's a marriage-and-kids guy; it's written all over his face. She lets go of his thumb, then to get his arm off her, leans down and rebuckles her shoe. When she stands up, his hands are in his pockets and he's frowning at the sidewalk.

"What's wrong?" she asks, hoping she wasn't too obvious. But the pain in his eyes goes deeper than anything she could have delivered.

"Nothing," he says. "I mean, Conningsby saved my childhood. I don't know what would have become of me if I'd been stuck in Terre Haute with only my parents. I wanted to thank him when I went out to Texas. But I didn't even say goodbye."

"You got into a fight?"

"Not with Conningsby, with a friend of his." He relaxes somewhat. "I took off in the middle of the night. Never said goodbye. Never said thank you."

"Conningsby knew that you loved him. Why do you think you're here? He wouldn't have mentioned you in his will—" She frowns down at her bag. "Let's open them."

"The ashes? Now?"

"No, just the bags. I want to see what the containers look like."

They are small tin cups with handles on either side, like the dusty trophies you see on display in diners and child-hood rooms. Philip closes his bag first. They start walking again. His arm is no longer wrapped around her. This is what she wanted, but it feels unduly absent. She lights a ciga-rette, wishing the smoke were warmer and more substantial.

The sidewalk gives out. They stop and look ahead: a dark road with dark shadows of houses and dark shadows of trees. There are still stars though. Fuck consequences. She wants his arm back around her. He's a grown man. He can take care of himself. She looks for a constellation. She'll nudge him, point it out, see what happens. This is bad. She wants it too much. His shoulder brushes against hers. She jumps.

"You're shivering," he says. "Take my jacket."

"No. I have to go." The words surprise her. That's not what she'd meant to say. But once said, they strike her as correct. She needs to get out of there, and fast. She's acting like an idiot. She touches his cheek, then touches her neck. "I have to get back to New York."

"You're leaving now? It's past midnight." His breath is a warm cloud of Scotch, slightly sour. She puts a hand to his chest to stop him from coming closer.

"I'm sorry. I didn't realize what time it was."

"Right," says Philip, retracting.

"It was lovely meeting you."

"You too."

"I'm sorry," she says again.

He draws himself up straighter. "Don't be."

"Well, goodbye," she says, stepping backward, still facing him.

"You better watch where you're going." She was about to walk into a fire hydrant. She sidesteps it and walks toward the funeral home's parking lot, feeling his presence behind her. Anything, the slightest little peep, and she'd stop. But he remains quiet. She gets to her car crying. She should have kissed him. Even a peck. Just one kiss. Something. She wipes her eyes. She hates crying.

She drives through town, through flat, unseen farmland, on two-lane highways and six-lane interstates. Somewhere near the border of Ohio, she finds herself all alone with no other cars on the road. She turns off her headlights and drives by the light of the moon. The pavement wedges into the darkness of the land. The sky is the same shade of dark, only translucent. She shivers. It's beautiful. It's a goddamn interstate, but all the angles, all the planes are glowing with a dark radiance, perfectly composed.

Chapter 3

S he wanted a cigarette. She hadn't had one in years, but the urge was as fresh and nagging as if she'd quit yesterday. She loved smoking. She hated it when people went on about cancer and that sort of thing. As if you smoked for your health. Health had nothing to do with it—you smoked for solace, solitude, that feeling of alive-ness and fuck-you-ness. Philip hadn't understood. He had been constitutionally incapable of understanding the joy of smoking. Stop. Stop thinking about him. Why even bother reading his letter? She knew what it would say. *Hi Sarah. Here I am, saving the world. Hope you're well.* Damn you. She'd toss it in the trash, mix it up with Sears coupons and fish parts. No. She'd make a collage: *Unopened Mail/Male*, some kind of semi-otic baloney title. That's what sold these days. She'd put it on the market, make a ton of money. It really was a good idea not reading it. She glanced at the trash can. It didn't have a cover. She'd have to bury it at the bottom or Max would see, and there was some pretty gross stuff in there. She could burn the letter. But that would be too melodramatic. She'd have to wait until Max went to bed, drop the letter in the trash, then bag it up and take it out. The garbage didn't get picked up until Friday, but at least the letter would be out of the house.

Stop sweating. It was October. She had no right to be sweating in October, particularly in front of an open re-frigerator. She ought to close the door this instant, and not stand there staring into the stained clean interior, cursing her brain—for isn't that where desire lies, some dormant withdrawal neuron, freshly awoken, jumping up and down like a child on a mattress? It was just a pack of energy, one of many. She did not need to pay it attention. She crossed her fingers and scrunched her toes. She couldn't have Just One, it was too hard to stop once she started. No furtive trips to the 7-Eleven, none of that. Last time she'd gotten a letter from him, she'd smoked half a carton in two days. She'd lit the first one before even reading it, knowing herself to be an idiot, hoping for impossible things, declarations of love and erasure as if—even if he did come back—they could ever fit together again. She'd known it, but still, seeing his hand-writing arranged so politely and neatly and inconsequen-tially across the page had driven her through the roof. More than half a carton; Max had staggered around the house, clutching his throat and repeating American Cancer Society slogans ad infinitum.

She closed the refrigerator door. She'd just given Max a lecture on how they had to reduce their electricity bill. She listened for his footfalls, but the house was empty. He was out front, as instructed, practicing his karate. She opened the letter.

Dear Sarah,

I've been trying to write you for months. I'll send this one, no matter how it turns out. I've been living in a tent in Goma, in Zaire or Congo, take your pick, the carcass of a country just east of Rwanda. The air around here smells like it did in that hole.

Sulfurous. There's a volcano nearby. It sputters ash and fumes and glows at night. The camps are set on fields of black volcanic rock. There used to be forest around here but the trees were chopped down by refugees wanting to cook their food. There are bodies moldering around the stumps. Death is so common here, more from disease than from violence pure and simple, though there is plenty of that too, and madness. Some have gone back to Rwanda. But loads remain. They need food, water, medicine, plumbing. The sewage is a real mess. You can't dig holes. The rock is too thick. The crap was piling up for months, that's what caused most of the sickness. Now it's getting trucked out. Everything comes in and out via truck.

My job is to keep the trucks moving. A whole slew of fuckers are attacking them for various reasons, and mining the roads and bridges while they're at it, blowing up tanks of shit along with kids' arms and legs. I rebuild the bridges. I do my best to identify places that would make good ambushes and try to make them safer. It doesn't always work. I have not dabbled in mine removal, though I met a mustached Canadian who you would have liked very much, who is great at it. Did you know that Franco defused mines in Vietnam? I remember him telling me that it was a thrill, like pickpocketing an armed man twice his weight.

There is lots of waiting. Waiting for supplies that might or might not arrive, for bribes to be accepted, for bosses to relent and allow us to do some simple thing that must be done. So many people have lost everything, Sarah. It surprises me that they don't all lose their minds. The Canadian and I rigged a basketball hoop from a slice of water barrel. It's got a burlap net and a backboard fashioned from the side of a dead truck. I taught a few of the kids to play. There is one who has killed and who has seen his family killed and yet when he plays, he plays

with a kind of joy. As if he has forgotten. He has white teeth and more meat on his bones than the other kids because I feed him.

I would like to talk with you. I've been thinking about the things you told me, or rather yelled at me, in that hole, and a hell of a lot of it was true.

I gather you do not want to see me, but frankly, I feel I have the right to insist. I will be participating in a conference in NY in October and have a day free on the 15th. I plan on taking the 9:07 (if there is still a 9:07) from Grand Central and should arrive on your doorstep sometime that morning. I am banking that you are still at this address.

I do, so much, hope that you are well, and that I see you soon.

Philip

P.S. Excuse the clunky announcement—the phone number you sent doesn't work. I'll try to get the right one when I get to New York. Otherwise I'll take a trip out to Connecticut and see what happens. This would be easier if you were more communicative.

She read the last part again several times. Many things had changed, but not the Metro-North timetable. There still was a 9:07. She folded the letter neatly, returned it to her pocket, then strode to the calendar to confirm what she already knew: the fifteenth was tomorrow. Tomorrow. A blank white square in a free Mike's Service Station calendar. Why did she feel so quiet? Even her nicotine neuron had calmed down.

"Kiai!" shouted Max from the front yard.

She splashed water on her face, took a deep breath that ended in a cough, and went out to watch Max. She had

conned him into his first karate class by telling him that Philip had been a black belt. It wasn't true. But if she had told him that Philip was into basketball, then Max would have taken that up, and she'd wanted him to learn a martial art. He needed to know that violence was part of life, not an aberration. At this point, she didn't need to do any more convincing. Max loved it. She watched him spin and kick, the leaves rustling about him, oblivious to her trembling. He was in the midst of his favorite kata. At the end, he bent down on one knee and with something that he called a knife-hand fist, executed the coup de grâce, a slice right through his invisible assailant's throat. Sarah clapped, perhaps a bit too forcefully.

"Please, Mom, you don't need to clap."

"Right," she said. She watched the next kata, focusing every bit of her attention on it. Max had an athletic grace that made her both proud and retroactively jealous. She'd been a gawky kid.

"Kiai!" he shouted, raising his legs in a quick double kick, scattering more leaves. Sarah forgot and clapped again.

"Mom!"

"Sorry."

"Kiai!" Max shouted. She didn't clap. He had Philip's hair, but longer than Philip's mother would have let him keep it. "Why are you looking at me like that?"

"Like what? You didn't want me to clap."

"You're looking at me funny. Did you read the letter? Is it from Dad?"

"What do you mean, *Dad*? Since when are you calling him *Dad*? You've never met the man."

"He is my dad."

"He's your father."

"Is the letter from my father?" Max said with exaggerated patience.

How the hell was she supposed to answer him? If Philip really did arrive on the 9:07, that would be one thing, but she'd be a fool to bank on that. "We are not talking about this now. I've got to grade the papers."

She went to get them from the trunk of the car. He followed behind her, way too close, as if he were three years old again, pulling at her skirt, wanting every particle of her. Although now he didn't want every particle of her. He wanted every particle of the letter.

"I thought you were making dinner," Max said.

"Can't I make dinner and grade papers at the same time?" she snapped.

Mr. Walpole, the retired accountant who lived next door, stepped out of his house, banging the door behind him. A moment later, he was shaking a bamboo rake in her direction. "Do you even have one of these? Can't you see your leaves are blowing into my yard?"

She rattled the trunk key, first right, then left. The Buick was a rusty, crotchety thing. Keys had to be slipped in just so, doors closed at exactly the right angle. She could feel Mr. Walpole's glare. Both he and Max, staring her down. Couldn't they see she had a lot on her mind? The trunk popped open.

"Every day I clean up after you!" Mr. Walpole shouted.

"What the hell?" she yelled back. Her voice sounded shrill, even to her. But Max broke into a big grin.

"You tell him, Mom!" He followed her into the house. "That was great, Mom."

"Thanks, sweetheart, but I shouldn't have lost my temper." She dumped her students' reports on the dining room table.

"So what's for dinner?"

"I don't know." Sarah covered her face with both hands.

"Mom?"

"Yeah?"

"Are you okay?"

"Just tired, sweetie." It took her some time to lower her hands. By then, Max had lost interest in her and was picking at a scab on his elbow. His fingers were slender and long, his nails dirty and bitten. His tender regard for his own scab made her want to cry. He scraped it off.

"Ew! It's bleeding!"

"Well, what did you expect?" She laughed, grateful for the diversion. "Let's wash it off in the sink."

Chapter 4

New York City, May 1981

Philip's business card lies on Sarah's dresser, smudged and soft from her hands. She touches it when she's going to the studio and when she's taking off her earrings. She has no intention of calling him. That night in Michigan was too fraught. She'd acted like a teenager, running away like that, crying. But she's glad it happened. If she hadn't lost her head, she probably would have driven back without noticing anything. In her heightened state, she'd had that vision of the highway: formal, perfectly balanced. She's been working out versions of it ever since, rearranging the planes of darkness, the translucent slabs of sky, the opaque land. The results are elegant, seemingly abstract. She picks up Philip's card, aware that it's become a sort of talisman. She ought to throw it away. It's superstitious. She doesn't want to become like Maya, collecting sacred objects. But she puts it away gently, in a drawer filled with silk scarves. She is just closing the drawer when she finds, much to her delight, the ivory pendant that Maya had given her to wear at Conningsby's funeral. She fastens the chain around her neck and smiles into the mirror. It's the perfect thing.

The party is in honor of Maya's latest deal. A warehouse in Dumbo that Maya has been eyeing for years now belongs

to her, permits cleared, zoning dudes pacified. Sarah has to bribe the cabbie to take her there. The neighborhood is notorious, but gorgeous in a decrepit industrial way. She tries not to gawk out the window, or otherwise betray the pleasure she takes in the vaulting metal arches of the bridge, the boats on the river, the spires of Manhattan shooting up so close and yet so far. She's never been here during the day—only to parties late at night. The cab stops at a nondescript doorway and Sarah gets out. She could make a mosaic from the red-and-green-topped vials wedged between the cobblestones.

Maya bursts out of the building, the sun shining down on her hair, the brightest thing on the block. "You are here!" She swoops Sarah up in a kiss. "You've been positively locked in that studio. I haven't seen you in ages."

"You saw me last week."

"For lunch. For a second. You should have stayed for dessert," says Maya, pinching her waist. "You are getting way too skinny. You forget to eat when you are painting." She gives her a kiss on the cheek, to show that she is not really chiding, and slips her arm through Sarah's. "You've never been here, have you? Let me show you around."

The weather is just right for a walk: midseventies, blue sky, the breeze carrying with it a tang from the river. Maya points out a tumbledown gas station where, reportedly, an ex-priest sleeps with a hose to spray anyone who might bother him, an anarchist squat, a concrete slab of waterfront where the Fulton Ferry used to be.

"And now the warehouse!"

They enter through the rear door. Sarah whistles. She had been expecting some drafty sheet-metal thing, but this is a substantial building with masterful brickwork, rusty

hooks dangling from the ceiling, two-story-high windows. Light shines through them, casting gigantic parallelograms on the concrete floor. Here, an orchestra finishes setting up. There, caterers tuck the last sprigs of parsley onto enormous platters of shrimp and smoked salmon. Maya takes her up an iron staircase to the second level, a platform about twenty-five feet wide that runs along three walls of the warehouse and looks down on the main floor below. Together, they watch the first guests come in, then more and more, a whole slew of them waving to one another, kissing and jostling, enthused by the fresh spring air and the novelty of their surroundings.

Maya took up real estate in her early twenties, after having experienced, if only for a month or two, the horror of being an international pop star. "Serpentine" had made her so much money that she was able to buy Max and Ma a sprawling apartment on Riverside Drive, start up her own business, and declare herself done with music. No more tours for her. She wanted to figure out how all those people who did not pack up and visit a new city or town every night lived. "I'm going to get myself a real job," she had famously told Max, defiantly, as if it were Max who had foisted singing upon her.

Now she leans in toward Sarah, informing her of who is who and why they are there, her eyes sparkling with enjoyment. Who lost money to what. Who's sleeping with whom. Who just came out of rehab, court, counseling. Sarah can't keep track, nor does she really try. It's Maya's rich crowd, sheikhs in French shirts and expensive cowboy boots, builders with geometric ties and bald spots, fashion people who will go anywhere Maya leads them. There are a couple of people from the art world too. Maya, after much

training, has learned not to point them out, though Sarah can tell she'd like to.

"What do you think about pirates?"

"Pirates?"

"I'm talking about this year's tour. What if I ditched love songs and concentrated on pirates? Stella thinks it's a good idea."

"Stella?"

"I'm very clear on your opinion of her," Maya says, "but she has brilliant intuitions. She knows exactly who to approach. And when. You know Reagan uses an astrologer. I'm not saying I like his policies. But you have to admit, the guy's got power." Maya spreads out her hands as if she's made an incontrovertible point.

"I thought that Stella advised you on property values. Since when has she gotten involved with your set list?"

"You don't like pirates?"

"I do. But you only have three months to prepare, so why not stick with what you know?"

"I've been preparing. You're out of the loop, you've been so absent recently."

Sarah sees Gus, her studio mate, wandering the floor below, looking lost and rumpled. "Oh, poor Gus, look at him. He'd like pirates."

Maya smiles. "Yes, you're right about that. Go down and say hi to him. We can talk about this later."

Gus gives Sarah a big kiss, sprinkling champagne on her shirt. "Whoops, sorry. Can I get you a glass?"

"No thanks, I'm going back to the studio after this."

"I'm staying here and taking advantage of this shrimp. This place is amazing. What's Maya going to do with it? Think she'd give it to me?"

"Probably."

"Think how tall I could make my totem poles."

"Lord have mercy. You'd need a lot of tin cans."

An hour or so later, someone starts chanting Maya's name. The orchestra stops playing, and all you can hear are more and more voices shouting for her.

"I never said I'd sing, you jokers," Maya drawls. "Think I'm going to give you a free concert on top of everything else?" She lets them roar a little longer, then with a Mae West saunter steps into the light. Gus grins. He loves Maya. He slept with her one night last year and gloated about it for six months afterward. Sarah doesn't usually get upset over that sort of thing; she and Maya often end up with the other's old boyfriends. But Gus wasn't an old boyfriend. He was a best friend, a more rare and more prized possession in Sarah's book, and Maya's too. Sarah is still slightly piqued, although not so much that she can't see the humor in it. She elbows Gus in the ribs.

"You're drooling."

"Can you blame me?"

"Dans le port d'Amsterdam
Y a des marins qui chantent
Les rêves qui les hantent
Au large d'Amsterdam
Dans le port d'Amsterdam
Y a des marins qui dorment
Comme des oriflammes
Le long des berges mornes."

Maya begins quietly, in a whisper that travels to the far ends of the warehouse. She toys with the lines until Brel's

passion catches her and she gives in, her voice opening into a lake of anger and desire that engulfs the whole audience. Except for Sarah who is still mulling over Gus. Maya senses this. She leans toward Sarah, her voice rising, thin now and trembling. Sarah can feel it in her chest. A vibration going straight into her heart. Maya's eyes shine into hers. It's hard not to melt when she looks at you like that, as if you are the entire world. Sarah stands firm, staring back proud and dry, until the ridiculousness of the situation strikes her, and she can't help but smile. They both do, like when they were kids, ending a staring contest in a fit of giggles.

"*Dans le port* . . ." Maya sings, joyful now, still gazing at Sarah, funneling all the energy of the crowd into her. Sarah feels it enter into her, a sensation of heat and expansion, a feeling that is almost embarrassing in its surfeit of pleasure.

Sarah and Gus share a studio, an enviable space in an old iron building in Chinatown that used to be a pillow factory. It was one of Maya's first purchases. The windows are cracked and sooty but enormous, big enough to let the light in no matter how dirty they are. A scratchy jazz station plays as Sarah mixes paint, linseed oil, turpentine. *Highway #3* hangs on the wall. It's gigantic by her standards, six and one-half by five feet. It took her ages to get the first coat on. The median is invisible, the asphalt a dense strip of gray that blurs into the land. The solidity of the road works, ditto the gusty sky, but the land needs something. The geometry of farm fields? Something wilder—the prairie. That's what she wants, impenetrable grass. Conningsby once told her that the grasses that made up the prairie had been so dense and tall, they could have ensnared an elephant. She imagines the tendrils and stalks and brambles, the massive tangle of

them pulling an elephant into their midst. She wants the feeling of that at night, when you can barely see it but know it is there.

The elevator cables creak. Probably Gus, only halfway through banging out his anvil totem pole. She misses his period of quietly gluing metal to wood. She dabs a dark shade of gray onto the canvas. On a whim, she smears it with the palm of her hand. She studies the result on the canvas, then examines her hand, interested in the way the paint gathers in the lines of her palm, and the resemblance of these palm lines to the veins of a leaf, and what such lines might look like transposed into prairie grass.

"Hello!" Maya calls in a company voice.

Sarah wipes her hand on her pants, confused. Maya is usually too busy to drop by her studio unannounced. A woman stands slightly behind her, slim and elegant, with sharply cut white hair. "Do you know Violet DeMeunys? She's doing a show on contemporary history paintings. I told her about your circuses."

"Pleased to meet you," Violet says, in a way that conveys that she might be interested in making Sarah's acquaintance, but probably not.

"Hi," says Sarah. She has told Maya a million times that she does not want or need help in the art department.

"Maya is quite keen on your circus paintings. I'd like to look at them if it's convenient."

"I'm flattered, but I don't think they're what you're after," says Sarah. "They are more personal than historical."

"Sarah, for fuck's sake, just show her the pictures. Where are they, anyway? Last time I was here they were all over the place."

"That's because I was arranging my storage area," Sarah

replies before marching to the storeroom, furious in the pure way that a child is furious. She flicks on the light, illuminating a good-sized room, one wall of which is covered with recently installed vertical racks, already filled to bursting. She had been happy, finally organizing her paintings, remembering ones she'd forgotten about, dusting them off and putting them in order. But at this moment the too-full rack feels like an admission of defeat. "I'll leave you guys here. The circuses are in the upper-left area."

The last time she showed the circus paintings had been a couple years after art school. An itinerant curator had fallen for *Circus #4*, a portrait of Ma, spangled and young, with a snake around her torso. But she put it in a show that was almost all conceptual feminist art and it ended up alongside a bloody tampon chandelier. On opening night, no one saw Ma and her snake. They only shuddered and wondered if the chandelier tampons were real and if the blood would drip down on them. Perhaps if *Circus #4* had been placed somewhere else, people would have seen it. But perhaps not. And more to the point: shouldn't it have been able to overpower some stupid tampons? Why is she compelled to paint stuff that can't compete against bloody fucking tampons?

Violet and Maya come out of the storeroom, chatting about a tennis game.

"Thank you, Sarah," says Violet. "The paintings are beautiful, but you are right, not quite what I'm looking for. Is this what you're working on now?" She squints critically at *Highway #3*. "Quite a change. Very masculine. Well," she kisses Maya's cheek and nods to Sarah, "nice meeting you."

"You too," Sarah says.

"I'll see you out," says Maya.

A few minutes later Maya returns, glaring and stormy.

"Don't look at me like that," says Sarah. "I didn't ask you to bring her over."

But that's not what Maya's upset about. She leans against a column, arms crossed over her chest, and looks at *Highway #3* as if she'd like to pick a fight with it.

"Since when are you doing abstracts? I thought you were against abstracts, the paintness of paint or whatever it was."

"It's not abstract. It just looks that way. It's the highway at night."

"It's enormous. It's like nothing you've done before. I felt like I had totally misrepresented you. It was embarrassing."

"The circuses are the same old circuses, and that's what she was interested in."

"Yes, but this is what hits you when you walk in. Violet's right. It *is* masculine."

"What's that supposed to mean? Because it's big? Because it's gray? Women can't use gray?"

Maya takes in the other paintings and studies four highways propped and tacked against the wall. "When did this begin? Where did you see this highway?" Then, quietly: "Oh fuck. It was in Michigan."

"On the way back," says Sarah, trying to sound nonchalant. She had told Maya little about these new paintings because she associates them with Philip, and she hadn't told Maya about Philip because she met him at Conningsby's funeral, and that was a subject best left alone.

Maya stares at her, long and hard. "You're not wearing your egg."

"What?"

"That ivory pendant with the charm. You wore it at the party."

"Oh yes, it's at home. I didn't want to get paint on it."

"You wore it in Michigan?"

"Yes." Sarah returns her sister's gaze steadily, but there's no telling if Maya believes her.

A month later, having completed another three enormous highways, Sarah realizes that they don't fit in her storage closet.

"What this means," says Gus, who's been trying to help her make space, "is that you've got to stop being so high and mighty and do something with them. They're great, Sarah. You could get someone to show them."

"I'm not high and mighty. I just don't like knocking on doors collecting rejections."

"Well, yeah, join the club."

Gus rolls her a joint. "Come on. I'll help you take pictures. You can use my camera. It's better than yours."

"You're so proud of that damn lens."

"It's a lens like no other."

There is nothing she hates doing more than shuttling her slides from place to place, the eyes of gallery girls glazing over as she mentions her scholarships and honorable mentions, all of which she received ever longer ago. But she has slides taken with Gus's fancy lens, and she even has Gus when he is free, loping along beside her, distracting her with tales of his aunts in Buffalo, and doing an excellent job pooh-poohing all those who pooh-pooh them. With him or alone, she dedicates precious days, days that might be spent at her studio, to buzzing buzzers and trudging up creaking wooden steps to obscure little galleries hidden on the top floors of buildings, edgy places where she might have a chance. She introduces herself to owners. She calls, if not all, at least a large portion of the contacts in her ad-

dress book. At the end of an exhausting and dispiriting week, she stops by the Simon Perez gallery, not to drop off her slides—the place is too intimidating—but as a treat to herself. She likes what's on the walls.

Simon Perez happens to be in, talking on the phone in the back room. He's got a reputation as a ladies' man, and when he turns toward her, she perks up immediately. She can play this game as well as anyone. She walks into his office, disregarding a rail-thin assistant who gives her the evil eye. Perez is still on the phone, but his attention is on her. He's probably in his sixties, with coarse white hair coming out of his nostrils, a wide flared nose, and smart blue eyes. He's not a man to sleep with, but definitely one to have a drink with. Or just to flirt with for five minutes. She likes his vibe. She hands him her slides. He takes them, smiling. He seems to have forgotten the person on the other line. "Eh?" he says when the voice gets so loud that Sarah can hear it. "Mmm hmm. Mmmm." He holds Sarah's slides up to the light and squints at them.

Sarah tries not to gloat as the assistant leaves the office with a loud clacking of heels.

"I'd like to see them in person," he says when he gets off the phone. Sarah invites him to come by her studio, and leaves the gallery with a bounce in her step. It might just be ass. But it's her ass, not Maya's.

The very next morning, she gets a call.

"Simon Perez?" says Gus, impressed and amused. "I better be here when he comes. I'm not leaving you alone with that guy."

But when Perez arrives his flirtatiousness is gone, replaced by a gruff seriousness, as if to make clear that this is strictly business. He wanders around with his hands in his

back jean pockets, his shoulders slumped forward, cocking his head at the highways which she has propped against one wall, and the Alligators and circuses which lean against another. She hovers by his side, rationing her cigarettes, then chewing on the inside of her cheek, trying not to analyze each shift in his expression.

"Nice work," he says after a while. He pulls his ear, twisting the lobe thoughtfully. "I'm interested in those dark planes."

"The highways?"

He nods. "Let me know where you go with that. I'd like to see more."

Gus, who had kindly desisted from banging on his anvils when Perez was there, wheels her around as soon as he leaves.

"He didn't say he'd show them, he just said to keep in touch," Sarah concludes, but she's grinning too. She rubs her ribs after Gus's strong hug. "I can get back to painting now, right?"

"Yes."

She plunges back into her work, trying to make up for the lost week behind her and the lost time ahead of her. Maya's tour begins in six weeks.

Maya's tours, her adult tours, had been Sarah's idea, born in those dark days after Ma and Max's plane went down. There was no family land to visit, no aunts, uncles, grandparents, cousins to clutch onto, no graveyard to lay flowers in, no speck of ash to throw—nothing, a big, gaping, enormous gulf. They'd had a small memorial for friends, but Sarah had wanted more. She wanted movement. She wanted a feeling of what they had done together. Maya had

been skeptical. She had been out of the music business for years. But Sarah wouldn't give up. She had booked that first tour herself, culling names from Ma's old address book, a modest-seeming affair, four shows in two weeks. Yet Maya's performances had been anything but modest. It's possible that they had forgotten how good Maya really was. More likely, she had smashed through the last traces of her girlishness. Sarah remembers thinking how unfair it was that Ma and Max could not be there, that they had to die in order for Maya to achieve such a thing.

Sarah paints. She sleeps most nights in the studio and is up at the crack of dawn. Her mind is silent, in such a visual place that words and phrases hardly enter. When they do, they seem thick and incongruous. It's not a problem at the studio, for Gus knows enough to leave her alone. But it's hard on Sundays, when she and Maya have their brunches and she can't keep up with their normal banter. The paint builds on itself, giving the flat surfaces depth, mesmerizing her when she takes her cigarette breaks, or simply slumps, exhausted, worn out by focus, on one of the salvaged car seats that Gus keeps around the studio.

Gus pulls at her shirt. "Come. I'll buy you dinner."

She shakes her head, her eyes fixed on a thick gray streak that needs to be widened.

"Give it up," Gus says gently, rubbing her shoulder. "You're leaving in a couple of days. You're not going to finish this."

"But I have to." How to explain? She's been working nonstop for three months and you would think that feeling of urgency would have faded, but instead it's stronger, a pull toward the paint that is deep and greedy.

They go to a bar with a pool table and order burgers with pickles and lots of mustard. The food hits her like a surprise. "This is the best thing I've ever eaten."

"That's because you've forgotten what food tastes like."

"Oh come on, I eat every day."

But it's true that she's been subsisting mainly on coffee and cigarettes, supplemented by her weekly poached eggs with Maya. She licks the salt off her fingers, for one sweet moment happy as a cat.

She goes home to her apartment that night. Gus is right, she'll never be able to finish. She may as well wash her hair. Her scalp itches from days without a shower. The tears start when she's standing under the showerhead. She wipes her eyes, not sure why she's crying. She clearly needs some sleep. She also needs to wash her clothes and think about what she's going to pack. She checks that her passport is still valid. Just barely; it will need to be renewed in six months. She frowns at the picture of her face ten years younger, a Sarah still in art school, her cheeks so full they are almost chubby. Ma used to pinch those cheeks. Not Max. He'd watch Ma pinch and Sarah wince, and hold back.

Their plane had gone down only months after that picture was taken.

The night is particularly hot. The fan must be doing some good, but it feels like it's blowing fevered breath on her. She dreams about a grizzly bear eating her passport. In the morning, she lies on her futon, contemplating the image of the bear, who was not very grizzly, more like Smokey the Bear but without the clothes, gamboling about, doing some sort of bear cancan, the blue corner of the passport peeking out of his enormous mouth. The fan whirs. Sounds from the

street filter in through the open window. Garbage trucks. Taxi horns. Laughter. Then quiet. A long, thoughtful quiet which is strange for New York. She lies still, barely daring to move, then bursts into laughter. The bear ate my passport. The dog ate my homework.

She reaches for the phone. Maya's not home. At nine, she calls her office. Maya has a ten-minute opening at ten fifty. Would Sarah like to schedule a call? "No, tell her I will be there in person." She takes another shower, the effects of which are thoroughly undone by the hundred-degree musk of the subway.

She enters the cool hulk of Maya's Midtown office feeling like a traitor. Leon, on the phone, blows her a kiss, then calls after her, "Seriously, ten minutes, Sarah. She's got an important meeting." Sarah waves back to the secretaries and almost bumps into a balding man in a bolo tie stepping out of Maya's door, Maya right behind him.

"Sarah, darling! How fun to have you drop by. Say hi to Richard, dear. This is Richard Ponset. Richard, this is my sister Sarah."

Richard's eyes light up, as if he would like nothing more than to stand in the doorway chewing the fat for the next half hour. "Pleased to meet you," he drawls.

Sarah pushes past him. "Pleased to meet you too."

They both stare after her. Then Maya laughs. "Oh, don't mind her." She sends him off with a kiss on the cheek.

The back wall of Maya's office is covered with black-and-white photographs of her buildings, posters from her shows, snapshots of celebrities and potentates wrapping their arms around her. Right in the middle hangs an early painting of Sarah's. Sarah turns from it toward the window. Tarry rooftops. Stalwart water towers. No clue as to how to proceed.

"Well, what's up?" asks Maya rather distractedly, searching for something on her desk.

"I need more time to finish this series."

"Oh, here it is," says Maya, leafing through a file. "A break will do you good. You'll get back and everything will be very clear."

"It's very clear now," Sarah says firmly. "I've got to stay."

Maya looks at her blankly.

"I know it's sudden, and I'm sorry. But I feel that I'm on the verge of something with these paintings. I can't stop right now, I'm too close."

Maya's eyes blaze, but her voice is controlled. "I have been trying to get Henri Vernhes face-to-face for over a year. He is due in about two minutes. You think this is a good time to have this conversation?"

"I'm sorry, but I had to tell you in person." She reaches toward her sister. "Don't be mad."

"Of course not, why would I be mad?" Maya says so coldly that Sarah freezes, her hand still outstretched.

Sarah gets back to her studio, her blood still rushing. She can't concentrate on painting, which is just as well because the phone keeps ringing. First it's Leon, begging her to change her mind, and quick. Then Maya's dressmaker, Patrick, an old friend of both of theirs, saying much the same thing. Then Stella, threatening her with some cosmic retribution.

She returns to her apartment. The phone's ringing there too. Maya's agent. Old boyfriends. Everyone chiding her. She unplugs the phone, lies on her futon, stares at the tin ceiling. The dents and blobs of paint, the fuzzy remains of a cobweb. At six a.m. people start buzzing her door.

Or maybe it's just one person persistently standing there, pushing the button every half hour. It's not Maya; Maya would just come up. Sarah stares at the fire escape across the way, some brownish spider ferns hanging neglected. A couple of girls in miniskirts and high-tops pass by on the opposite sidewalk. They are giggling, their foreheads almost touching, sharing some secret. Sarah gets into her painting clothes. The person at the buzzer is Maurice, a soft-faced documentary maker with an Afro and a Rasta T-shirt. She'd always thought he was primarily her friend, not Maya's.

"Hey, Sarah, just passing by." He's nervous, squirming around like a two-year-old with a wet diaper.

"What did she tell you, Maurice?"

"Who?"

Sarah glares.

"Don't look at me like that, man. She's worried about you. You're acting strange, trying to cut off your ties. You can't do that. She's your sister."

"Maurice, please. I'm not cutting off any ties. I'm just trying to get some work done." She shoves past him.

"What's up with you?" he shouts after her. "What are you doing to your crew?"

She is too frazzled to paint. She wanders around in circles, smoking, then stops to rest her forehead on the sooty window. The smell of fish and dumpster mush rises from the street below. Her skin feels stale and tacky as flypaper.

She awakes to the bleat of the buzzer, her skin sticking to the vinyl upholstery on one of Gus's car seats. It's morning, but just barely, the city still sleeping.

Maya's town car crowds the narrow street below. She

leans against the hood. Sarah bypasses the creaky industrial elevator for the faster stairs. The air is cooler than it was, misty. Maya wears an outfit that must have been from last night, a long, green dress intricately patterned with lighter and darker shades. Fish scales. It's a mermaid dress. She opens a brown paper bag and takes out two cups of deli coffee. "Regular, no sugar," she says with a smile. The warmth in her voice cracks Sarah's chest wide open.

"Nice dress."

"Just pack your bags and come. What's the point of going without you? It's madness."

Sarah touches her cheek. "Why don't I join you in a month or so? I should be ready for a break by then."

"You won't. Don't you see? You've been doing this ever since I had that dream." She touches Sarah's throat, her fingers electric. "Please, Sarah! This is a pattern. There's still a chance you can break it."

"There is no pattern, Maya. I just want to paint for a few extra weeks."

Maya keeps looking at her, waiting, waiting. But there is nothing to wait for. At last she steps away from Sarah. "God help you," she murmurs, and turns quickly.

Sarah watches the limo trundle off. And then the empty street, after it has disappeared from view.

She can't paint that day either. Walking seems to be the only thing she's capable of. She heads toward Broadway, the sun slicing across the sky, then uptown, sweating in her tank top, brooding on the wads of gum that dot the sidewalk. There are people all around her but they don't feel real. New York is a ghost town, the pedestrians in their sundresses and greasy pants projections in some future exhibit, showing how crowded the city once was. She walks

through the morning and deep into the afternoon, eventually taking cover in a bar.

She drinks too much, and just avoids going home with a fat Greek contractor. She wakes in her own place, glad that she at least saved herself from that. He had oddly soulful eyes and a florid, greedy demeanor. She gets up and splashes water on her face. Outside a traffic jam, the honking of horns, irate drivers, plumes of exhaust adding their mark to soot-streaked bricks. New York. What she wanted. She walks to her studio. At the corner on Franklin Street, she sees a paintbrush lying on the curb.

It looks like one of hers.

It is.

A shiver passes through her. She walks, but feels like she's running, her legs prickling, her breath short. There were sirens last night. She imagines Maya tossing a match, torching the building. It's her property. She could make a fortune in insurance claims. She sidesteps an old bow-legged woman, workmen lugging boxes. Here's her block, the dumpster, the desperate ragged flyers pasted to every available surface. The pillow factory is still standing. She beholds it, oddly deflated. The dusty grooved ironwork, the grills, the graffiti. Nothing has changed. She goes up to the fifth floor, biting her lip, then gasps as she pulls back the elevator grate. Here it is. Lesser damage, but damage nonetheless. Puddles of gesso, squashed tubes of Mars Black, razor blades. Her canvases are in tatters, her studies and gouaches trampled upon. She checks through Gus's area and her storage room, terrified, but it is only the highways that are ruined. Every study, every sketch, every completed and uncompleted work. It is quiet, so quiet that she can hear the electric hum of the Woolworth's clock,

the faint whine of the fluorescents, the whirling rush of her thoughts and blood. High-heeled footprints lead out of a gesso puddle. She doesn't need proof. Still, she crouches over, staring. She gets down on her knees and puts her hand on one of the footprints, gently, as if she's touching a fragile artifact. The sobs that rise out of her sound strange to her ears, like those of a wounded animal. She's too stunned to know if it's Maya that she's crying for, or the lost paintings. She only knows that her whole body hurts, as if she's been torn in two.

Chapter 5

Connecticut, October 1997

Sarah tossed slivers of garlic into the olive oil and watched them brown around the edges. She breaded two fillets and slipped them in, side by side. In the woods out back, the Metro-North rumbled down the track, jiggling the dishes on the shelves and the silverware in the drawers. In the winter, when the branches were bare and the interior train lights were lit, you could see the passengers' faces. The train was why she lived here. Partly, its noise made the rent affordable, but more importantly, she liked it. When she was a girl and they were living on West 155th, the el had run only feet away from their apartment. The Great Lisbon Earthquake! She and Maya would flail about in the narrow hallway, shaking things up even more.

She used to amuse herself, imagining how she would convince Philip that the train tracks were an asset. She had thought he would come back. He had pulled out so incompletely. What man leaves the arrowheads he found as a kid, his transcripts, his bank accounts in the hands of someone he no longer loves? He had asked for and she had sent his passport and Social Security card, but that was all. They had never even divorced. She'd had a recurring fantasy that he would burst through the door as she was doing the dishes.

What the hell are you doing in Connecticut? She'd turn, exposing her enormous belly, flummoxing him. Relentlessly sappy and soft-focused: the two of them standing close together, not having to say a thing, this child moving inside her and the train rumbling outside.

But he'd never come back. Hardly even called, arranged everything through Samuel.

She uncorked a bottle of Rioja and took a draft, barely tasting it. And tomorrow? If he came, how would she ever explain herself? Seven years is a lot different than seven months. He'd take one look at Max and get so mad that he'd leave all over again. She refilled her cup, rubbing her stinging eyes. She should have told him. She knew that. She should have done it when she realized he wasn't coming back. She should have hired her own lawyer to send a letter requesting a divorce and informing him that he had a son. The problem was, the realization hadn't come in a flash, but in dribs and drabs. And it hadn't come completely. There was still, even now, this festering, ridiculous hope, a gooey little slug with its antennae extending toward the slightest possibility. It was pathetic. Other people got over these things.

She slipped his letter out, not to read it, just to see his handwriting, the familiar ache of it. There was a terrible noise. The fire alarm. Smoke was billowing from the frying pan, explaining her stinging eyes. Her fish, her sole! Two tiny black shards. She switched off the burner and threw the pot in the sink, resulting in a ferocious crackling and hissing. She grabbed the broom. Max ran into the kitchen, his hands over his ears.

"What's happening, Mom?"

"Fucking fire alarm."

"I thought we were supposed to say *darn*."

She jabbed the broom handle, trying to dislodge the alarm from the ceiling. You had to knock it off the plastic base, so that it would hang down, tethered by its red and green wires. Only then, if you stood on a kitchen chair, could you reach the off switch. There was also a stepladder in the basement. But the broom was generally easier. Sometimes.

"You think the fire engine's going to come?" asked Max.

"No," said Sarah, finally whacking the alarm so effectively that it both slid off its base and stopped ringing. It dangled from the ceiling, a dirty white disk of molded plastic, silent at last.

"You want me to help with dinner?"

"No," said Sarah, her pulse racing. "I can take care of this. What you need to do is your homework." She poured a fresh glass of wine. "I'll call you when I figure out what the hell I'm making."

Chapter 6

New York City, September 1981

"Y ou got the commission? Fucking A!" She hugs Gus. "That's amazing!"

"Ah, it's nothing, a sculpture garden in Buffalo." His grin is wide as a house. "I found some excellent trash too. An anchor, a giant one," he says, spreading his arms to their full extension. "Oh, a whole bunch of stuff. It's down in the truck."

"Want me to help unload?"

"No, keep painting." He looks over her shoulder, only then taking in the empty feel of the studio. "Yo, what happened?" He wanders over to her space and casts a critical eye over the freshly primed canvases. "Where are your highways?" He touches her gently on the arm. "What happened, Sarah?"

She explains, feeling as if she's confessing her own crime.

"Maya destroyed every one?"

"Only the highways. It's all right. I can repaint them."

"It's not all right. If anyone trashed one of my sculptures, I'd twist his head off."

"You want me to twist her head off?"

"Well, she deserves it, doesn't she?"

Gus and his friends drag stuff in from the elevator—

fenders, axles, gears, pipes, bedsprings, the anchor, a rusty old basketball hoop. They grunt and scrape and shout, asking where to put things. She stares at the canvas. She had blocked out the lines of the highway yesterday, and was trying to remember whether she had applied a layer of translucent gray to the entire canvas the first time she did *Highway #1*. She can recall the finished canvases vividly but the stages they went through are less clear.

The next day, she brings Philip's card into the studio and tacks it up on the wall, hoping that its mojo will help with her work. But it doesn't seem to. It doesn't seem to be working at all. In a few weeks, she produces two overly worked smears of black and gray. It's not her imagination: they really suck. She shouldn't have tried to do it from memory. You have to react to the paint itself, not copy what you think you once did. When she imagines the highway, all she sees is a line of pavement stretching into the dark.

"Sarah," Gus says softly, "forget them. You already painted them. You can't go backward."

"But Simon Perez."

"He'll look at other stuff."

"He saw my other stuff. All he liked was this and I can't do it."

"What about a basketball lesson? I'm telling you, it clears the mind." This is his latest thing. He's nailed the hoop he found in the upstate junkyard to the far side of the studio and takes out the ball about five times a day.

"Since when did you get athletic?"

"I've always been athletic, I've just kept it hidden." He rolls the ball over to her. It's dumb and orange.

"I prefer smoking."

* * *

Her palette is a swamp, globs of paint and dust and stray bristles fallen from old brushes, bristles that used to belong to animals, that used to perform a useful function, warming, covering, sticking straight up to signify anger, fear. Now they slip out of rusty metal paintbrush bands and get stuck in sad blobs. She's never been blocked before—well, maybe for a few hours, but not this eternity of day after day. She gives herself formal exercises, interlocking squares of light and shadow, but the results are so dull and dispiriting that she stops even that.

She walks. A dull haze hangs over the city. The sounds of the street are distant, as if they've traveled through cotton to get to her ears. That stab of pain and exhilaration she had upon first seeing Maya's rampage has turned into a festering sore. She drags herself around the city, buys newspapers and sits in cafés, reading for hours, her butt sore, her eyes bleary. *New York Times*, tabloids, *Le Monde diplomatique*.

In late September, in the back pages of the *Financial Times*, Maya's latest headshot smiles out at her.

How can I express the emotional blitz that one endures listening to her? There is no room to hide in sentiment or judgment. She forces you to look unblinkered into the tenderness and cruelty of love. For whether she is singing of the ocean, or the trials of a bitter chambermaid, her real subject is love. Its abundance or lack or mismanagement. One cannot look at her without thinking of love, she trembles with it.

A shout wells up in Sarah. She leaps up from the table and heads for the street. Idiot! Why are reviewers such idiots? Someone is yelling, loud enough to pierce her scram-

bled brain. Her waitress. Halfway down the block, a broad, red-faced woman with short white hair runs toward her, waving the bill. Sarah gives her a twenty and rushes off, too mortified to wait for change, the newspaper still crumpled in her hand.

She sharpens a pencil and stands in front of a blank sketch-pad. She draws a spiral, wavery but identifiable. A doodle. A companionable shape. Gus bounces his ball. She looks up. Her eyes clear. He has finished his upstate sculpture. A gravity-defying balancing act, the gigantic anchor he recently found flying midair, barely attached to an I beam.

"Wow, Gus. It's great. When did you finish it?"

He bounces his ball, shaking his head at her. "A couple days ago."

"Why didn't you call? I would have come in to see it."

"I didn't dare. You've been barking at me for a month straight."

Sarah winces. "I'm sorry." She walks over to him. He throws the ball at her. She tries to catch it, but it snaps her finger back and continues its trajectory. "Ow! What am I going to do, Gus?"

"Get the ball."

"No, I mean really. What am I going to do? I can't paint."

"Get a job. You can't concentrate when you're worried about money."

"I'm not worried about money."

Gus gives her a look. "You should be. Maya's not going to keep you on payroll, is she?"

"I don't know."

"Has she called yet?"

"I don't know. I haven't been answering the phone."

* * *

Gus gets her a job at Le Bucks. It's a good place to work, as far as restaurants go. It's owned by a couple of rich art school pals who'd set it up to have a place to hang and provide their friends with cash. No fine dining, just a bunch of painters, potters, puppeteers running around, trying to remember which platter goes where. On slow nights, they sit around the bar and gossip; on fast nights, they make a fair amount in tips. Sarah gets calluses on her feet and new muscles in her arms and starts to feel much better. She reprimes the failed highways, sanding the gesso more thoroughly than usual, enjoying the labor involved, even the close feeling of the mask she wears. There is great satisfaction in erasing all of that mud, returning to pristine fields of white. She sets the canvases up around her studio, beautiful rectangles and squares, sublimely empty, waiting. She won't start anything until she feels ready. She was too impatient before.

For now, she has the restaurant to keep her occupied. She is surprised by how much it interests her. Not the patrons, they're old hat—crackpots and artists and potheads—but the loudness, the urgency of people when they're hungry, the layout. The different rooms for different functions, the sour-smelling basement freezer, hanging ham carcasses, the crates of produce, leaves poking out, hoping for sun, the narrow, creaking stairs, the fury of the kitchen, the washing, skinning, deveining, deseeding, chopping, parboiling, sautéing, rendering, the sizzle of fat, the weighing and measuring, the arrangement. The order when the plates leave the kitchen, the chaos when they return.

There is also a waiter whose name is Falk, a Buenos Aires-Detroit hybrid, his narrow hips encased in paint-splattered jeans, his face fine-featured, his eyes big and bright. He fol-

lows her around, studying her as if she knows the answer to a nagging question. She does not return his gaze. He is twenty-two. But she keeps finding him next to her, bumping her shoulder in a way that is not unpleasant. One night, as they are cashing out, he grabs her by the elbow. "You've got to at least try my beer. I make it from scratch."

He lives on MacDougal, up a crooked staircase with peeling banisters that look much like the ones in her place. "I'm so glad you're here," he says once she's inside, sidestepping the socks on the floor. He washes a glass carefully, uncorks a ceramic jug from the minifridge, and pours it ceremoniously. Her mouth puckers at the sharpness. He laughs, his mouth wide, his eyes sparkling. "I hope you like bitter."

He finds a photo album hidden under a tray of nails and screws and shows her a faded picture of his grandmother's house in Argentina, an enormous blue farmhouse with a tile roof and red chickens in the yard. "That's her neighbor Nadi," he says, pointing to a tiny figure in the garden. "She got rid of my warts when I was a kid."

"How lovely to have a place like that to go back to."

"I've only been there once," he says. "My mom's place in Buenos Aires is more like here." His hair brushes her forehead. It smells of wool or baked earth or dried beer foam, she doesn't know, just that it smells good.

In the morning she tries to slip out quick, wanting her own shower, her own soap, her own silence, but he won't let her go until she's had some coffee. She sits in his bed, hands curled around a chipped coffee mug, as he rummages around in the closet, grunting and cursing as things clatter down. Eventually a collection of homemade skateboards is laid out for her inspection. She admires each one, feeling somewhat dutiful and wishing he wouldn't look at her so eagerly.

"Try this one," he says, tapping a particularly wide board toward her.

"No thanks."

"Just try it."

She's never been on a skateboard before, and rather enjoys teetering around his obstacle course of a room. He stands by the window, his bare chest lit by the sunlight, indecently supple. She comes to a stop before him. Holding her elbows, he steps onto the board with her. It is big enough to hold them both, but his added weight upsets the angle and Sarah loses her balance. He pulls her back and readjusts himself. After a series of minute shiftings and adjustments, they reach a point where they can both stand still, sharing the board together, the soles of their feet and toes alert to every tremor, the air electric.

"Do you do this with all your pals?" she asks lightly, hoping to confirm that he does indeed have other pals.

"Mami, you're crazy," he laughs, and falls off.

She is at the studio, eating Chinese food with Gus, moo shu sauce all over her fingers, when the buzzer buzzes. It's late. Neither she nor Gus is expecting anyone.

"Maybe it's your Falky-Falky?" Gus suggests with a grin.

Sarah goes down and finds instead, much to her astonishment, Maya. Her hair is limp, her skin is wan, her body is half obscured by an elaborate mass of flowers. Peonies, lilies, roses, bell-shaped blossoms, Queen Anne's lace. A wall of white and green, overly fragrant.

"What are you doing here? You're supposed to be on tour."

"You haven't been answering my calls. I thought I'd better pop over." Maya hands her the flowers. "In any case, it's better to apologize in person."

Maya has never given her flowers before. Sarah can't remember if she's ever even apologized, but she must have. They've been in fights, though never anything like this. Sarah takes the bouquet, wondering what in the world she'll do with it. "Whoa, this is heavy." She heads toward the elevator, then remembers that Gus is up there, still pretty much in his off-with-her-head mood.

"Let's go to Walter's."

The bell attached to the door clangs as they enter. Sarah nods at Walt, with his bifocals and ever-sparser crew cut. The place has been here since forever, her favorite 24-7 diner, fake blueberry muffins shiny in their Saran Wrap encasings, a 1930s Coke dispenser, vinyl booths. They slip into one. Sarah props the bouquet of flowers next to her. It's as tall as she is. Maya holds her chin in her hands, an expressionless, exhausted look.

"When did you get in?"

"Just now. I came straight from the airport."

"That was a nice review in the FT. You seem to have been doing okay without me."

"I didn't mean to do what I did, Sarah. I mean, that wasn't my intention. I thought you would be in your studio and I wanted to say goodbye in a better way. But instead of you, there were those fucking highways taking over your whole space, and I just, I just saw that X-Acto knife. I kept expecting you to come in and find me. I thought if we could fight, I mean physically punch and kick, everything would be all right. But you never came back. I was angry about that too. If you weren't going on tour with me because you wanted to paint, then why the hell weren't you painting? What were you doing?"

"I was walking."

"Oh god. I went crazy, really crazy. Like Max, in one of his fits."

"Don't bring him into this. He never hurt anyone."

Walt comes over with two greasy menus. "How you doing, Sarah?" He eyeballs the flowers. "Someone die?"

"No. Well. Someone, somewhere, but we're alive and kicking. They're pretty, aren't they? You want a coffee, Maya?" Maya doesn't answer, lost in her own grief, so Sarah orders for them: "Two coffees, please."

Walt takes the menus.

"Maya," Sarah says softly after Walt has gone.

Maya raises her gaze toward her, her famous honey-colored eyes so anguished and repentant that a weird little giggle rises in Sarah's throat. Maya's eyes water over.

"Don't cry."

Maya presses both hands to her face. Walt slips their coffees onto the table. Sarah scoots in next to her sister, enveloping her in an awkward hug. She holds her for a long time, until the sobs cease and Maya's hands fall to her lap. Quietly, Sarah strokes her sister's hair, remembering a time when they were kids, out in Nebraska or somewhere, one of those places on the way to somewhere else. They were in a cow pasture—Maya, Max, Ma, and Sarah—eating Pepperidge Farm cookies from a bag. Sarah laid in the grass, resting her head on Ma's lap, the rough black fabric of Ma's dress scratching her cheek. Ma had smiled down at her, tugging her fingers through Sarah's curls. *Och och, such hair. Just like your father's.* Maya had been jealous of Sarah's hair. It so clearly marked her as Max's.

The next day, she flips through the circuses, looking for an untitled picture, never completed, of Max running away

from home. It wasn't a circus. She had wanted to balance
the circuses with something of Max's world, but it hadn't
worked, her knowledge too fragmentary: a town in the Car-
pathian Mountains, his father the shochet, six brothers and
sisters, all said to have died in the war. The painting had
been crude and stick-figure-like. A village on a hill with
pine trees and a single-engine plane swooping overhead.
Max, with his beard and curly hair, on the road outside the
town, looking up at the plane. He hadn't wanted to be a
rabbi. He'd wanted to know what it was that made planes
fly. He'd walked through summer and fall to get to Vienna.
Never went back, never saw any of them again. Never once
spoke about it; all of her knowledge, her paltry knowledge,
came from Ma. Where had she put it? It's possible that
she'd thrown it out when she edited her paintings. But she
couldn't imagine doing that. She'd wanted to work on it.
She'd had an idea for winding the road all the way to a min-
iscule Vienna, suggesting summer and fall by the changing
colors of the leaves on trees alongside the road.

She goes to work, the lost painting chewing at her mind.
Could Maya have destroyed that one too? She had resented
Max and used to wonder if he was really her father, al-
though she'd been quieter about that since he died.

Hardly anyone is at Le Bucks: the old lady with sun-
glasses who sometimes wets herself, a table of punky Brits.
She and Falk amuse themselves by playing with the old-
fashioned double-plated scale, kept for decoration in the
dining room. It's a beautiful thing, big and brass, the same
design she's seen in etchings from the Middle Ages. Falk
puts his order pad on it, and they place bets as to whether
it's as heavy as one fork or two. A line of thinking that even-
tually leads to what she calls the equivalencies of balance.

Half a melon equals a bag of split peas. A cleaver equals two butter knives and a cupcake. A chicken breast equals an old wet rag.

A few days later, she sketches out a study. She hardly thinks about the composition; it just appears. A simple golden background taken over by a brass scale. Instead of food, there's a feather on one plate, a rock on the other, the feather slightly outweighing the rock. She tacks it to the wall, recalling that Bambi Peterson had gone through an icon stage. She knew how to roll gold. She'd call her. She had an idea.

1982

It's January, dark by five o'clock, the city slick with sleet. Sarah is at Le Bucks, running a forgotten plate of sole meunière to table 12, thinking the food looked better before it was so overly arranged, when she stops in the middle of the aisle. He's outside, folding up an umbrella, in the same trench coat he wore at the funeral, looking like a clean-cut guy in a 1940s movie. She spins around and just misses colliding with the busboy, a classical still-life painter named Shun Li. She shoves him the sole meunière and runs into the kitchen. Past the bellowing chef. Down the basement steps. Past the boxes of vegetables, the sour-smelling mops, the buckled freezer door. Where is she going? She ducks into the employee bathroom, locks the door, and clutches the sink. It's a cramped, paint-chipped closet that smells of disinfectant and basement mold. Not a great place to hide. And why is she hiding? He doesn't know that she's here. He probably came because of the *Times* review. He's one of those uptown people looking for atmosphere. She can't believe she's hiding out from someone looking for atmosphere. She splashes

water on her face and gropes around for a nonexistent towel, hitting the plastic angel that hangs from the lightbulb chain. She wipes her face on her apron, lowers the toilet lid, and sits. The angel swings back and forth, pendulum-like.

She returns to the floor. Falk winks at her. Philip, seated at the bar, talks to a red-haired man. He doesn't see her. Well, why should he? He's facing the bar, not the restaurant. She weaves her way to table 12. They smile up at her, a portly, pearly gathering, celebrating the close of a business deal. Yes, yes, they got their sole. All is well. She smoothes her apron.

Philip has turned around. He's watching her. He's not as good-looking as she remembered. He's too pale. He smiles. It's a lovely smile, kind of lopsided. Her arm shoots up.

"Holy smokes," she says.

"Holy smokes, yourself."

He grins and nods at the red-haired man beside him. "Meet Clyde. Clyde, this is Sarah, the Cinderella from Conningsby's funeral." She and Clyde shake hands. She and Philip don't. "You should have seen her," Philip says. "Rushing off in the middle of the night. *I've got to get back to New York!*"

"Still drinking Scotch, I see."

"Can I get you one?"

"After my shift."

Philip looks a little embarrassed. "I may as well tell you this isn't totally a coincidence. Tori told me you were working here."

A slow smile spreads over Sarah's face. Falk taps her shoulder. "Table 7 wants their check."

"All right," says Sarah, adding up the total.

Falk remains beside her, looking over her shoulder as

if to check her math. She introduces him. He crosses his arms in such a surly manner that she wishes she hadn't. Philip and Clyde remain through her shift, parked on their barstools. Philip drinks successive Scotches, but they don't make a dent on his posture. If anything, he sits straighter as the night goes on. By closing time, he looks like a drill sergeant surveying a shoddy company. He couldn't have been this rigid in Tulapek, but perhaps he was. Perhaps it's just seeing him in New York. She remembers that she hadn't wanted to see him in New York. Falk cashes out. She nudges him gently.

"Come have a drink with us."

"You're crazy, mami. They look like they play golf with my father." He grabs his skateboard, his hair falling over his face, his disgust so pure that she admires him for it.

"Come on." Clyde, slightly tipsy, tugs at her elbow. "You gotta show us around. Philip's so square, this is the only happening joint he could come up with."

"You're from out of town?"

"I'm from elsewhere."

"Where?"

"Pennsylvania, the Quaker State. But I'm moving to Connecticut."

They go to a bar she knows in Chinatown, a twenty-four-hour place with chickens clucking in the back and flickering purple fluorescent lights. She's chosen it for its antiromantic lighting. They order Tsingtaos. Philip looks around warily.

"It's all right," she says, "I've been here before."

"With who?"

"Oh. A Chinese gangster."

Philip wipes the rim of his glass with a napkin and pours his beer.

"Where did you get that posture?" she asks.

Clyde laughs. Philip tries to look more relaxed, but he only looks more uncomfortable. She feels terrible.

"My father liked me to sit up straight."

"Was he in the military?"

"No. Just extremely correct, if you know what I mean. He didn't like irregularities. He used to mow the lawn at ninety-degree angles. If a line wavered, he was sure afterward, even when the lawnmower lines had disappeared, that the grass didn't look right. He would have liked Mondrian if he'd bothered with art." Philip smiles at Sarah. "How's the painting going?"

"Pretty good. And the building?"

"Ironclad."

"Ironclad?"

"He's a security specialist," says Clyde. "Buildings that can't be broken into."

"Of course," says Sarah. The name of Philip's company is High-Security Design. She ought to know, she thumbed over his business card enough. "You don't do prisons, do you?"

"No. Too many regs. No room for innovation." He glances around the room. "I like this place."

"You do?"

"Well, it's better than Le Bucks."

"He's a snob about trendiness," says Clyde. "You should have seen him in school. No patience for anything fashionable."

"You went to school together?"

"A fashionable one," says Philip.

They sip their beers. Sarah's glad Clyde is there. He makes things easier. She smiles at Philip and he smiles back.

He has a wonderful smile. She looks at the table next to theirs. A trio of ancient-looking men plays cards.

"Think they're gambling?" asks Sarah.

"Sure," says Philip. "The Chinese always gamble. I read it somewhere."

"Everything's gambling," says Sarah.

Philip raises an eyebrow. "Some things are."

"My father was a gambler," says Clyde. "Gambling sucks. I hate cards. What you need is good, honest contact. I'm a hockey man."

Sarah groans. "I hate sports."

"Hockey's not just a sport, it's an art. It's physics."

"It's guys on blades beating the hell out of each other."

"Exactly. It's sublime."

"You ought to meet Gus. He thinks basketball is bringing him into a new plane of existence."

"Probably is," says Clyde. "Who's Gus?"

"My studio mate. He's installed a hoop on his side of the studio. It's only a matter of time till the ball runs amok and hits a wet canvas."

"Philip plays basketball," Clyde says. Philip grunts. "He's great. I don't know where it came from. He sucked in prep school."

"Don't listen to him," says Philip.

"He coaches little black kids. Even they think he's good."

"You're a coach?"

"Not really. It's a neighborhood organization. I meet with some kids and give them pointers."

"He organizes matches and buys them ice cream. He's a big brother."

"I call a game now and then."

"Let's play," says Clyde.

"What?"

"Let's play a game."

"Now?"

"Come on. I've never played basketball in an artist's studio before. That's something for the wife and kids."

"Kid," says Philip. "You only have one." He turns to Sarah. "Could we go? I want to see your paintings."

She walks between them, her chin tucked in her neck, praying that Philip's card isn't still tacked to her wall. She thinks she took it down when she gave up the highways, but she's not positive. They reach Franklin Street. But where would she have put it? She should have pretended that she'd lost her keys. She still can. They get to her block. Her door. She hasn't said a thing. Okay. She'll risk it. She unlocks the door. The elevator is a gaping cage with a wooden floor and metal grating. Clyde is suitably impressed. Philip nods. But he's an architect; he's seen stuff like this before. She shows Clyde how to man the lever, and they jolt and shudder up. At five, she aligns the floors, opens the grate, and flicks the lights.

Clyde whistles. "Whoa!"

She runs over to the wall by her easel. The card is still there, smudged with fingerprints. She slips it in her back pocket, her heart beating. Philip and Clyde are still by the entrance, Clyde craning his neck, Philip quietly taking the space in, hands in his pockets.

"This place is huge," Clyde says. "What's the rent on a place like this?"

"I know the owner of the building. We get a good deal."

Philip heads toward her worktable. "These are cool." About twenty scale paintings lie on the table, in different

stages of completion. From a distance, they look like Byzantine icons, small and wooden, painted with egg-based tempera and laid with gold leaf. At the center of each is a scale with different objects weighed upon the plates. Philip smiles at one that features a combat boot slightly outweighing a saltshaker and a tin of herring. "How do you get the gold on?"

"It's excruciating," she says, explaining how careful you have to be not to crack the leaf.

"Come on!" shouts Clyde, who has found the ball. "Let's play!" He hurls the ball at Philip, scaring Sarah, but Philip catches it neatly. He bounces it back to the relative safety of Gus's section and shoots. The ball transcribes a giant arc and drops through the basket. Sarah flops onto a car seat. Watching sports is not her idea of fun, but once they get away from her paintings, it's not bad. Clyde is an excitable puppy, Philip a greyhound without the high-strung quivers. An effortless shrug, and the ball glides through the air, more often than not swishing through the net. After a while, Clyde collapses next to her. Philip, alone, picks up speed. He bounds around the room, the tail of his shirt flapping. Hardly a tin soldier, he's fucking Nureyev. Clyde hiccups.

"Want some water?" she asks.

"Nah." Clyde stretches out, throwing his head back over the seat, his Adam's apple bobbing toward the ceiling. There's something in the way he does this, a sloppy abandon, which suggests he's reached a greater stage of drunkenness than she'd been aware of. "What I'd like," he says, wagging his finger for emphasis, "is dental floss."

"I don't have any."

"Please."

There's an edge to his voice that motivates her to stand up and do something. She goes through her drawers and finds a

roll of picture-hanging wire. The ball bounces. Philip seems to have forgotten her and Clyde, left them for a parallel world with a different rhythm and gravitational field. She stands on its periphery, holding the roll of picture-hanging wire, feeling a little dizzy and sad, not a bad sad, sad like a warm rainy day. Philip catches the ball and tucks it under his arm.

"Bravo," she says. He smiles. His hair is brown with sweat. "Want some water?"

"Yeah."

She hands him the wire and heads for the sink.

"What's this?"

"It's for Clyde. He needs some dental floss. Tell him to be careful. It might rip his gums."

"Clyde? Oh yeah. Hey, bud."

She brings Philip his water. He drinks it looking at her.

Clyde examines the picture wire with a confused air. "This looks like fishing line."

Philip wanders back to her worktable. Clyde loops the wire around his fingers. She concentrates on Clyde, trying to block out Philip observing her work. She doesn't understand how Maya can enjoy having her audience right there in front of her.

"I love these!" Philip shouts from across the studio. "But where are the ones of Conningsby's father? Didn't you paint some pictures of him?"

"Go on," says Clyde. "Show him. I can do my teeth in private."

She lets Philip into the storage room and takes the Alligators down from the rack.

"There's the castle!" Philip says, pointing at the first Alligator painting.

"You recognize it?"

"It's wonderful. They all are. You should do something with them."

"Easier said than done."

He wants to see more. The circuses, early stuff from art school. "You're going too fast," he says.

She lights a cigarette and lets him flip through them at his own pace. She's still nervous, but grateful too. He really seems to like them. He keeps returning to a painting called *Map of X*. It's a strange piece. When she was editing her canvases, she had a hard time justifying why she was keeping it. But she likes it. She just does. X was a town where they had stopped on one of Maya's first European tours. She can't remember the name, but she remembers the place. The church was lined with cracked wooden saints and pails of yellow and white plastic roses. Maya sang up at the front, by the altar, a local musician on the organ, her voice young and raw, amplified by the ancient stones. Max had a cold. He shifted next to her, his nose yellowish and runny, his lined brown eyes blinking away a sneeze. Aside from the church, Sarah can remember a boulangerie, a pension, twisty, narrow streets with grills over the shops and rolled-up awnings. In the painting, she tried to recreate the plan of the streets by remembering the way from the church to the boulangerie to the pension. The process had fascinated her, the scenes appearing in her head, so clear, one day out of many. She had seen her foot coming down from a curb, a little white lace sock with a cuff, some kind of scuffed leather shoe. Horse crap in the street. A mud-spattered Peugeot. The scenes made her feel strangely triumphant; something she attributed to the thrill of recovered time—time not considered important, but time lived. The indestructibility of an ordinary day. She gets this feeling

when she looks at the painting, but it hasn't—until now—seemed to resonate with anyone else.

"Why do you like it?" she asks.

"I don't know," says Philip. "The colors, maybe. The texture?"

"It's a street plan," she explains. "Of a village in France. I don't know the name."

Philip laughs and keeps looking at it. "I want to buy it," he says.

"You want to buy it?"

"Yeah. How much does it cost?"

"I don't know."

"Well, I want it."

She can't think of a price. It hadn't occurred to her that anyone would want to buy it, and now she's not sure she wants to sell it. "What about some wine?" she suggests.

"I could have wine." They sit on the best of Gus's finds, a leather seat from the back of an old Mercedes, and she uncorks a bottle of Bordeaux.

"Here's to you, Cinderella."

"But I don't have an evil stepmother. And my sister is hardly ungainly."

"You have a sister?"

"Yeah."

"Older or younger?"

"Older."

Philip smiles. "I guess it's an awfully conventional question." He's not stiff so much as nervous. She's touched.

"Conventional, yes, but pertinent." As a rule, she doesn't tell men about Maya until she absolutely must. Their eagerness to meet her is too discouraging. "Do you have any brothers or sisters?" she asks.

"No. I wish I did."

She runs her fingers through his hair. It is pleasantly thick. He looks ahead, his profile handsome and difficult to read.

"In Michigan, when you ran off like that," he says, "I thought you were afraid I'd kiss you."

"I'm not afraid of a kiss." She turns his face toward her. His lips are soft and salty. He's still damp from basketball. He puts his hands on her shoulders and holds her about a foot away, regarding her. She smiles, trying to lighten him up. He touches her carefully, tracing the curve of her neck.

"I'm not that fragile," she says.

"I know. You're a tough cookie." He unbuttons her shirt and kisses her so tenderly that she moans from surprise. He cups his hand around her breast. "You're beautiful," he whispers.

"Don't talk." She begins unbuttoning his shirt.

"I'm not talking."

She kisses the pulse of his neck. He trembles. Her hand slips between his knees and up his thighs. He twitches, not in a good way. She pulls her hand back, embarrassed. He's shocked. Goddamn him. It's 1982. Is she supposed to stop above the waist or something? Outside, a garbage truck rumbles down the street.

"Wow," he says, jumping up, "I didn't realize what time it was." He goes over to the window. "It's getting light out."

She wants to slap him. She slaps herself instead. His mouth drops open.

"Don't look at me like that. There's nothing worse than a halfway screw." God. She's had too much to drink. He comes back over.

"Sarah, I'm sorry. I didn't mean to offend you."

She shakes her head, feeling stupid. "It's all right."

"I'm sorry, I'm a jerk. I really like you. I just . . . I haven't done this in so long. I don't know what I'm doing." He buttons his shirt lopsided.

"How long?"

"Years."

"Years? What have you been doing?"

"Working."

She studies him, perplexed. He returns her gaze, his awkwardness mainly gone. He is a man she barely knows in a lopsided shirt in the early light of morning. She is relieved now that they stopped when they did.

"Were you terribly in love?" she asks.

"Hmm?"

"Usually if you're celibate for so long, it's because you're recovering from something major."

"Terribly in love doesn't sound right. But we were together for nine years."

"Why did you split up?"

Philip shrugs. "We wanted different things."

"What's she doing now?"

"Married with kids."

"And you're working."

"Mmm hmm."

"And that's enough."

"I never said that. Will you see me again?"

"I don't know. I've never gone out with a celibate."

Philip laughs. "I haven't always been."

Chapter 7

Connecticut, October 1997

"Max!" she yelled. "Max! Where are you? I need you to set the table."

He clomped down the stairs. "Salima Carpenter says she's going to be Darth Vader for Halloween, can you believe it?"

"Sure."

"But Darth Vader's a man."

"He's the force of darkness. Women are old hands at that. Anyway, Salima's not a man or woman. She's a girl, and when you're a girl you're allowed to be anything."

Max folded the napkins into triangles and carefully placed a fork upon each.

She slid the eggs onto the plates, decorating them with the parsley she'd bought for the fish.

"I like eggs better anyway," Max said.

"Thanks, duck." She chucked his chin. The kitchen still smelled of smoke, in spite of the open window. She sat across from Max, but couldn't manage a bite. She poured another glass of wine.

"So what do you want to be for Halloween?"

His eyes twinkled. "What do you think?"

"A samurai?"

"No."

"A fireman?"

"No."

"What?"

"A potato!" He tilted his chair back and laughed.

"A potato?"

He slipped off the chair and ran around the kitchen, snickering and dancing.

"Eat your food, darling."

She couldn't have any more wine. She had those papers to grade. But how in the world could she grade papers? Max ruminated over his last bites, propping a lovely cheek up with his hand. She heaved such a big sigh that he looked up.

"It's okay, sweetie. I'm just thinking. I'll clear the table. You finish your homework."

"I did finish my homework. You can check it if you want." He scraped his plate over the trash can, scattering rice on the linoleum. The train rumbled by. The cutlery jangled. It was impossible to believe that Philip could be on those very same tracks only hours from now. The 9:07. It got in around 10:23. She'd drop Max off at his school. Call in sick to hers. Which meant that she didn't have to finish those Gilgameshes after all. Better to use that time to clean the house. She pictured the cab pulling up, its green door opening, but she couldn't picture Philip. Only what he would see: a rundown house with a chain-link fence, a scooter in the driveway, a Batman welcome mat. Too much at once. It would be better to head him off at the train station, prepare him somehow, or if not prepare him—for how could you do that?—then at least confess.

"Can I put the soap in the dishwasher?" Max asked.

"Sure, honey. Thanks."

She swept up the rice, breathing easier now that she had

a plan. Meeting Philip at the station felt much better than him just knocking at the front door. She'd bring the Gilgameshes with her in case he was late or didn't show. Still, she needed to clean the house. She sent Max up to brush his teeth and started on the windowsills, which were caked with train grit. The phone rang. She jumped. It wasn't Philip but Carlos, fellow adjunct and occasional lover. She considered telling him about Philip's letter, but the likelihood was that she'd spend tomorrow hungover, grading papers in the Buick, growing increasingly glummer as train after train rolled in empty. He asked her if she wanted to go to a barbecue on Sunday.

"Let me see if I can find something for Max."

"Bring him along. There will be other kids there."

She sighed in exasperation. Carlos knew that Max did not meet any of her boyfriends, no matter how unboyfriendish. A mechanical grinding interrupted them.

"What now?" The dishwasher lurched from its place under the counter and began to travel across the kitchen floor, vibrating spasmodically and spewing soapy water. "Holy shit. I can't fucking believe this."

"Sarah? Are you okay?"

"I'm fine. It's just these appliances, they are going mad."

She jabbed at the buttons, trying to turn it off. The machine snarled, a grating metallic sound from deep in its interior. She kicked it. It coughed and shuddered. She tried to push it back into its hole, but the floor was too wet to get any traction. The mop. She needed the mop. She had put it down in the basement because it was so gross. She'd been meaning to buy a new one, but she hadn't gotten around to it. She sat on the top basement step, taking off her socks, which were wet and clammy from the dishwater, but she couldn't go down there in bare feet. Too much grit on the

floor. She went upstairs to look for a pair of slippers.

"Have you brushed your teeth yet, Max?"

"Yeah."

He stood on his mattress, tying a white nylon string to a nail. There were strings everywhere—twine, nylon, and yarn, dangling from bedposts, shelves, doorknobs, hangers. He hopped down and tied the opposite end of the string to a string from the other side of the room, connecting the two.

"What are you doing?"

"Making a suspension bridge."

She plopped down on his bed, her wet socks still balled up in her hand. "The dishwasher's gone berserk. It's a disaster down there."

"When are you going to give me the stamps?"

"What?"

"The stamps on the letter. From the Congo."

She should not have told Max about Philip. That was her biggest mistake. *Your father's a hero. He killed a criminal and now he builds bridges and refugee camps.* That's all. Nothing about who the criminal was, or why Philip had killed him. Just the hero bit. No one expected heroes to hang out in Connecticut. Heroes wander. Women wait. But not for seven years. Why should she care if the house was clean? She had nothing to apologize for.

"When are you giving me the stamps?"

"Tomorrow."

He sighed and returned to his construction. The water from the socks had started to soak into her pants. She had to go down and get that mop.

"Can you help me with this plank?"

"Sure." Sarah held a piece of wood while he tied string underneath it.

"Do you think Dad would like it?"

"Your bridge? Yes, he'd love it."

"Did he ever build a suspension bridge?"

"I don't think so. I think you're the first person I know to have attempted such a thing." He knew Philip's name. Even if he didn't come tomorrow, even if she didn't give him the letter, he'd figure it out eventually. He'd be bragging to one of his friends about his heroic, unreachable father, and they'd say, actually, they've taken that rule off the books. You can correspond with wandering heroes. You can send them pictures. You can Ask Jeeves what they're up to.

"Hold this one, please." He gave her another piece of wood, a nicely sanded plank of pine.

"Where did you get this?"

"The basement."

"I don't remember any loose lumber down there."

"It's not lumber. It's too small to count as lumber. It's a small piece of wood that wasn't doing anything."

"Where did you take it from?"

"Your shelves. The broken ones that weren't holding anything up."

"You should have asked, Max."

"Sorry. May I use scraps from broken furniture to make something new?"

"What's so great about new? Answer me that. People are mad about the new, but there isn't anything new, really. You know what I mean?"

She let go of the wood. It floated midair, the delicate strings holding it up. For a tiny moment, she forgot about the wet socks in her hand, Philip, the Internet, everything, so caught up she was in the beauty of Max's bridge, and the sweet feeling of Max beside her, pleased as punch.

Chapter 8

New York City, 1982

The first time Philip invites her to dinner, she says no. The silence on the other end of the line pains her, but it's best to be on the same page with a man. Someone who has been celibate for several years is not only not on the same page, he's in a different book entirely. But she keeps thinking of him. A week later he calls again. She says yes. But this doesn't make her any happier.

"Give yourself a break," Gus says. "You're allowed to fall in love every now and then."

"I'm not in love."

Gus looks skeptical.

"I'm not," Sarah says. "I'm just being an idiot."

"You need to get into bed with him."

"That would solve something," she says. "But he's not really a just-get-into-bed guy."

"What does Maya say?"

"Maya? I haven't told her."

"I thought you guys were talking again."

"We are. But we won't be if she finds out I met him at Conningsby's funeral."

Sarah walks to the subway, sucking nervously on a mint

lozenge. A soap bubble pops in front of her. There's a trail of unpopped ones, clear and bluish, shivering in the wind, coming from the toy shop. A mechanical elf dips his wand into a tray, lifts it to his mouth, blows. One more block to the subway stop. The train. The restaurant. Philip. Her stomach flips. She can't do this. She looks for a pay phone. The wind blows off her hat. She runs after it. It's a great hat, a powder-blue flapper she found in a thrift store. She can't cancel. She has this wonderful hat. She put on eyeliner. She spent half an hour looking for her rhinestone belt.

She almost trips on a homeless man, curled up on a cardboard box.

"Sorry, sir."

"Watch where you're going," he says.

She slips the token in the slot and walks through the turnstile. A train screeches by in the opposite direction. An A train, identified by a blue circle with an *A* in the center. She remembers being a kid, reading *The Scarlet Letter*. She'd been pleased that her favorite train was the A train, but glad that it wasn't on the red line. A red *A* would have been too much. A blue *A* was just enough. Pleasantly wicked without going overboard. She leans against the iron beam. No train. Blackness. She'll be late. She thinks about herself as a little girl, sitting on the train, all alone. She used to get on at the station outside their apartment. She wouldn't have any money, just two subway tokens, enough to go somewhere and come back. Anywhere. She'd just go. It was her magical mystery tour—hers, not Maya's. She explored strange Midtown streets, fountains hidden between skyscrapers, peepshow palaces with neon nipples flashing, chocolate shops with iced and ruffled truffles, each one costing more than a week's allowance. Or she left Manhattan, went to the end

of the line, the quiet trashy Rockaway streets, the diners with sky-high meringue pies in the window, the salt in the air, the crash of surf, then, at the end of the block, the end of it all, the endless gray ocean with the seagulls swooping.

A is for ages. C for centuries. Hard to go back, you get disoriented, wait on the wrong platform. Sarah only catches her mistake when a tall guy with dreadlocks and maroon corduroys asks her where she's going.

"Uptown," she says in her leave-me-alone voice.

"No you ain't. You headed down under the Brooklyn Bridge to the best borough beyond."

She slinks to the opposite platform. Across the tracks, the guy with dreadlocks grins at her. He is smooth and muscular, with a golden earring. A handsome boat, as Maya would say. Handsomer than Philip. She shouldn't have been so snotty; should have said, *I'm going where you're going, mister.*

The train comes. She hangs onto the pole, the lights flickering on-off, on-off, off . . . off, on again. A Salvadoran lurches down the aisle, selling Cracker Jacks from a crumbling cardboard box. A woman buys some for her kid. The Salvadoran gives her change then moves on, slow-paced, silently offering his wares. Why does she think he is Salvadoran? He's got a peasant's hard-worn body and Indian features, but that doesn't limit him to El Salvador. It's because she's been reading about Salvadoran massacres. He looks like he has seen a massacre, something about the lines of his face, his eyes. She should do a painting of him. But she can't get that look. She's tried with her father. *Ding-dong:* 42nd Street, her transfer. She doesn't want to get off. She wants to follow the Salvadoran into the next car, eat Cracker Jacks

for dinner. She's seen her father in him. He used to say that if it weren't for Ma and her business sense, he'd be peddling buttons on the subway.

She pictures him at JFK, so tiny and old-world in the midst of the new space-age terminal. He and Ma were dressed up, he in a dark, striped three-piece suit, his beard combed and glossy, Ma in a wool skirt suit with cloth-covered buttons, her hair styled into a frozen wave. They were excited and nervous. Max's boycott was over. They were going back to Vienna for the first time since the war. They kissed Sarah then Maya goodbye. Max held Ma's arm as they disappeared into the portal. A few hours later, the plane's engine conked out, smack in the middle of the Atlantic.

The restaurant is a candles-on-white-table-cloth affair, cozy with exposed brick and a chatty host who looks like he should be smoking a pipe on a porch somewhere. She pulls her hat down around her ears and checks that the feather is still at a jaunty angle. Philip sits in the smoking section, reading the paper, his hand curled around his drink. She sneaks up on him, something she's particularly good at. She used to tiptoe into the kitchen when Ma was making break-fast, and the toast would fly. She has startled everyone ex-cept for Maya, who can always sense her. She slips the glass from Philip's fingers and takes a sip. "Hi."

"Oh," he says, startled. "I didn't see you."

"I noticed."

"Nice hat."

"Thanks." She sits down. He smiles. He is almost as good-looking as the guy with the dreadlocks. "Have you ever thought about getting an earring?"

"No."

"Too bad." She lights a cigarette. "So," she says, blowing out the match, "I almost didn't come."

"Why not?"

"I don't know. Don't you ever wig out? Take shelter in a telephone booth?"

"No." Philip looks confused, maybe a little impatient. She takes a slice of bread from the basket. It's good home-made bread.

"Here," she says, breaking off a piece. "Taste."

"Thanks."

She smiles. She's happy. She's happy! She can't be in love. She's never happy when she's in love. She's consumed, electrified, miserable.

"Would you like to look at the wine list?" the waiter asks.

"Yes, please."

"Actually," says Philip apologetically, "I was just going to order a glass. I've got a meeting at dawn."

Sarah laughs. She wants to hug him, but thinks the better of it. Who wants to hear how pleased a girl is that she's not in love with you? "A meeting at dawn. A duel?"

"Of a sort. I'm jogging with a developer."

"Isn't it a little nippy?"

Philip shrugs. "He says he gets a feel for people by their pace and stride."

"So how's your pace and stride?"

"I hope it's adequate." He cracks a smile. The waiter clears his throat. "Do you know what you want?" Philip asks.

"A glass of champagne," says Sarah. "I want to toast to us being friends."

"I'll have a glass of red wine," he tells the waiter. "I don't know if I want to toast to that."

"All right, then cousins."

"Cousins?"

"You could think of Conningsby as a sort of uncle."

"I definitely do not want to drink to us being cousins."

The waiter brings their drinks. She holds up her glass. Philip lifts his.

"Better left unspoken," he says, clinking her glass.

"What's better left unspoken?"

"Nothing."

"All right then. Here's to nothing. *A rien.*"

"*A rien.*" Philip looks into her eyes.

"Have you been to France?"

"No. I've never been out of the country."

"Wow. You're a real 'mayrican."

"Whatever that means."

"I hardly know anyone who's spent their whole life here. Except for my friend Bambi Peterson. She grew up in Westchester, went to church, the whole nine yards."

"You find that exotic."

"Kind of. You should meet her. You'd like her."

"I like you."

She looks at the menu, a little flustered. "So who's this developer? What's he developing?"

"A retirement community outside of Orlando."

"Good grief."

"It's not that bad. They're focusing on aesthetics and uniqueness. Each unit will be designed differently, so there's none of that canned feel, and the security will be serious but subtle. The idea is naturalness, a place that looks organic and comfortable."

"Why do you need high security for a retirement community?"

"It's as much about keeping the people living there in as keeping others out—Alzheimer's, you know. People wander."

"My sister's coming back tomorrow," she says, as much to herself as to him.

"Where is she?"

"In London, tying up some deal."

"She's a lawyer?"

"No, a singer, but she makes her money from real estate. She owns six or seven buildings and apparently wants more."

"And you disapprove?"

The words rise up, the pressure of them. She grew up with a simple and affirming distrust of the rich. Of all Maya's difficulties, it's the money that she finds hardest. "Our parents were landless," she says carefully. "I think that's her way of dealing with it." Philip nods, as if he understands. But he can't. He's a businessman himself. She crosses her arms over her chest, willing herself to keep quiet.

"What's her name?" he asks.

"Maya Marker for real estate, Maya Myrrh for singing. She tries to keep her worlds separate."

"Never heard of her." He sounds dismissive.

"She's famous in her way. She even has her own Hinckley."

"What do you mean?"

"A guy tried to shoot her, one of her fans. She didn't know him but he was crazy in love with her. He'd gone to fifty of her concerts or something like that. He was going to kill her, then kill himself. He thought they could be together in heaven."

Philip puts down his drink, all sympathy. "What did she do?"

"She ducked."

"No, I mean afterward. Is she okay? What an awful experience."

Sarah nods. It was definitely an awful experience. But Philip's sympathy is conventional, trite. Maya came out of it fine. "She was good about it. She was more empathetic than usual. I think she felt responsible for him. He's in a mental institution now. He'll be there for the rest of his life. She'd like to write him a letter, but the doctors won't let her."

"Poor woman," says Philip.

"And the guy?" says Sarah. "He's going to be imprisoned for the rest of his life."

"You want him free?"

"No. I understand that he's dangerous. But he loved her."

"That's not love."

"It was to him. Love isn't always some pretty thing."

Philip shrugs. "I don't spread my sympathy around as easily as you."

He may as well have called her a slut. Her mouth drops open. Philip appears not to notice, his eyes on the waiter who approaches their table with two oversized steaming plates. A steak for Philip; chicken fricassee for her. She frowns at her dish, feeling as shredded as the poor bird strewn upon it.

"Pepper?"

"Sure," says Philip, smiling at the waiter. The smile remains when the waiter leaves, a determined smile. "Mmmm," he says, holding his head over his plate and inhaling. "Smells great."

She grunts.

"It is great," he says. "You want a bite?"

"No."

"How's yours?"

"Fine."

She pushes the food around on her plate. Philip holds forth on movies and the challenges of jogging in Riverside Park. She can't possibly eat. Her stomach is twisted in knots. She keeps checking his watch. When are they going to get their check? Why doesn't the waiter come over? He's ignoring them. Why won't Philip flag him down? How is she supposed to sit here? Outside a cold wind barrels down the avenue, blowing trash and newspapers. The pedestrians grimace and clutch at their coats. Sarah zips up her jacket.

"Thank you for coming," Philip says. "I had a good time." Could he possibly mean that? "Can I get you a cab?"

"No thanks." She doesn't want the dark introspection of a cab. "I'll take the subway."

He looks concerned. "Isn't it a little late?"

"I like the subway," she snaps.

He shakes his head, confused and frustrated. "Well." He leans over and kisses her on the cheek. "Goodnight, friend."

"Good luck with your developer," Sarah says. She digs her hands deep in her pockets and walks into the wind, wishing the air could blow right through her.

No more nights alone after that. It's Falk, Bambi, Gus, Maya when she's in town. But she can't get Philip out of her mind, that horrible conversation. What was she thinking? Why had she told him about Maya's loony attacker? Who wants to go on a date with a woman who declares love to be a species of homicidal madness? No wonder he had recoiled. She's told Gus and Bambi about the date, but jokingly, making no reference to the misery it still causes her. To

talk about that would be to expand it, to give it oxygen.

On a sunny, cool morning, wind whipping through a freshly chinked window, Wendy Flanders drops by the studio, her nose red, her scarf homemade and bunchy. Her appearance surprises Sarah. Wendy was a far more powdered type when she was going out with Gus. Now she's married, with her own cheese shop on the Upper West Side and a thick stack of baby pictures. Gus croons over them, his behavior impeccable. Sarah can't tell if Wendy's visit is a form of payback or a spontaneous little hello, which is how they're playing it. Wendy, stir-crazy at home, no time for anything except for cheese and nursing, but her mother is in town, taking care of the baby, and the shop is closed on Sundays, so here she is, for the first time in how many years? The air in the room is taut and expectant. Perhaps it's the extra energy that makes Wendy so enthusiastic over Sarah's icons. She offers to buy one. Sure! says Sarah, before she gets a chance to change her mind. *Ka-ching!* Her first sale in over a year.

Sarah is pleased, though a week or two later, when Wendy calls to say that her customers love *Artichokes and Onions*, and would Sarah be interested in having a show, an uncomfortable silence follows.

"You mean in your cheese shop?" Sarah says. The thought of asking Maya to an opening in a cheese shop is not appealing. Gus, who had originally picked up the phone, methodically bounces his ball, making a show of not noticing their conversation.

"It's a storefront with great light and high ceilings—a nice spot for art, I've done shows here before."

Sarah agrees to check it out, and goes up a few days later with Falk. Falk, new to the Upper West Side, puts his hand

in her back pocket and gazes goofily at the grand old build-
ings and the people selling books on the street. They walk
past the restaurant where she had her meal with Philip. She
doesn't look at it, afraid she'll blush, and focuses her eyes
on the intersection ahead, the women with shopping bags,
the yellow cabs, the blinking *Don't Walk* sign. The cheese
shop is nicer than she was expecting, high tin ceilings,
an antique mirror looking over the wheels of Camembert
and Brie, dried flowers in earthenware vases. *Artichokes and
Onions* hangs in the middle of a large empty wall, the gold
shimmering almost magically in the sunlight.

Wendy comes out from behind the counter, gives her
a hug and shakes Falk's hand. They study the light on her
painting, approvingly.

"But don't you think it would be even better with more
surrounding it?" says Wendy. Sarah can almost feel Ma be-
side her, clicking her gums. *Och och, what's wrong with cheese?*

Philip calls the next day. His voice is not altogether steady.
Sarah pats her pockets for cigarettes. Say something. "Hey,"
she says. "What's up?" A couple of raindrops, fat and quiv-
ering, splat against her window.

"I'm calling about a painting."

"You're kidding. No one ever calls about my paintings,
and you're the second one this week."

"That's how it works. I don't get a commission for a
year, then I get three at once."

"You've gotten three commissions?"

"No, not at the moment. But it's happened. I did get that
Florida job, though. That's why I'm calling. I wanted to buy
a piece of art to celebrate, and I keep on thinking about that
painting you did, that *Town X.*"

"*Map of X?*" She lights a cigarette, trying to tamp the flutter inside.

"Yes. I've got the perfect spot for it. I have this idea that it will spark my imagination. I have a thing about plans of French villages."

"I thought you've never been to France."

"I said plans, not the villages themselves."

He's smiling, she can feel it. That lopsided smile. She closes her eyes and takes a breath. "What about I lend it to you?"

"Lend it?"

"I don't want to sell it. I—I can't think of a price. If I can think of a price, maybe you can buy it."

They agree to meet at her studio. By the time she leaves her apartment, the scattering of raindrops has turned into a barrage, but she doesn't mind, she welcomes it, actually. She loves storms, the jumping backward as cars whoosh through puddles, the fountains of black water all over the place. Lightning flashes. She can feel it zinging through her, relieving her of her thoughts. At the studio, she wraps up *Map of X*, first in cardboard, then in double layers of plastic. Rain pelts against the window. The thunder claps and rumbles so loudly that Sarah doesn't hear the buzzer right away. She hurries downstairs, purposefully not looking at the mirror near the entry, and throws open the door.

"Isn't this insane?"

Philip doesn't hear her. He is leaning into the backseat of a taxi, struggling to get something out. A wet cardboard box. A case of some kind of wine.

"A token of my gratitude," he says, rain dripping down his forehead, his eyelashes wet and dark. He tilts the box to show her the label.

"That's good champagne. Hurry. You're going to float away out there."

"It's from a client. I figured I ought to give you something in return." He makes it to the doorway and shakes the rain from his hair, inadvertently spraying her. She can smell the wool of his coat. He looks around her studio, rubbing a crick in his shoulder. "This place looks different in the daytime," he says.

"You want some tea or something? You must be cold."

"No. Where's that painting? I want to put it up right now."

It leans against the wall, tied up with twine.

"You promise this is it?" Philip says. "You're not fobbing me off with shoddy goods? Come help me hang it."

"I shouldn't. I need to paint."

"On a Sunday? Come on. Let me show you my office."

Sarah breaks into a big grin.

The taxi tires swish reassuringly in the rain. He puts his arm around her. She studies his profile, wondering what he has been up to the past month. If he feels this way, why didn't he call? Perhaps he had as many reasons for not wanting to see her as she for not wanting to see him. But he seems to have made a decision; there is no hesitation in the fingers that curl around her waist. She closes her eyes and inhales. Tweed and solidity. She could ask him to explain himself, but why bother? Out the window, the headlights glow foggily, and beyond them, the gaudy neons, eventually replaced by the soft grays of the Upper East Side. The cab stops on a well-to-do block. They run through a light drizzle to a town house half covered in ivy. Philip's office is on the second floor. The lobby is a big windowed room with tall ceilings and a minimum of furniture. It's a good

place to hang a painting, and there's a perfect spot behind the reception desk.

Philip opens the door to his workroom. "Here we go," he says, "the inner sanctum." Quite a different thing: bookshelves double stacked and sagging with books, coffee mugs, a woebegone aquarium sitting on top of a minifridge, articles and notes jotted on legal paper pinned to the walls, a defunct copying machine, shabby armchairs. Not what she would have imagined. He edges to the wall behind the largest drafting table and unpins a Polaroid and a scrap of graph paper.

"This is where I want to put it."

"There? Don't you think it's kind of dark?"

"I'll install a light."

He sorts through a desk, looking for a hammer and hanging hooks. Sarah flops down on an armchair. His portfolio is on the table in front of her. She flips through it. The exteriors of his buildings are clean-lined and understated, made of steel and stone and slabs of handsome wood. They all have windows, large walls of them, giving the impression of openness, but the interiors are complicated, spiral staircases and multitiered rooms. In one, a zigzagged hallway.

"You specialize in convoluted insides," she says.

"I wouldn't say convoluted, I'd say precisely organized."

"What's with the zigzag hallway?"

"That was for a client who said she didn't want to know who she was going to bump into until the last minute."

"Sounds like a dangerous way to live."

Philip finds the hammer and swings it in the manner of a golf club. "She knew what she wanted."

"You don't play golf, do you?"

"When I have to."

"Oh god. Tell me you haven't played in Detroit."

"One of my best commissions came out of golf. You would have liked it, a house with a secret passageway. The guy paid me extra to draw up a false blueprint.

"Where did it lead to?"

"Can't say."

"Oh, come on."

"A secret's not a secret if it's told."

She's never thought about secrets that way; the whole point is finding the right person to share them with.

"I love this," he says, unwrapping her painting, "I really do." It looks different than in her studio, elegant and deliberate, hardly the haphazard, organic surprise that it was. She remembers working on it, that intense feeling of rediscovering time, the streets of the town popping up so clearly. Something nags at her. The name of the town, perhaps? But if she remembered, she'd have to change the title, and she likes *Map of X*.

He asks her to hold it in position and walks backward, squinting. "A little up," he says.

"What do you think about going back in time?" she asks.

"A little to the right."

"If you could get into a time machine—"

"That's it. Keep it there."

"My arm hurts."

Philip takes a pencil from his pocket and marks the wall. "All right, you can put it down."

"Aren't you going to answer my question?"

"Going back in time? What's the point?" He hammers in the nail. It only takes two blows. She's impressed; she's terrible at hammering.

"It's never over," she says. "What about that woman at the funeral, Miss Merriweather, still in love with Conningsby after sixty years?"

"Proof of her insanity."

"You were more charitable at the time."

Philip hangs the painting, then rubs his hands together, evidently pleased.

"It guess it's not that dark," she says.

"I'll install a light, and you'll be happy."

"Whatever. It's your painting."

"Mine?"

"For the time being."

"You know what? I'll get you a frame for it."

"You've already gotten champagne," she says, looking around for the bottle they brought with them.

He grabs something from his desk, not the champagne but a toy truck that he puts in the palm of her hand. It's a model of an antique ambulance with a canvas top and white wagon wheels.

"Speaking of the past," he says, "this is the kind of ambulance that Conningsby used to drive." The tiny back door opens with a click. The interior walls are lined with stretchers, three on each side. "See? They carried six stretchers, and see the pulleys? The Ford ambulances had pulleys—that way the wounded got less jostled. They were the envy of the French doctors."

He wheels the ambulance down the pad of his palm then up along a deeply grooved line, his lifeline. Sarah recognizes it from Maya's fortunetellers.

"He was just seventeen. He was trying to get out of Terre Haute. You can't blame him for that."

"What did Conningsby tell you about the war?"

Philip squints self-critically, as if he's not sure he should have started this. "He wasn't proud of it."

"I know. What happened? Please tell me. I loved Conningsby."

Philip rubs the underbelly of the ambulance with his thumb. She doesn't think he's going to speak, but then he does: "Not long after he got over there, they put him on the night shift, transporting wounded between the Verdun and a place called Bar-le-Duc. The ambulances were driven with their headlights off so the Germans couldn't see them, a method that worked as long as there wasn't snow and a full moon. But one night there was snow and a full moon, and Conningsby's ambulance got hit. The force of the explosion threw him out of the cab. The snow worked as a cushion, saving his life, but his knee got bent the wrong way. He couldn't move. A couple of the men he was transporting, still strapped to their stretchers, flew out the back and slid down the hill. Conningsby said that for a split second they looked like bloody mummies strapped to toboggans. The others were trapped in the burning ambulance. Conningsby lay there, listening to them yell. After a while he heard soldiers speaking German. He crawled away, dragging his bad leg behind him, and kept crawling all night. Finally he passed out. When he woke, he was in a farm field with a boy standing over him.

"The boy couldn't speak. He was a deaf mute. He led Conningsby to the ruins of a little stone village. It had been shelled, and some of the buildings were only half standing, but it was better than nothing. There was a store of potatoes and onions in one of the basements. Conningsby and the boy stayed there, living in the most complete house, making fires with broken furniture and roof beams. Later, when

Conningsby's leg got better, they set traps for rabbits, and in the spring they collected shards of stained glass from the church windows. The idea was to piece them back together, like a mosaic . . . Then the kid tripped over a mine wire."

Sarah grimaces.

"Yeah," says Philip.

"I don't understand," says Sarah. "Why would Conningsby be ashamed of that story?"

Philip looks surprised. "When his ambulance was shelled, he just lay there. The guys he was responsible for burned to death—"

"He couldn't move."

"He moved when he heard the soldiers."

"Oh for god's sake, you're being too hard on him—"

"I'm not being hard on him. He was the one who was ashamed. And then he went AWOL. When his leg got better, he could have taken the kid to an orphanage and returned to his post."

"He was a volunteer. He was sixteen."

"Seventeen."

Sarah snorts.

"All I'm saying is that Conningsby didn't feel good about it—he blamed himself for the kid's death." He wanders back over to Sarah and runs the ambulance up her arm. The wheels plow up goose bumps. "It gets me going when I'm stuck," he says.

"The ambulance?"

"Yes. I wheel it along my notes, and I think of Conningsby and me in the basement, working on that model, and sometimes something clicks. That's why I wanted your painting—it's another reconstruction of a French village.

I've never been to France, but for some reason these French villages keep coming up."

Sarah is lost.

"I'm sorry," he continues. "I thought I told you. The model in Conningsby's basement—remember, the one that he and I worked on?—it was a model of the village he and the kid stayed in."

"The model was of a shelled village?"

"Yes, but in the model it wasn't shelled. I think he was returning to his original project, you know, of piecing together the church windows, but with me instead of the deaf mute. He was so patient with me, and he didn't have that kind of reputation. People were afraid of him. That's why my parents sent me to boarding school. They thought I was hanging out with a kook." Philip misreads Sarah's smile. "Okay, but he was a great kook."

"No, not that," Sarah says. "I was smiling because you said before that you didn't give a flying fuck about the past—"

"I don't believe those were my exact words."

"That ambulance is your time machine."

"It's a sentimental weakness." He touches her hair. "I love your hair."

"It's my father's hair. Oh my god." The ground seems to shift.

"What?" says Philip, concerned.

"I just realized why I painted that painting. It wasn't an ordinary day at all. We were on tour, Maya's first European tour, and my father had a fit. He hardly ever had fits. It must have been being back in Europe—it was the first time since the war, and he was also sick. He was standing in the middle of the road, shouting. He wasn't shouting at me, he was

shouting at, I don't know, his parents, the people who had killed them, I don't know—but he was shouting insanely, in a language I didn't understand. It was terrifying. Ma had a doctor's note. It was probably for Valium, lithium, some medicine, and I was running through the streets, looking for a pharmacy. That's why I remembered the layout of the streets." She stops, unsteady.

"And your father, did he get his medicine?"

Yes. She had turned down the last alley, and there was the green cross of a pharmacy, not yet lit, but she'd banged on the gate and got the pharmacist.

Philip strokes her hair. "Bravo."

"Ptchinka."

"What?"

"That was Max's name for me. That's what he said afterward. "Thank you, ptchinka."

A tear rolls down her cheek. He leans down and kisses it.

They take a walk. The storm has cleared but for a soft rain. They enter Central Park. The paths are shiny wet, twisting and turning for them alone. The twigs have big droplets clinging to them and the leaves are sopping and scattered everywhere. She twirls Philip's umbrella and its reflection flashes back in a puddle.

"You'll get your hair wet," he says.

"I don't care."

He draws her off the path, the earth squishing, giving way below them, toward a thick-trunked tree with soft, mossy bark. She leans against it, and the wetness seeps through her jacket. Philip leans into her, his warmth balancing the coldness of the tree. She imagines the tree leering.

They can't stop kissing. A squirrel chatters at them, throws acorns.

They wobble back to his apartment, weak-kneed, giggling like teenagers, although she'd never felt quite so innocent as a teenager. They go straight and finally to bed.

She had been a little nervous that he would be twitchy and virginal. But he isn't. He is as free and easy as that Nureyev on the basketball court. "It's like bicycle riding," he says. "You never forget." They stay there for two days and two nights, Philip intent on making up for lost time. They could easily stay there longer, ignoring their growling stomachs and ever-sorer limbs, but Philip has a meeting and Sarah has a shift.

They part with promises to see each other the next day, and Sarah takes the subway home, grinning stupidly at everyone in the car. At her apartment she gets into the shower, grateful for Conningsby, for Tori, for Clyde Bandersnatch, for Gus for putting the basketball hoop in the studio, for the planet for rotating, for the bed for squeaking, for the soap for bubbling in such a perfect way all over her skin. She shouldn't use soap, it'll wash off his scent. But it will be back. This is what is making her so happy. She will smell like him over and over and over again. This luxury of slowness and repetition, this knowledge that she doesn't need to reveal herself completely, for they will have time to reveal themselves—ah, she's delirious. Shampoo gets in her eye and she laughs at the sting.

Chapter 9

The basement was too disgusting to face at the moment. And the mop was probably so moldy it wouldn't work anyway. She got an old towel from the closet and began sopping up the water on her hands and knees. The dishwasher sat there inert, apparently suctioned to the floor, cobwebby tubes coming out the back of it. She toweled around it. The train rumbled by. God, she wanted a cigarette. She poured herself another glass of wine and was shocked to see that the bottle was now empty. She leaned against the dishwasher, sipping her last glass and contemplating the linoleum. She had nothing to apologize for. Yes, he had been writing to "a black hole," as one of his letters put it, but how else could it be? The only thing she cared about was Max, and as she was not going to play the Max card, what was she supposed to write? Ah, how the sparrows sing in the trees? Silence at least had some dignity.

She crawled to the stack of newspapers piled high in the corner of the dining room. Why was she crawling? She'd only had a bottle of wine—a lot, yes, but not unheard of. She flipped through the papers, looking to see if there was a mention of the sort of conference that Philip might be speaking at. Refugee Situation? International Peace? What

had changed that he could now land in New York, stand behind a podium, enunciate his words before a sea of people? She reread his letter, more slowly this time, poring over each sentence. *I would like to talk with you . . . I gather you do not want to see me . . . I feel I have the right . . .* Of course he had the right. She smoothed the letter against her chest, knowing better than to believe it. And yet, wasn't it possible that he meant by those words what she wanted them to mean? They had once thought in the same ways. She sobbed, the wish so big inside of her.

"Mom?"

"Max! I thought you were in bed."

"I forgot. Sensei said I had to wash my gi." He stood in the doorway, holding his bundled-up karate uniform, taking in the newspapers scattered over the floor, her wet face.

"What are you doing?"

"Organizing."

"Where should I put it?" Max held out the gi, his expression stubborn, inquisitive. Could he see the paper she held to her chest? She thought about handing it over right then. But she wanted to be alone with it a little more.

"You can put it on the dining room table, honey. I'll do a wash before bed."

Chapter 10

New York City, Spring 1982

The first night in her apartment after being at Philip's for ten days, and already the solitude of her bed feels novel, enjoyable in its way. She stretches herself in a big X, taking over the whole mattress. She's meeting Maya the next day. She'll introduce Philip as a fait accompli and that will be that. She's through worrying about it. She gets to sleep without too much trouble and wakes to the twittering of birds. She goes through a couple of outfits before deciding that a motorcycle jacket and jeans with an old-fashioned floral-print sweater is the look she's after. Tough, but not too tough. She spends more time thinking about what to wear for Maya than for Philip or anyone else. Maybe she is a little nervous. But the nerves leave her the moment she opens the door.

It's a spectacular day, the first real day of spring. The sun is a fresh idea, an alien magnificence. The people on the street tilt their faces toward it, and trip along drugged with pleasure. The shards of glass in the sidewalk sparkle, and the crocuses pop up from between tree roots. You can smell the green, the buds, the bark. It's a crime descending into the darkness of the subway, but luckily the train comes quickly, and when she gets out, at 68th and Lex, it's warm enough to take off her jacket. The sun streams through the

wool of her sweater, seeps through her T-shirt, spreads over her chest. Those old myths about the gods leering at maidens, leaping down to lay with them, were based on this sensation. The fingers of the sun.

She turns toward the park, the trees mostly gray and naked, and gets to Maya's impressively gargoyled building. "Hello," she says to the old black doorman, who bows and replies, "Nice to see you, Miss Sarah," in this Uncle Remus way that always freaks her out. A new attendant with a white waxed mustache presses the elevator button for her. The elevator cab is a beautiful box of inlaid wood so beautiful that you must forgive its excess.

Maya's personal assistant Martha greets her, a surprise as Martha is usually diligently at her desk, almost invisible. But here she is in a green dress and a new bob. "Sarah, so good to see you! Maya's on the terrace catching some of this amazing sun."

Out on the deck, Maya's white pajamas poke through the black crisscrosses of a wire chair. Her elegant neck and voluptuous knot of hair look way too regal for the calculator and clipboard that occupy her lap. "Darling!" She jumps from her chair, wobbling it backward, and hugs her tight. There is her perfume and her arms, such strong arms Maya has. "You look wonderful." Maya steps back to inspect her. "Just wonderful! I could eat you up!" She gives Sarah a wolfish grin. "Sit down. I want to hear all about iconography."

"I know nothing about icons—I just learned how to hammer gold leaf from Bambi, who learned from an old Russian guy out in Brighton Beach. Apparently if you crack the leaf, it's a reflection of the state of your soul, so you have to be careful on many accounts."

"Can I try someday? Oh, Sarah! Wait just a sec, I have to

show you something." Maya leaps up, leaving her clipboard on the table between them, a bulleted memo on tax regulations in London, salty commentary scribbled in the margins. Maya quickly returns, an object cupped in the palm of her hand. A scarab, carved out of green stone. "It belonged to a king," she says, delighted.

"Really. What king?"

"Oh, I don't know, Psamtik II or I or something like that. I thought you'd like it, you and your ancient history."

"Where did you get this?"

"It was given to me."

"Is it legal? It looks like it should be in a museum."

"I didn't ask."

"Who gave it to you?"

"Remember Rich Sommers? Mr. Happy Birthday Cotswolds? He has become rather ardent."

Sarah grins. "So that's why you sang at his party."

"He popped up in London, and wouldn't quit."

"And Mrs. Sommers?"

"She wasn't there," says Maya innocently.

Martha rolls in a tray of coffee. Down in the park people walk dogs and the mud puddles shine glossily in the sun. Sarah studies the scarab, pleased at its gentle weight on her palm, thinking about the people who held it before, and whether it did indeed belong to Psamtik I or II, and if so, what was its purpose? And for that matter, what is its purpose now—why has it been given to Maya?

"Are you in love with this Sommers? The scarab guy?"

"Unclear." Maya smiles shrewdly. "I suppose I'll find out soon enough."

Sarah crosses her ankles on the terrace rail, thinking of Philip with a softness she does not show. Maya peers out

at the park, a muted, intelligent gaze with a touch of sadness in it. Not the look of a power broker or a Cotswolds snatcher. Sarah leans over and kisses her on the cheek.

"What's that for?" Maya asks quietly, touching the spot where Sarah kissed.

"I'm glad to see you. You've been so busy with all of this London business. Am I ever going to see you once you own half the world?"

Maya laughs. "Just you wait!" And ignoring or unaware of the melancholy that has come over Sarah, she expands on her project, the partners and politicians involved, the contingencies, the possibilities for further growth. She works things out as she talks, the coffee jiggling in her cup. Martha comes out with the telephone, a guy from Lloyds. Maya takes it, apologizing to Sarah, who is relieved, who no longer wants to talk, who wants to be like the birds, flying in great circles over Central Park.

June rolls around and she still hasn't told Maya about Philip, which is awkward, as her show at the cheese shop is coming up and she'll have to invite them both to the opening, although Maya probably won't be in town. She tugs at her hair, twisting it between her fingers, releasing a faint smell. Of Philip. Fuck. She forgot to take a shower this morning, and she's meeting Maya for lunch. She digs through her bag for her brush and strokes vigorously. Her hair crackles with static. The static is still going strong when she gets to the restaurant.

Maya grins. "Your hair, my dear, is all over the place."

"I know. I was brushing it in the cab."

"If you're worried about that man," Maya says grandly, "please. It's ridiculous to worry about men."

Sarah sinks into her chair.

Maya laughs. "I wish you could see your face."

Sarah tries to hide whatever it is she's showing.

"I'm not a moron," Maya continues. "You've been dancing around for months. You're not pregnant, are you?"

"Huh?"

"Just trying to figure out why you finally decided to tell me."

"I'm sorry, Maya. I meant to."

Maya rolls her eyes.

"It's true," Sarah says. "I was just worried you wouldn't like him. Don't be angry with him. It's not his fault."

"Why would I be angry with him? I'm happy for both of you. I'm thrilled." Whatever Maya is, she's not thrilled. But she's not exactly angry either, at least not as angry as she'd have the right to be. She breathes on the tines of her fork, then polishes them on her sleeve. "In any case, it was bound to happen."

"It was?"

Maya nods gravely. "I'm glad you're not pregnant." She reaches under the table and hands Sarah a long white box. "I got it in the islands. It would not be kind to a bun in the oven."

Sarah peeks inside—red silk fabric with delicate orange beadwork. "It's gorgeous."

"It's going to look great on you, all necky and leggy. I want you to wear it to Temple's. I'm opening there—"

"I know, on Friday. I've been looking forward to it, and now I have a perfect dress to wear."

"And bring Philip."

Sarah sits straighter in her chair, her alertness returning. "You know his name?"

"Of course," Maya crows. "He's an architect. Built a house for Chaz Peabody. Single, no exes, no prison record, but—"

"You didn't."

"What? Nothing wrong with a little security check. What's wrong?"

"You shouldn't have done that, Maya."

"Please. I just had my boys do some due diligence. Don't you want to hear more?"

"No." Sarah lights a cigarette.

"Jesus, Sarah. I'm giving him my blessing."

"He doesn't need your blessing. He's fine on his own. I'm sorry. I didn't mean to snap. It's just that Philip would be upset knowing that you'd been digging around in his affairs."

"Well, don't tell him."

"I won't."

Maya smiles. "It will be our secret. Are you sure you don't want to hear more?"

"Maya. Stop."

Maya studies her, a sharp look in her eye.

Sarah takes another drag off her cigarette. A cylinder of ash lands on the dress box. "I should have told you about him earlier. I'm sorry."

Maya nods, acknowledging her apology. "I've known for a long time, ever since your first marvelous date. Since then I've been watching you squirm."

Sarah bumps into furniture, bruising elbows and upper thighs, determined to get water to her long-neglected plants. "If you put them in easy reach, it wouldn't be so hard," says Philip, sensibly, from the couch.

Sarah stands on a milk carton, lifts the rusty watering

can over her head, aims. Philip frowns at a scuff on his shoe and finds a rag to wipe it off. He agreed to go to Maya's concert, though the idea didn't seem to thrill him.

"Don't worry, Sarah. I'm not going to fall in love with your sister."

She floods the asparagus fern. "What?"

"Isn't that what you're worried about?"

"Who said I was worried?"

Philip laughs. "Oh, no one. Just a wild guess."

She kisses him on the top of the head. "Okay, maybe I'm a little worried. But I'm not worried about *that*. I mean, you are allowed to fall in love with her a little. That's her due. Just, you know . . . keep it under control."

He doesn't smile. She gets a roll of paper towels and squats to wipe up the water and flecks of soil dripping on the floor.

Philip pours himself a glass of port. "You want some?"

She takes a sip, then grimaces. "How can you drink this stuff?"

"I think it's good."

"It's syrup." She puts the glass on the coffee table. She pulls out a record, her favorite, a live concert in Antwerp. "Just listen to this. Tell me it's not good." She pauses to examine the record. The photograph shows Maya from behind, the silver sweat on her back, a profile of her face. She hands Philip the cover. He looks at it, and Sarah looks at him looking at it, and the record trembles in her hand. Maybe she is a little worried that he'll fall in love. But that's the least of her concerns. She's more worried that Maya will be horribly rude. But most of all, she's worried about herself. She feels like such a different person when she's with each of them. What will she do when they are in the same room? She feels like she might split right down the middle.

"Aren't you going to put it on?" he says.

"Yes."

She finds "Mi Corazón" and places the needle down. The first notes come out of the speaker: "*Mi corazón, no se, no se. No translation, no price to pay . . .*" The audience roars. She closes her eyes, the amplitude of that roar getting into her, dimming her concerns, until she's back in that night. The sticky humidity, the closely packed bodies, that roar. Underneath and over it, you can hear Maya's voice, throbbing. She shivers. Only when it's over, as the needle circles in the end-of-the-record dust, does she check on Philip. He could be sitting at a bus stop, he looks so composed.

"What do you think?"

"Sounds good," he says.

Sarah wipes the sweat off her lip.

"Why are you still over there?" he asks. "What's wrong with this spot on the couch? This perfectly viable cushion?"

"Can I have the cover back?"

"Sure."

She slips the vinyl back into the slip and the slip back into the cover and the cover back into the shelf. "Funny how you can store music vertically. It doesn't seem vertical when you're listening. It doesn't seem containable."

The dress is outrageous, red silk with a plunging V-neck that cuts between the breasts. A getup that gets up, as Maya would say. Rita Hayworth might have worn it, slinking into some nightclub, back muscles purring. Rita Hayworth is Maya's favorite actress. She saw *Gilda* thirty-two times as a kid, squirming with delight at her shoulders, her high-slitted gown, the way she rolled off her black, elbow-length glove. It was only a glove, but she removed it so

audaciously that Franco censored the scene on grounds of obscenity. Maya still brought it up. Huh? Men in charge? Wanna explain old Francisco Franco, thirty-year dictator of Spain, unmanned by a glove?

Sarah takes one last look in the mirror then runs down to the street. She waves for a taxi, and three swerve toward her. The power of a Rita Hayworth dress. At Philip's office, an older woman with glasses on a chain sits behind the reception desk. Mrs. Harris. Sarah knows that she left a good job at Philip's old firm to help him set up his own business, and that she lives in New Jersey with two cats and a husband whose bladder, kidneys, and parking tickets have been discussed with Philip in great detail, but whose first name remains undisclosed.

"Hello, I'm pleased to finally meet you. I'm Sarah." She offers her hand. Mrs. Harris, blind to it, stares at the dress. "Is Philip here?"

Mrs. Harris looks her straight between the breasts, purses her lips, and presses the buzzer. Her eyes finally move up to Sarah's. They flicker then steady into a pale brown. "You're a lucky woman," she says. "Mr. Clark is a good man." Philip opens his door and whistles. Mrs. Harris's lips get whiter.

On the staircase, he grabs Sarah from behind. "Oy vey, it's the Harlot Marker. Where did you get that thing?"

"The dress? Do you like it? I was worried you might think it was too much."

"Too much? Quite the opposite." They get into the cab. "Are you sure you want to go?" He sits near, but not too near, a sliver of cool air between them, through which she can sense his fingers and breath. Her nipples poke into the red silk.

"We have to," she says sternly.

"Yes ma'am."

She frowns at her dress. "I don't know why Maya wanted me to wear it."

"It's beautiful."

"It might be a joke. She has a perverse sense of humor."

"Why would it be a joke?"

"I don't know. She gets into these elaborate games, and they can go too far, make a real mess."

"A trickster," says Philip.

"Exactly. Ma blamed it on the fairies. She swore up and down that Maya had fairies in her blood."

"Only Maya? Not you?"

"Oh, you don't have to worry about me. I'm 100 percent human."

"So how did the fairies get into Maya's blood?"

"I'm not sure, but early on, in the womb. Apparently, if a child is born with its eyes open, then you know the fairies were somehow involved. Ma used to say that Maya was born 'eyes open, staring through a film of blood.' It scared the hell out me."

"But how do the fairies get into the womb?"

"I don't know. Maybe they dive through the belly button or something."

"Maybe Max was a fairy."

Sarah giggles. "He certainly was not."

They get to Temple's: a smoky cloud of chatter and anticipation, the host bobbing his head, eager to please, ushering them to the best spot in the house, an honor wasted upon Philip who looks down on Manhattanite seating wars, though he likes the complimentary champagne and the old

New York feel of the place, the lamps glowing on the tables, the dark, polished panels that have soaked in a century's worth of expensive cigars and handshake deals. He smiles his lopsided smile and Sarah squeezes his arm, glad that this night has finally arrived, that it will soon be over with. The pianist starts up and suddenly Maya appears shimmering in a silver suit that Bowie might have worn or, years before, Dietrich. She slips through the tables, mercury smooth.

"Let me introduce my sister . . . who humbles me daily." She leans down for Sarah's champagne flute, showing off her cleavage and a new necklace made out of silver feathers. "This one's for Sarah and her new beau." She takes a sip. "A little ditty I thought up about an hour ago. Do me a favor and forgive its kinks."

Sarah's chest is alarmingly tight. Maya and Philip are both in the same room at the same time. But they look okay; it's just her who can hardly breathe.

Maya nods to the pianist, then turns back to the audience. "Really. Do forgive its kinks." Her eyes sparkle. She twists the mike cord around her fingers and strolls around the room, thankfully visiting other tables.

"Forget me not.
One last Foxtrot
before you blow,
we who took the O-hio.

"Now you set off Columbus sailing,
hi ho silver big white whaling.

"Forget me not.

X marks the spot
that we once knew.
Where we had our fond canoe.
Where we baited rusty hooks
and read our dirty books.

"Forget me not.
I'll go to pot.
Plow up fallow land.
Turn up empty hands.
Be destroyed—
and be annoyed."

The audience laughs, as does Sarah. A sweet euphoria flows through her; Maya has never written a song for her, and this one is so right.

"Baby, all I need's a kiss, an invitation, hit or miss.
A garden party, spot of tea, a bouquet of flowers for me.
Snapdragon, sugar pea . . .
Forget me not."

Maya wiggles her hips and winks, a triumphant, contagious wink that melts through the last of Sarah's tension. This is exactly how she wants Maya to love her. Exactly this way. Sarah leaps up and gives her a hug. Her face is damp, glowing, her scent heady.

"Sorry, Mr. Clark. I meant to do a song for you, but I got more inspired by my sister." Her behavior isn't hostile. She's acting like Ma—wary, protective, good mannered.

Sarah wishes that Philip would smile back, but he's embarrassed by the curious-envious eyes of Maya's fans.

He pulls himself together and flashes a smile of his own. "How could I blame you? She's a far better muse." Maya gives him an approving nod.

Wow. They did it beautifully. Sarah sinks into her seat, limp and dazed. Philip didn't get scared. There was none of that weakening that she's seen in other men. He seemed more dislodged by the audience, something she understands well. She slips her hand into his.

Maya moves on to the next song. Sarah hums along under her breath. Not Philip. She'd hoped that live, in concert, he'd be able to appreciate what he couldn't on the record, but he really doesn't seem affected. He doesn't look bored exactly; he looks, well, neutral, like Switzerland or Sweden, some blond country observing from a safe distance. Maybe it's because he doesn't know the song. The next number he has to know. "Old Man River"—everyone knows that. Sarah gives him a gentle smile. Listen. Listen! That's my sister up there. You're allowed to fall in love a tiny bit. His hand finds her thigh. His fingers are light and playful, but they do not move in time with the rhythm, and when Maya gets a pair of maracas and switches to bossa nova, they do not register that either. He's hopeless, but only in the music department. His fingers slip down the slope of her thighs, tease the crease between her legs. She opens slightly and he dips in, smoothing the silk against her skin. She squeezes her legs shut, trapping him. Up till then, he's remained Switzerland, observing the stage, but now he's turning, a spark in his eye. His hand digs deeper. It feels like he's going to plunge right through the fabric.

"Philip, you dog!" Maya leans over the table, damp, slightly out of breath. Her set has just ended, and the applause is still going strong. "You've stolen her heart. How

did you do it?" Her lids sparkle from silver glitter. Her irises flash with something other than sauciness.

Philip eyes her back, once again surprising Sarah with his self-assurance. "Good show," he says. "I didn't know people still sang cabaret."

"Oh yes. It doesn't go away." Maya slides in beside Sarah. "Ma always said, you stick to the classics, you'll be okay." She nudges her sister, her silver suit rough against Sarah's bare arm. "Remember that?"

"Of course." Sarah smiles, trying to convey that she loved the set, every single moment. "Thanks for my song. It was perfect." She smoothes a fleck of silver off Maya's cheek.

"Ma had a great disdain for the idea of keeping up with the times," Maya tells Philip. "Take the circus—has it ever gone out of style? No. Been around in Caesar's day and it ain't going anywhere. Why? Because it doesn't deviate. It's got everything you need: beauty, talent, and danger."

"An interesting trinity," Philip says. "I see it for the circus, but I'm not so sure about your act."

"What am I missing?"

"Danger," Philip says.

Maya tosses her head. "He's right. I'm a toothless, danger-less triangle. How depressing." She puts a cigarette to her lips and a bearded man lunges across the aisle to light it for her. "Thanks," she murmurs.

"I love you," the man whispers.

Maya releases him with a smile that she developed particularly for this sort of occasion, inspired by her brush-in with the lunatic. A masterful expression so intimate and ironic and ultimately kind that the bearded man crows with victory even as his friends drag him away. She turns back

to Philip. "You've got the same problem. Your buildings are beautiful—I didn't need Sarah to tell me that, although she did, of course. So you've got beauty, and naturally you need talent to design them, but you're into security. Ta-ta danger."

"But I'm not a showman."

"He needs a different trinity," says Sarah. "Light, charm, absence of leaks."

"A decent address. Are you going to build Sarah a house?"

Philip smiles. "I hope so."

"Build me one while you're at it. I'd like to live in a minaret. Can you do that?"

"I could try."

"With a courtyard outside where the faithful can prostrate themselves. I'm going to be innovative, have them pray faceup instead of belly-down, cloud-gazing instead of ground-grazing, eyes-to-the-skies as I ululate away."

"I don't think the Muslims would like it."

"We won't tell them. We'll keep it very, very secret."

Sarah sips her champagne, grateful to them both. Philip's knee rubs against hers, a fond *bump-bump*, but he's paying the proper attention to her sister. Now they're groaning about some over-the-top golf club. Now he's complimenting her on her investments. This must be how he talks to clients. His tone is different—not formal, but bluff, cordial, confident. When he's talking to her, his voice is softer, with more cracks and fissures. He doesn't seem cowed at all. Her boyfriends don't act this way with Maya. Then again, she's never had one with a tin ear. She puts a hand on Philip's thigh and squeezes Maya's hand with the other. She can't talk; there's too much inside, a heady glee, the possibility of an almost inconceivable fullness.

A man in a black turtleneck winds through the narrow

aisles, compact and graceful, coming toward them. "Franco!" Maya's arm shoots up. He bends down to kiss her. Maya grabs his shoulders and won't let him go. "I'm so glad you came! Look at you! Can I just look at you for a minute?"

"Look away, honey. I'll send you a bill afterward."

He catches Sarah's eye, rewarding her with a fan of wry smile lines. *Your sister's insane, help!* She likes him immediately, but Philip is pale and tense. She nudges him, wondering what's wrong, but he just drains his champagne. Maya scoots in, making room for Franco, so that they are all squished together on the curved banquette.

"You've got to have a drink with us. Is there any more champagne?" Maya lifts the bottle from the ice bucket. "These bottles are so small. They used to be bigger, didn't they?" A waiter hurries over, bearing more. Maya stretches out her arm, showing off a delicate silver watch. "Franco made this, can you believe it? By hand, each little gear." She pops open the watch face to expose the workings inside. "Don't you love this, Sarah? Isn't it amazing? He learned how to make watches in prison, in this great rehab program they were doing out in California."

Franco snorts. "Do you have anything else to tell them?"

"I do like to chat, don't I? But you must understand—Sarah is a passionate critic of the penal system. She should know that positive things can happen in prison. It's not all oppression."

"Yeah, there's a strong artisan network," says Franco, straight-faced, making Sarah wish that Philip would relax. She can't stop grinning. She could so easily see Franco at their place on 155th, smoking cigarettes on the stoop, chatting with Max about nothing in particular. He might have sold him a hot car. He might have been banned by Ma.

There were the girls. There was Ma's implacable respect for the law. But even Ma would have liked him. A shard of jealousy cuts through her, that Maya could still have friends like this, in spite of her tony crowd.

"Franco," Maya announces rather ceremoniously, "I wanted you to come tonight because Sarah's new fellow specializes in security. Philip, Franco is starting a consulting business. Thief-proofing from an ex-thief's point of view." She looks terribly pleased with herself; she's gloating. "I thought you guys would be a natural fit."

Philip glares at her, unabashed and livid. The flare of dislike between them is so strong and sudden that Sarah is disoriented. She focuses on the tablecloth, dark burgundy damask lightly scattered with ashes that didn't hit their mark.

Franco whistles. "Philip? Philip Clark? Man, long time."

"Hi, Franco."

"It's good to see you," Franco says, as if he means it. Philip nods grimly.

"How do you know each other?" Sarah asks when the silence becomes unbearable.

"We met out in the desert," says Franco. "At Marshall Conningsby's. Do you know him?"

"I did," says Sarah. "Do you know that he died?" Franco looks startled. "I'm surprised Maya didn't tell you." Sarah now realizes how very deliberate this meeting must be.

Philip stands abruptly and takes out his wallet.

"I've got it," drawls Maya.

Philip is calmer now, magnificently disdainful. He tosses some twenties on the table. Sarah follows, casting an apologetic glance at Franco. His gaze is intelligent and interested, not confused. Sarah is the one who is confused.

Chapter 11

S he bundled the towel used to mop the kitchen with Max's gi and clomped down the basement steps, grit poking into her bare feet. A fat cricket jumped across her path, startling her, but she made it to the machine, dumped in her bundle, sprinkled detergent, then stared at the detergent flakes as if they were tea leaves. It was after midnight now, officially Wednesday the fifteenth, Miercoles, the day of Mercury, god of roads and lies. She closed the washer door and pressed the button. The machine groaned into action. On the way back up, she stopped in front of the storage shelves, shelves she'd built herself, nails poking out preposterously. She'd never been good at hammering; she used to get Gus, then Philip, to do the corners of her frames. The case of shelves that Max had pilfered for its planks sagged against a bookcase lined with canisters of varnish and turpentine, shriveled tubes of paint, canvases water-stained from the last flood. A folded square of better-looking canvas sat on a high shelf. It was still supple. She brought it upstairs, unfolded it on the kitchen table, and ran her palm against the creases.

The last time she'd stretched canvas had been in New York, seven years ago. Philip was in the desert, about to climb

into his hole, and she was in her studio, deadline-edgy, on the verge of the Quetzalcoatl paintings. Not thinking about Philip directly, concentrating instead on the petroglyph she'd seen on Part I of her ruinous trip out to West Texas. From this came the idea of the plumed serpent. She'd mixed the paint with sand from the desert, and ashes—not Conningsby's actual ones, but a handful she'd bagged at an old fire circle in the canyon. She had primed the canvas, turned off the phone, not left the studio for seven days and nights. And he had emerged, spiraling out of the canvas with his fiery breath—not as she had envisioned him, but as his own majestic, fearsome, self-created self.

An amazing seven days and seven nights. Aside from *Quetzalcoatl #1*, she did a study for *Quetzalcoatl #2*, a sprawling depiction of the Second Era of the Fourth Sun, the end of Quetzalcoatl's domain when hurricanes blasted the earth and men turned Darwin-backward into monkeys. A joke sketch of the marriage of Maplethorpe and Tlazolteotl, the Goddess of Filth and Purification through Sin. She even took care of business, not a planned thing of course, but the buzzer buzzed and she, on a ciggie break, opted to answer. God. Eddie Kiebbler and Simon Perez, giddy with the success of his second gallery, bursting in, high on something, bearing Kit Kat bars, chanting her name. The Quetzalcoatls were good, fabulous, right on the money. They jabbered about what to serve at the opening. "Aztec, baby. Do it right, pyramids, poi." "Did they eat poi?" "Better yet, virgins, babes, and boys, toppling from pyramids. In marzipan." "Who says they were virgins? You can't tell. It's scientifically imposs, the membrane pops any old way." "They didn't eat marzipan or poi either." Jeez, that was business? She'd complained about that? What would she have done

if she had gotten a glimpse of the assistant principals and sputtering parents, the disputes over soda machines in hallways and Huck calling Jim a nigger?

The canvas lay on the table, the fold creases stubborn, resistant to her palms. She went back to the basement and searched through the supply shelves, looking for a stretching frame. She'd take one from another canvas. She had a terrible painting by Bambi Peterson. No, she didn't. She'd given it to the PTA silent auction, and someone had bought it for $175. There were staple guns, a rusty canvas clamper, tack nails, a glue gun, two-by-fours of odd, scrappish lengths. A postcard. What was this doing down here? She sighed. It was a postcard from Gus. A picture of the Maine coastline, a lighthouse on a cliff. He was living up there now, running an artists' colony in an old boat factory. He'd invited her up. It was a fabulous offer: she'd cook meals in return for a studio overlooking the ocean. She'd said no because of Max. It would be hard for him up there, the nearest school an hour and a half away. And more to the point, she had been afraid of word getting back to Philip. Gus could keep his mouth shut, but a hell of a lot of the other writers and artists who went up there were part of that crowd who had known her and Philip, and she would not bank on them.

Perhaps word had gotten back to him anyway. Fuck. Her stomach fell right out of her, an eddy of air where flesh had once been. Last year, giving in to Max and his desire for the type of Halloween costume only to be found at the Stamford mall, she'd brought him to that dreadful place, only to run into Clyde Bandersnatch. Smack in the middle of the atrium, pacing around some potted plants, yelling at someone on his cell phone, his hair still red but thinning. She'd grabbed Max's wrist and hurried on, pretty sure they had

not been noticed, but her grip was too tight, resulting in one of Max's enormous elephant roars. Clyde looked up. He saw. Panic took hold and she sprinted out of there, dragging Max behind her.

There was no more wine left. She shouldn't open another bottle. She wasn't solid on her feet. But it tasted good, the blood of the bull, or the lamb, whatever you wanted it to be. And why couldn't she have another drink, just one last sip? She was an adult, she could drink as much as she thought proper, and why—while she was on the subject of why—hadn't she married Gus? Someone who made sense, who she understood, who understood her. Or Carlos, for that matter. He was comprehensible. But Carlos was already married. Their favorite topics of complaint, rivaled only by Connecticut, were their respective spouses. His was some lunatic surgeon who lived down in Peru. You only marry people who drive you crazy. What was the point of all this wine without a cigarette? What had happened to Quetzalcoatl #2, the one painting Maya hadn't been able to sell? Simon Perez might have it in a storeroom somewhere. There was nothing more depressing than storerooms filled with art.

She found herself in the dining room squinting at his handwriting. October 15. It definitely said the fifteenth. You might not be able to tell what was going on in his head, but his penmanship was impeccable. He probably knew. That would explain it. Clyde probably told him about Max. Fucker. She wadded the letter into a ball, aimed from the doorway. Perfect shot. Couldn't be that drunk. She shook the empty bottle onto her tongue, catching the last drops, then filled her glass with water.

The water tasted good. She peered out the kitchen window, too dark to see anything except the reflection of her

face. She rinsed the glass and put it on the drying rack. Something beeped. A warped, strung-out *beeaaaaeeeep, beeaaaaeeeep*. The washer. "All right, coming." She hurried downstairs. The machine bleated. She yanked open the door. Silence. A gust of warm, moist air, a smell of manufactured lemon scent. Not a bad smell. A perfume, according to her mother, who had at one point supported the family by taking in laundry and washing it in a big vat over the stove. The day Maya gave her the Maytag might have been one of the happiest of her life. Sarah had been fifteen at the time, embarrassed at her mom dancing around with an enormous box of Tide detergent: "You know how wonderful it is? You put in the soap, cha-cha-cha. You flip down the lid, cha-cha-cha. You press the button. Ta-da!" Her hips swished, no longer shrouded in black. That was in the midsixties, her days of wine and roses. She and Max and Sarah were living easy on West 68th Street. She wore a green muumuu.

Sarah squeezed the wet clothes to her chest. It was better that Ma ducked out when she did. She was essentially conservative: spectacles were held under circus tents, real life was led with decorum. You behave. You ignore others' misbehavior. You don't mention bodies in pits or sisters with murderous senses of humor. You brush your teeth. You impart the knowledge of the hypotenuse.

She dropped the clothes in the dryer and went back for the gi. It was heavy and clammy and tangled up with the washer column. She tugged. Her grip slipped and she fell backward. Ma wouldn't have approved of the wine either. She got up and managed to get the gi into the dryer. What to do? Lie in bed with her head spinning? Music might help—blaring, bone-shaking music—but she couldn't wake Max, and the best music was Maya's anyway. Everything else felt second-rate.

The dryer thumped. She leaned against the folding table. A huge pile of socks rose up, a slithering pyramid. She balled. She sorted. She felt stronger on her feet. Reds with reds, blues with blues, blacks with blacks. At the end, a tube sock with a grass stain above the heel lay all alone on the table. She looked for its match, upturning baskets, crawling around on the cement floor, wary of crickets. She found dust balls, moldy dimes, rusty screws. *Sock, sock, where are you?* They had a fight. One sock told the other, *Go away, don't come back no more.* Ma would have been especially stern about that. You were supposed to forgive people, especially family, especially Maya. She couldn't help it. Fairy blood. Why had she gone on so much about that fairy blood? She'd half convinced Maya that she was only half human, half other horrible thing. No sock. No sock anywhere. She pulled herself up and brushed the dust from her knees, then squeezed between the dryer and the crumbling, spiderwebbed wall. At the rear was the dryer tube, a grimy, accordion-folded thing that looked like a relic from the Industrial Revolution. The poor sock might be stuck in there, in the dark, all alone. She inched closer.

Maya was getting married. There had been an engagement notice in the Sunday *Times* a few months ago. Maya Myrrh, soon-to-be-sixty, saying "I do" for the first time. The guy was an architect ten years her junior. Yes, an architect. Original. But not Philip. Bigger and better, the man who was building the next new tallest building in the world, over in Singapore, or Shanghai, or wherever it was. A bulbous needle, twice as tall as the World Trade Center. Maybe Philip had heard. He could have heard, even off in the Congo, slapping mosquitoes, avoiding further insanity. Maya had a kind of fame—no household name these days, but you bumped into people who had heard of her. He could have

been having a bourbon with some UN people and met a doctor who'd been invited to their wedding, that kind of thing. It would be an elaborate wedding, according to the *Times*. Sarah wouldn't even know how to crash it. It was being held on an island she'd never heard of, some hotshot's personal volcano out in the middle of the Pacific.

The phone rang. The phone! She sprang out of the narrow space behind the dryer and raced up the stairs three at a time. But it wasn't the phone. Or if it had been, it wasn't any longer. Just a dial tone. Her arm was scraped, angry lines of pink and loose snatches of skin. She must have scratched it against the basement wall. She wiped off plaster and cobweb and washed it under the faucet. Aspirin would be good, but to hell with it. She uncorked a second bottle of wine, looked for the glass, found it nice and clean, ready for more.

She sat at the table, drinking.

He hadn't driven her crazy when they were married. When they were married, things felt right. Being with him felt right. She hated this. She hated middle-aged women sobbing over their past. Somewhere, perhaps somewhere near, he breathed. She didn't have to eulogize him. They'd fought. Not often, but she remembered locking herself in the bathroom and sitting in the tub fully clothed for hours as Philip pounded on the door. Why hadn't she sat on the toilet? It would have more comfortable. What had they been fighting about? Something stupid. The laundry. The hours for the liquor store. They only fought about stupid things. The serious stuff they left alone.

They got married in City Hall. But they marked their anniversary from the day they hung the *Map of X* in Philip's office and walked back through the park, that first kiss that they hadn't cut short. There hadn't been any question in

her mind after that kiss. Her favorite anniversary was their third, when Philip turned their bedroom into an Arabian oasis. God, that tent. He'd done it so well that, at first glance, she thought he'd bought it from some Far Eastern bazaar, but it was made of old household stuff: sheets, tablecloths, curtains, mosquito netting, expertly draped and folded to hide stains, seams, labels. It was an elaborate wrapping for the present inside: a brass candelabra with Arabic flourishes. He'd rigged it so that it hung over the center of the bed. She crawled onto the mattress, and he got in behind. They lit it together. The tent glowed. It seemed to be moving. It was the way the candles flickered, the light they cast on the fabric. She untied his pajamas. They rolled, him on top, then her, then him, a festival of it, backward, frontward, sideways, giggling like kids, with the bedsprings squeaking and the lamp waving; in the interludes, one of their hands or legs would reach up and steady the candelabra to keep the flames from the fabric. Sometime afterward, she padded to the kitchen for a glass of water. It was dark. They had long since missed their dinner reservation. She sat naked on a chair, Philip still warm inside her, feeling like they had a life stretching out before them.

The official wedding was more an excuse for a party, a nostalgic toast to Ma and Max, who would have insisted, were they alive. They met outside City Hall, under the arched entryway, the late-summer sun hot on the asphalt. There was a hot dog vendor in a corduroy cap who wheeled his cart after Maya, insisting on giving her a free Coke. It had taken awhile to find the room. They'd clacked up and down marble-floored halls, happily bickering. City Hall was so big. When they found the room, the benches were full. There were so many people, a flock of Puerto Ricans in

pink taffeta, a tweedy white couple in their late seventies, a young soldier in full dress uniform with his skinny, freckled bride-to-be, all sorts, rich, poor, black, white, united only in the desire to get married and to do it quickly, efficiently, for forty dollars a pop. Clyde Bandersnatch was supposed to have been Philip's witness, but he got caught up in a traffic jam and didn't get there until the reception. Maya covered for him.

She and Philip had reached a gruff sort of understanding. "As long as I don't have to pretend that I like him," Maya would say. She called him "The Drag." *What's The Drag up to?* Philip called her either "The Floozy" or "La Grande Flu." They didn't say these things to each other's faces. They greeted one another with resigned smiles. Overall, Sarah couldn't complain. She kept them apart and everyone agreed that this was the best way to do it.

They behaved at the wedding. And at the reception afterward—held in a Chinese restaurant under the Manhattan Bridge—Maya and her date, a famous Spanish guitarist, did a flamenco-inspired number that people talked about for years afterward. Then she toasted Philip, welcomed him as a brother, and Philip toasted her back. "Thank you for sharing your sister." Sarah had never heard those words spoken out loud, and for a moment she couldn't breathe. That's what the wedding had meant to Sarah—not so much a new thing between Philip and herself as a new thing between Philip and Maya.

Maybe what happened later was, as Maya claimed, a fluke, a misjudgment. More likely it was a relapse. Oh, who knew? How did her glass get empty so soon? A film of red wine clung to the cup like diluted blood, reminding her of the streaks of it clinging to the porcelain bathtub. That horrid shower after Philip got back from the hospital.

Chapter 12

New York City, Winter 1989

A high-ceilinged Soho gallery, iron columns painted white, the floor messy with bubble wrap and scraps of masking tape and brown paper. Earlier in the evening, the place was crowded with artists and assistants tape-measuring, tapping nails, nudging corners. Now the art has been hung and the crowd has relocated to a nearby bar where Sarah plans to take Philip, if he ever shows up. She sits on an aluminum ladder, watching Eddie Kiebbler examine her work. He wears overalls and horn-rimmed glasses, and his freshly famous face, befuddled and bearish, breaks into a goofy grin. "These rock! They're painterly, baby, really cool!"

They are her love maps, personalized per respondent: Where have you done it in New York? Here, here, and here. Red dots for unions, greens for breakups. They are modeled on the New York City subway map, partly because she loves the map's geographical incorrectness, a blatant fiction that everyone uses to orient themselves, partly because of the colors and curves of the subway lines, their swerviness. She thinks of them as electric currents, connecting everyone in the city.

Eddie noses up to the Danish au pair's map. "Look at

this big red dot. Over the water? Did she do it on the Kosciuszko Bridge?"

"In a Honda hatchback, in a traffic jam."

"No way."

"It is not for me to question. I simply transcribe."

The next map is Eric Peterson's, Bambi's younger brother, dying of AIDS. A great swath of reds up and down the West Side, barely a green in there. Why break up? Why not leave it open? She is proud of that map, not for her artistry, but proud of Eric, for doing it. She had been nervous on the way to his hospital room, wondering what he would think of her, traipsing around collecting fucks and breakups as if it were all a great joke. But he applauded as she entered, his IV tube glimmering. The room was crowded with people and their stuff—cassette decks, cards, plants, an enormous stuffed rabbit. Bambi sat on a pile of coats, her hair bunched into a messy topknot, eating a piece of chocolate cake. His boyfriend was sprawled in the armchair, snoozing, and there were more friends of theirs, shoulder to shoulder on the window ledge, kicking their legs in time to a Prince song. Everyone was rumpled. They'd been camping in that room for days.

"Turn off the music," Eric ordered. "I can't think straight. Sarah, so good to see you! Should I think straight? No. Keep the music on. Who wants to think straight?" He laid back on his pillow, exhausted from his speech. Bambi took the list from her back pocket, and everyone watched Sarah read it. It was clearly a group production, the addresses and dates done in different pens and pencils. They'd been working on it for a couple of days, and they all seemed pleased by its depth and scope, even Eric's boyfriend.

"He wants his map buried with him," Bambi said. "Is that okay?"

"Of course," said Sarah. Eric smiled. She tried not to stare at his body, almost unrecognizable. She focused on his face, his eyes still bright, looking at her, at that moment, with a kindness that she had not remembered when he was healthy.

His is the only map not for sale. Eddie Kiebbler glances at it, then moves on to the next. Sarah closes her eyes and listens to her own breath, the pipes banging, the intern stuffing trash into a bag. There is a tapping on the window. Gus, in a fur cap with earflaps, his breath white in the cold, gestures at his watch. Everyone's waiting at the bar. But she can't leave the gallery. Philip is supposed to meet her here. The intern sweeps up the packing debris, increasingly grumpy.

Finally she clears her throat. "I'm locking up." They wait on the sidewalk out front, smoking in the February damp. Eddie bounces beside her, warming himself, chiding her for worrying. Brice is always late. But it's not like Philip. He ought to have come by nine thirty. It's now past ten.

"He just built a museum, for Christ's sake. He can have an extra glass of wine."

Sarah thinks of the Haupt House more as a folly, the vanity project of an aging bazillionaire, but it is an impressive folly, thanks to Philip. Half nineteenth-century town house that has been reelectrified, replumbed, retiled, refloored, rewalled, reconfigured, reroofed, and half Philip's own glass-domed creation. Haupt, Emile Haupt, the collector behind the thing, had practically swung her in the air, he was so pleased with it. "Your husband's a genius! A genius!" Speaking in emphatic doubles. "Top rate! Top rate!" He'd given Philip plenty of artistic rein, but hadn't expected much on the aesthetic front. He'd hired him for his security smarts.

A taxi appears at the end of the block, the light on its roof fuzzy in the wet air. It slows as it nears them. Samuel

Fischbaum, Philip's droopy-eyed lawyer, unrolls the back window. His skin sags pale and wrinkled. There was an attempted burglary at the Haupt House. Philip's at the hospital. That's where she would like it to stop: Samuel Fischbaum's face, lit by a streetlamp, the pit in her stomach, the simplicity of that.

In the cab, Samuel tells her that Philip will be fine, but the thief is in bad shape. Philip had apparently stabbed him. Static-plagued cheering comes from the radio, some game the cabbie is listening to. An excitable announcer shouts words that Sarah can't decipher. The taxi cruises up Lafayette, past the cube at Astor Place. Kids in leather and spikes sit on the curb, shivering and bored.

A couple of years before, she and Philip, walking back from a dinner, had come across a fight in Riverside Park. Teenagers yelling and throttling one another, the kind of thing anyone would want to avoid, but Philip had known those kids. He had played basketball with them. He had shouted angrily, his tone more of a bark, startling her. She had never heard him sound like that. The mass of boys disbanded, all except the two at the center. Philip put hands on their shoulders and pulled them apart. He stood between them, calm and stern in the midst of all that heat. The fighters looked at the ground, panting, their expressions sullen and disoriented. She had hardly been able to believe it: her Philip, like some mythic Wild West sheriff, establishing order merely by standing there.

How could he have stabbed a man?

But then she sees Maya, tripping down the vaulted halls of New York Presbyterian, her face flushed, engulfed in a suspicious urgency. A stout, older man guides her, murmuring gravely, his white hair bright under the fluorescents, the

veins on his cheeks spidery and red. Sarah only recognizes him as Emile Haupt when they are almost upon her. This is partly due to his mood—she's only met him once, when he'd been jolly and ebullient: "Your husband's a genius! A genius!" But also because of the way that Maya leans upon him, as if they are intimates. Maya has never given any indication that she knew him, and what the hell is she doing there, anyway?

Sarah retracts from her hug. A mute appeal, a warning in Maya's eyes. Sarah looks past her, at the closed door to the hospital chapel and the brass names of donors lining the wall. Where is Philip? Samuel holds her back. Voices rise and fall. Samuel's calm, methodical questions. Haupt and Maya's excitable replies.

The story they give: Thomas Price, a prominent architectural critic, wanted to see Haupt's office, and so Philip took him there, along with Maya and Haupt. The exhibition rooms were gorgeous, but Haupt's office was the jewel in the crown. At first sight, it looked like any executive office: a mahogany desk and a wall full of windows. But there was handsome paneling everywhere, and if you flicked subtle switches, the walls would slide back to reveal a glowing, thrumming collection of video monitors and computer screens as well as old-fashioned safes and papers. An expert from the British Museum had gathered together any information that Haupt could want about the building, his personnel, and his collection, and codified it all in this multimedia brain, sleekly hidden away. The entryway, not quite up to code, but somehow finagled, continued in this hidden vein. There was no door. One simply touched a fingerprint sensor on an unremarkable corridor wall, and the wall slid away. But tonight when Philip touched the sensor and the wall slid away, instead of an empty, elegant office, the

critic, Maya, and Haupt discovered a compact man in black, standing by an open panel, blueprints in hand.

"Your husband's reflexes were okay. I'll give him that." Haupt's eyes are blue and cold. "He would have made an all right security guard. As an architect, he sucks. That fingerprint sensor cost as much as a house. Who the hell does he think I am?"

Someone else, someone perhaps more useful to Philip, would soothe Haupt. All Sarah can do is stop herself from sneering at him. She tugs at Samuel's sleeve. "Please, I need to see Philip."

They wander through the halls. At his room, a policeman makes them wait in the corridor. Philip is being questioned. The detective finally comes out; somewhere in middle age, with pale gray eyes behind thick glasses, his complexion suggests he's been up for the past twenty-four hours. He unwraps a stick of gum and thoughtfully, or exhaustedly, folds it into his mouth. He offers Sarah a stick. Not wanting to offend, she takes it and enters Philip's room with the strange taste of Doublemint on her tongue. Philip lies on the bed, facing the ceiling, swollen and discolored and unsettlingly expressionless. She spits the gum into a piece of paper.

"Philip?" She is aware of her footsteps, his absence. "Philip? Philip, baby." A flicker. There he is. "They're going to let you go home, if you can get yourself out of this bed."

He tries to smile. "Hi, Sar."

She squeezes his hand. He winces. People in various uniforms file in and out of the room, bearing clipboards, questions, a polite request from the police for Philip to stay in the city until things get sorted out.

"Of course, of course," says Samuel, nodding in reasonable agreement.

Maya knocks discreetly on the door, bearing coffee for Sarah and fresh clothes for Philip. "Don't say they came from me," she says, lingering in the hallway. "He won't want to wear them." Which is true, so Sarah doesn't.

Later, as they are finally getting ready to leave, and Sarah is helping Philip into the stiff new jeans, she worries that the clothes might be another one of Maya's tricks. But they have just been bought, the receipt is there in the bag. What could she have possibly done, except mutter some curse, and hasn't she cursed him enough? Samuel escorts her and Philip out of the building.

It is day, past noon already, and Sarah is so glad to be out of the hospital that she finds herself swinging her bag, a plastic bag, given to her by a hospital attendant, which is stuffed with Philip's bloody suit. She stops, then with a pang remembers swinging the bag with Conningsby's ashes those many years ago on the streets of Tulapek. Samuel helps them into a waiting cab. There is grungy blue upholstery, and on the floor, a portable pack of Kleenex someone has left behind. "How handy," says Sarah, trying to cheer Philip, but he doesn't hear.

"Will he be all right?" Philip asks, once the cab has left the curb and Samuel is far behind. She wishes he would look at her. Instead he gazes at the back of the cabbie's head, an oily bald spot, rung around with dark, still-supple hair.

"I don't know. They said he was in critical condition."

Philip turns toward his window. "Fucker."

She wonders which fucker he's referring to, but thinks it better not to ask. They drive around Columbus Circle, the pigeons perched on the statue.

"I am sorry I missed your hanging," says Philip. "How did it go?"

"Oh. Fine. It doesn't really matter."

"Yes it does. I'd like to take a shower and rest and then I'd like to go see it."

She smooths his hair. There are dried hard bits in it. Blood.

She gets into the shower with him and scrubs him with a washcloth. He moans at the pain. He has bruises everywhere—on his face, arms, chest, legs, and particularly his neck. There is blood under his fingernails, in the hairs of his chest, in his eyelashes. There are teeth marks on his shoulder. "They just went at it," Maya had said softly. Her voice had betrayed a certain wonder. It was the first time, to Sarah's knowledge, that Maya had been impressed by Philip. The water runs pink down the drain. She throws the washcloth away.

He sleeps, thanks to a strong dose of painkillers. He sleeps curled up into her. The setting sun comes in through the windows, shining down on him, on the white sheets, on the grays in his hair. She lies beside him, propped up on pillows. She can't read; she can't concentrate on anything. She listens to him breathe. Around them are the books on the shelves, the Indian chest with the blankets inside, the figure fashioned from matchsticks glued together, a funny little man Philip had made as they were playing Scrabble. A siren wails outside; Philip sleeps through it. He wakes later, confused. Why is he in bed? He tries to move and groans.

"It's going to be all right," she says.

It's dark. She's making dinner. The phone rings. It is Samuel. The thief is dead. His name was Francisco Luis McCarton.

"No," Philip says. It's the most forlorn sound she has ever heard.

He is hunched over, his face hidden. She touches him carefully on the back. His spine quivers. He jabs at the door. He wants her to leave; she refuses. He gasps for air. He is crying, gulping down air, biting off the sounds. It comes as a shock. She has never seen him cry.

"Get out of here!" he hisses.

As soon as she is gone, his sobs break free. She sinks down on the other side of the door, clutching her knees, listening.

She had known it had to be Franco. The moment she saw Maya, she knew, but she had hoped she was wrong. But of course. That's why Maya had been so interested in the plans for Haupt's office, its impermeability, the details of the fingerprint sensor. Sarah had gone on and on, answering all her questions, bragging. She had thought that Maya was finally giving Philip his due. She'd even shown her the blueprints.

She splashes her face at the sink. Her reflection gazes back, pink watery eyes, frizzy hair, skin the color of an old rag. She only met Franco that one time, but she had recalled him over the years. People rarely caused that kind of stir in her, that sense of recognition for someone who you do not know. She had thought that Philip had sensed this, that he was jealous, that that was the reason for the sudden shift in mood. But later, when she'd asked about it, he said no, all kinds of people felt that way about Franco. He was magnetic. You could hardly get mad about it. He'd just been pissed at Maya for gloating so.

She dries her face. She leans her forehead against the bedroom door. He is quieter now. She opens it a crack. He is sitting on the floor, wrapped up in a blanket.

"Why did she do this?" he asks, his voice cracking.

"I don't know."

"Please call Detective Domingo."

"Why?"

"He doesn't know that we knew each other. He doesn't know that Maya engineered this whole thing. He doesn't know that she kicked me the fucking knife."

"He *does* know that she kicked you the knife. It wasn't a knife, actually. It was a dagger from Haupt's collection. It had been left in his office. He'd been thinking about using it for a letter opener. Maya and Haupt told him. They said that Franco was strangling you. Wasn't he?"

"I want to talk to the police."

"Why don't you talk to Samuel first?"

She pours Philip a big glass of Scotch and one almost as big for herself. They sit at the kitchen table, a table that Gus made them, a thick slab of wood salvaged from a barn, sturdy knobbed legs, steel fittings taken from a ship. There's a sofa in the living room that looks out on a lovely view of the Hudson, but this is where they always sit. Other nights they read the paper or do the crossword or plan dinner parties. But tonight they wait for Samuel. Philip sips Scotch, his head swollen, his anger gone for the moment. "Franco taught me how to play basketball. There was a court an hour's drive from Conningsby's. It was behind a little school with sagebrush all around. We'd drive out there, listening to Jimi Hendrix on the eight-track. He must have stolen that car." A tiny smile breaks into his face. "It was a nice car."

"Why did you hate him so much?"

Philip looks at her, as if surprised to find her there. His eyes are bright amidst the mess of his face. "I didn't."

Chapter 13

She held the canvas to one edge of the table and stretched it by hand. The table wobbled under the pressure. It was a cheap thing with dented aluminum legs and a plastic top, some fifties-era substance that was once shiny and optimistic but was now old, dull, cracked. She stopped stretching. The crease was still there. She'd live with it. She drew a picture of Philip. A crude picture, dull lead on untreated canvas, yet there were his eyes, flickering. It took a month for the bruises to go away. When his face returned it was a narrower, more asymmetrical face than the one it had been. Perhaps it would have been better if he had gone to the precinct and started blabbing to the first police officer he met. He had so disapproved of lying, and to be bound up in the same one as Maya?

On one of those trips to Texas, Tori had shown her a snapshot: Philip's hair sun-bleached and shaggy, Franco leaning into him, a crinkly smile aimed at the camera. Sarah had pored over it, fascinated by this vision of Philip, his shirt not all the way buttoned, his eyes shining happily, both him and Franco gorgeous in that way of young men. Philip had been in grad school. He'd visited Conningsby as part of a larger trip. He was on his way to New Mexico to see an

architectural commune inspired by the geodesic dome.

Franco, according to Tori, was one of Conningsby's projects. A young man with no family, back from the war, in need of a job. Conningsby gave him a shack on his ranch and some mechanical work. The very first day that Philip was there, Franco offered him peyote, and Philip said yes. When Philip had told her that, Sarah hadn't been able to believe it. Her Philip? But he hadn't been hers yet. He had been twenty-six, in awe of Franco, who had defused bombs, who had dealt drugs, who treated Conningsby with a nonchalance that Philip couldn't muster. They found the basketball court behind a one-story whitewashed school. Philip had played basketball, of course. Kids in Indiana play basketball, but he'd never played well, never liked it until Franco took the time to counsel him. The way he told it, Franco changed his fundamental understanding of the game. The two of them would practice for hours in the desert sun. One day, when the temperature stupefied them, they found a shaded trail by the court. It took them to some canyons where they scrambled up old footholds into a cave. There they sat and talked and talked, words pouring out of them, until it was dark and they had no light and stumbled and groped their way home.

Philip had not known why Franco bothered with him, he felt like an innocent beside him. Then one day they had wrestled by the lip of an old mine, and Franco had kissed him. A sweet kiss. That was the word Philip had used, more than twenty years after, still shaking his head in wonder. A sweet, simple kiss from an unsweet man. Philip had shoved him off. But he couldn't get that kiss out of his mind. He had planned on telling Conningsby that he needed to go to New Mexico a little earlier, but he stuck around day after day,

unable to let it go. Finally, he touched Franco's belt loop and suggested they return to the basketball court.

He waited under the hoop for a long time, appalled at himself. He did not know what he intended to do, but he knew he had invited a possibility into his life that he had never imagined, and he was terrified. Franco finally drove up in his white sedan with the eight-track blaring. There was a girl beside him. She stuck her head out the window and waved. She had a tube top with huge tits spilling out. Fine, Philip thought. Franco had taken him at his word. They would play basketball, the girl would watch Franco cream him. Franco didn't get out of the car though. Philip walked over. Franco sprawled behind the driver's wheel, smiling, and with his eyes still on Philip he reached over and squeezed the girl's crotch. "Come on," she giggled. "Let's party." Philip had mimicked the girl's voice in a way that made Sarah's skin crawl. He left that very night, without even saying goodbye to Conningsby.

Franco must have felt it too, whatever it was that bound them. How else to explain the madness of him agreeing to do what he did? Even if everything had gone according to plan, and the only people who discovered him were Maya and Philip, could he have possibly thought Philip would simply chuckle—*Dang, old fellow, well done*—and they'd all shake hands? Was it pure cockiness? Did he think he could stop him with a smile? He had struck her as intelligent that night at Temple's. Perhaps he'd had a plan of his own, one he simply could not execute. He had not—could not—have known the fullness of what he was getting into.

So many times she had imagined Philip straddling him, the metal gripped, and that pause, that terrible pause when Philip could have stopped. Instead, he had looked at Maya.

He had insisted, when Samuel came over, that it was wrong to call it self-defense. It was enraged manslaughter and he did not want to lie about it. Samuel had listened patiently, not outright arguing, only commenting on the slipperiness of memory and the welter of emotions that can spring up and muddle the best of judgments. Philip kept returning to Maya's eyes, how they had glittered. His tone was uneven, edged with fury, as if he were blaming her not just for kicking the knife but for his own muscular action. Sarah sat at the table, drinking in Samuel's calm reason, and yet, even as she did so, she had a vision of Maya's eyes—enormous, honey-colored, urgent—her breasts white and heaving. She could see the two of them staring at each other, the knife going down as if directed by their mutual hatred.

How the hell was she supposed to explain this to Max?

There hadn't been a trial. Philip had been a good husband and a good businessman and did what Samuel told him to do. Sarah did not know what he said or did not say, but he must have lied. Wouldn't they have asked, as a purely procedural matter, whether he knew the perpetrator? If they had discovered that he or Maya knew Franco, certainly there would have been more of an inquiry. But it was 1989. Stray bullets were flying into kitchen windows, kids were collapsing in their Cheerios. Poor Detective Domingo was exhausted and in need of a rest. Why bother with the death of a known burglar, whose consulting business was proved to be a sham, who was suspected of numerous high-end burglaries and safecracking, who had no friends willing to come to his defense, who had, according to three eyewitnesses, clearly been the aggressor? It was the highest murder year on record, and the detective's daughter had just

dropped out of school and was threatening to hitchhike cross-country to find her mom.

The day the case was dropped, Philip locked himself in his home office and sharpened pencils in the electric sharpener. *Zzzzzzpppppp, zzzzzzzzzpppppppp, zzzzzzzzzpppppppp.* For hours. He came out past dark, holding a wastebasket filled with pink eraser tips and metallic bindings, which he neatly dumped in the middle of the kitchen floor. She'd wanted to hurl them back at him, so pissed she was by that point. Skin contact repulsed him. He would jump even when she just casually brushed past him, shudder if she tried to draw him into anything intimate. It was awful. Night after night, to lie next to a man who shudders at your touch. It wasn't so bad in the beginning, given the obvious physical hurt he'd suffered, but later, when his bruises faded, when she could see his body as it had been . . .

They had, before it happened, been trying to have a child. He had been so eager, drawing up charts about how they could split child care, proving that she'd still have enough time to paint. She had taken out her IUD. For his Christmas present. Almost impossible to believe, the pleasure of returning home from her studio, dreaming up new variations on old things, their warm bed, his mulchy smell, the way he held her. All that, poof. And yet not altogether poof—perhaps that was the worst part. Once he had braved the outside world to buy her a tin of tea from a little coffee-tea-spice shop they used to go to when she still had her apartment in the Village. Indian tea leaves in a tin decorated with a tasseled elephant. "Elephants always remember," he'd said.

"Remember what?"

He'd looked as if she ought to know. "Better times."

He'd boiled the water, stuffed the leaves in the tea ball, told her that the man behind the counter was still smoking cigarillos, that his apron was still smudged, that there was a cat still asleep in the corner. "Was the old one white and gray?"

Sarah couldn't remember. "All cats are gray in the dark," she said.

He smiled. She got a painful lurch in her chest and looked out the window. Rain fell on the fire escape. He came over and they drank the tea and listened to the fat drops falling on windowsills and windowpanes and, down below, the swish of tires on wet pavement. Then he spoke. He said that he knew how difficult he was to live with. He wanted to apologize. He didn't touch her, but he stood close, agitating the air. She said that she understood, that it was fine. It was patent bullshit. What had gotten into her? Time had broken, and Philip had stood there, talking to her, seeing her—but she'd gotten so used to being seen *through*. She didn't grasp it until it was too late. He raised a wavering hand and put it on her shoulder. She clung on to that afterward, the weight of his hand, the place that it had lain on her skin and bone. She could still feel its ghostly presence, so relentlessly she'd clung.

The 7-Eleven sign glowed through the trees. The woman behind the counter, a water balloon of a lady with thin hair and a blotted complexion, glanced up from a tabloid and nodded in recognition. Sarah hesitated. "I'll get these," she said, picking a roll of peppermint Life Savers. "And a pack of Winstons too."

The woman pursed her lips. "I thought you quit."

"What?"

"You told me last time not to sell you cigarettes without giving you shit."

"That was two years ago."

"I'm a mother. Mothers always remember."

"That's elephants. Elephants always remember!" She was shouting.

The woman tut-tutted then handed her the pack. "Don't ask for what you don't want."

She smoked the first cigarette in the parking lot. Just stood there, rooted to the ground, inhaling, coughing. What did she want? She wanted to punch him in the nose. No one, before or after, was ever so good to share a bed with. Fucker. She coughed up some phlegm and spat it out, then headed home, the streetlights few and far between.

Chapter 14

New York City, 1989

The phone rings. Sarah inhales, exhales, watches the smoke fork. *Buh-ring. Buh-ring.* What are you *buh-ringing* me? Greenpeace? Samuel? Eddie Kiebbler? It won't be Philip, wondering where she is, dark already and no word. He'll be relieved to be alone. *Buh-ring.* She lets it ring. The phone stops. It starts again.

"Hello?"

"Can I come over?" Maya asks.

"Now?"

"Yeah."

"Where are you?"

"Downtown. Five minutes away."

Even less. Sarah is smoking the same cigarette when the buzzer rings. Maya waits on the sidewalk, her hands in her pockets. She's wearing a gray suit with a white buttoned shirt underneath, very tailored and British. She spends most of her time in London these days. They face each other, not hugging or kissing, just standing there. They haven't seen each other in months, taking advantage of their different cities. But they have to, eventually.

Maya squeezes Sarah's shoulder. "You look exhausted," she says.

"I am."

"Are you on a good painting jag?"

"Nope. Just escaping the apartment. You want to come up? Have some coffee with no milk?"

"No," says Maya. "I want to take you out to dinner."

They walk. They find themselves in Chinatown. The density of the place bears down on them, the packed sidewalks, the awnings dripping backpacks, T-shirts, pseudo silk pajamas, the peddlers wheeling carts of asparagus, coconuts, grapes, the vendors squatting over blankets of windup dolls and fake jade fountains. Cars honk and drivers curse and fish flop on their beds of ice, and it's strangely restful. They duck into a Vietnamese place that Sarah likes, fake wood tables, plastic banana trees, and an Asian clientele that pays little attention to them.

Maya frowns at her menu. "Where have you taken me? No champagne. I want to celebrate your sales. You didn't tell me how well you did at that show."

"A beer will do me fine."

The waiter arrives, a Vietnamese kid with a big Adam's apple and skinny, nervous fingers. "Oh god," Maya says. "What are we getting? How can one keep making these decisions? I've found a place in London that doesn't have a menu. They prepare a delicious meal every day and you just take what they got. It's marvelous."

"Two mint shrimp salads and Saigon beer," says Sarah.

The waiter bows and leaves. "Do me a favor," Maya calls after him. "Make sure the beer's extra cold, and put it in champagne glasses if you can find any."

"He doesn't understand a word you're saying," Sarah whispers. But he returns carrying the beer on a tray with two wineglasses and makes a show of pouring it.

"Very good," says Maya. "Come have a beer with us when you finish your shift."

He blushes. Maya laughs.

"You're right," she says to Sarah when he leaves. "This is a good place, in spite of all this—" She waves around at the menus and plastic trees. "Now, here's to you—or rather, your love maps."

"Thanks."

"Why didn't you tell me you were the only one who sold anything at the show?"

"That's not true. Other people sold stuff, Kiebbler's pump went to some museum out in Texas."

"Yeah, but you sold everything."

"Almost everything." Not Eric's map, which had been taken down early, rolled up with a bow, and placed in his coffin.

"BB is furious. I mean, he's pretending to be the great man of art but he's seething." Maya laughs. "Oh god, sweetheart. And you're getting a solo at the Galley!"

"I don't know if the Galley's really going to happen. It's a possibility."

"You don't look as pleased as you should."

"Do you even have a clue what Philip's going through?"

"Forget Philip." Maya looks annoyed with her for bringing him up. "I don't want to think about him. You can't blame me for all his shit. Excuse me. I know you have to think about him. I don't know how you do it, personally. What are you grinning at?"

"Nothing." She doesn't understand how Maya can go on as if nothing has happened, but at this moment she's grateful for it. "You are right. I don't have to think about him, not right now." It's a wonderful release.

Maya pours the rest of her beer into her cup. "When do you find out about the Galley?"

Sarah rubs her neck. "A couple months."

"You picked that up from Philip."

"What?"

"That neck rub. Don't be nervous. You'll get it."

"Well, if it happens, I don't know what I'm going to do. I haven't been able to paint."

"Sweetheart, you've got a studio filled to the gills. You've got enough for five or six shows."

"It's all old."

"Old—don't tell me about old." Maya makes a face. "I'm thinking of cutting my hair. What do you think? A man's cut. I'll scare the hell out of them at board meetings."

The waiter returns, arranging plates piled high with chili-flecked bean sprouts and leafy stems of mint.

Maya squeezes lemon on her salad and takes a bite. "Oh! This is good. I love mint."

"Do you remember that stream with the mint growing—"

"Yes! Near Roncesvalles, I think."

"Where they stoned Charlemagne's army."

"Oh god, that was a cold stream. My feet were ice. What a good day. Can you find water that clear anymore? I remember looking down and seeing your white toes and the round speckled pebbles."

"Maya! Since when are you getting nostalgic?"

"Since I looked in the mirror. Did you read that review?"

"It said you were a legend."

"It said I was a historical reenactment. It's that Henrietta Porchetta whatever-her-name-is, overrated. Ah, what the hell. They still like me in Biarritz."

"You're still top of the heap—the reviewer said as much."

"She's afraid to cross me." Maya pushes away her plate, her salad half-eaten. "It becomes a bore," she says, "keeping people in line. And for a hobby too. It's pathetic, at my age."

"Maya?"

"What?"

"Henrietta's nothing, a blip, a pimple on a porcupine."

Outside, it is finally cool, with the taxi lights glowing in the humid air. They walk through sour-smelling alleys to the wide, oil-puddled avenues by the Hudson piers, then north to the Meatpacking District. The trucks rumble by, and the streetwalkers swish their hips and check their watches. They don't say much, enjoying the silence, the beer in their bellies. Sarah, not eager to return to her and Philip's deadly apartment, would like to walk all night, like back in art school, walking, ducking into delis for candy bars, resting on stoops when her feet get tired, getting up and wandering again until the sun rises. But stoops don't look as welcoming at forty.

She and Maya find a bar with a sign flickering in the window, and inside a bunch of faded and aging gay men who don't seem to have left the place for the past twenty years. They shift on tarnished barstools, their expressions neither welcoming nor sneering, but droopy-jowled and boozy-eyed. The air is stale and hotter than outdoors, but Sarah and Maya are inside now and don't feel like backing out. They sit. Sarah bums a cigarette from her neighbor, a Latino guy in a stained white shirt with penciled-in eyebrows. She thanks him as he lights it for her. "De nada, precious." Out of the blackness at the far end of the bar, the bartender appears, out of place and with a bounce in his step, a young blond boy in a sleeveless T-shirt that shows off his muscles.

"Heh-lo!" he says in Scandinavian sing-song. "What can I get you?"

"Two whiskey sours," says Maya.

"I give you extra cherries, just for being here." He prepares their drinks and places them on the bar with a flourish.

"So," says Maya, raising her glass to him, "are you a bartender-bartender or an actor-bartender?"

"A performance-artist bartender. I'm having my first show in September."

"A pity. I won't be here."

"Where will you be?"

"In Biarritz, doing my last show."

Sarah laughs. "How many last shows have you had?"

"This one will be it."

"Ah. A singer. According to Mr. Mariachi," he nods at the pencil-eyebrow man next to Sarah, "that is the highest art." The bartender pours them another round, then a shot for himself. "On the house. I like that phrase. It makes me feel like I'm on the roof." They clink glasses. "Why don't you sing a song for us?"

"Here?"

"We have a piano." He tosses his head toward a dark corner of the bar.

Maya sucks at her cherry.

"Do," says Sarah.

The bartender takes them to the back of the bar, and the stench of disinfectant and cheap booze gets stronger. Sarah makes out shadows of men slouched in booths and the waxy glimmer of beer pitchers. Maya stands by the piano, fingers laced together. The Swede sits at the piano bench and experiments with a chord.

"When in hell's that thing been tuned?" shouts one of the men.

"It's a blues piano, Frank."

The men in the booths laugh and grumble until Maya's first note breaks forth. Then the men lean out of the booths, cigarettes hanging forgotten from lips. She holds her arms out to them and a few voices join hers, a derelict chorus that compliments her tunefulness. By the end, most are on their feet, swaying and singing. All of them applaud. Maya wipes her forehead, grinning. "You know Piaf?"

The bartender shakes his head. "Only Robeson."

"Ah, the frigging Swede," says Mr. Mariachi, slipping off his barstool.

"Emiliano!" the men shout.

Mr. Mariachi, or Emiliano, stumbles, catches himself, arrives at the piano in one piece. The bartender winks at Sarah and disappears into the darkness. Mr. Mariachi sits at the bench and adjusts his cuffs. "*Je ne regrette rien,*" Maya says.

"You got that right," he replies. He touches the keys. His style is sad and playful, just right for that piano. Maya slinks around the murk, casting devilish looks to anyone who can see her. The queens giggle and slap the tables and dish back what she's giving. *Non, rien de rien. Non, je ne regrette rien. Ni le mal, ni le bien.* Sarah smiles shamelessly.

The bartender gives out free pitchers of beer, and Maya and Emiliano sing a duet. He's got a surprisingly strong voice for such a spent-looking man.

Maya insists that he come to Biarritz with her. "Don't you agree?" she calls to Sarah.

"Yes!" Sarah shouts back.

"We'll all go to Biarritz!" says Maya, weaving toward

her. She grabs Sarah and they waltz around the comfortably blurry room.

Sarah laughs, amazed that she can be happy. They spin, narrowly avoiding tables and knees. Sarah could be twelve. They could be dancing to the radio in a cheap motel, so comfortable in each other's arms, their flesh the same temperature, as if it belongs to the same body.

Chapter 15

Connecticut, October 1997

The photo in the wedding announcement showed Maya and her architect leaning against a stone fence, she dressed in a simple black V-neck, he dark-haired and eagle-nosed, the two of them holding hands, their smiles not too bright, just marking a nice moment by a stone wall. She held the picture under the desk lamp and squinted, trying to get beneath Maya's expression, find something that hadn't been there before, a Max-like regret, an acknowledgment, something in the eyes, but it was newsprint, just black-and-white dots the closer you got. The younger Max coughed in his sleep. The whole upstairs reeked of tobacco. She opened a window, then fell back on the bed. The mattress was a mess, all the stuff she'd taken out of the drawer when she was searching for the wedding announcement. A pack of cards, a broken barrette too nice to throw away, the keys to the Riverside Drive apartment, a rusty bell from Philip's old Schwinn. He'd spent the best part of his boyhood on that Schwinn, bumping down dirt roads, past the cornfields to Conningsby's house, the sky big above him. She pressed the bell to her mouth, tasted the rust on her tongue.

They had found the bell in his parents' garage on their

one trip to Terre Haute together. She could not recall a single conversation with his parents, just the sinking feeling of trying to tell them a story. They'd sat side by side, their clothes pressed, their faces impassive. What would they say if they found out they'd had a grandson all these years? *Not well to judge* probably, something like that, their lips straight and thin, their eyes so guarded you had no idea what they were thinking. *She must have had her reasons.* They would give Max checkerboards, sports jerseys, pay for a month of summer camp. They would forgive her. It would be unchristian not to. Max could visit them, screw the Christmas tree together, help them hang ornaments. It wouldn't be so awful. He needed more old people in his life. She went downstairs, scowled at the dishwasher, the faint smell of burned fish, and poured herself another glass of wine. There were no trains, the last had screeched by an hour ago. There were no telephone calls. She checked the ringer. It was on. Of course it was. It had rung when Carlos called. She listened to the dial tone, sniffing her knuckles, the sour tang of tobacco. She dialed.

"Tori?"

"Sarah—is that you? Is something wrong?"

"Oh god. It's late. I'm sorry," said Sarah.

"I don't get to have too many nocturnal conversations these days." A dry husk of a laugh, but good-humored. Sarah could hear her laboring to pull herself up and settle against a pillow.

"Philip's coming here tomorrow. Or he might be."

"Is that so? I'm glad to hear you two patched things up. Conningsby always did like that young man."

"We didn't patch things up. I don't even know if he'll show."

"Well, you should, no reason not to. I hope it rains. You should see my squashes."

"I think he found out about Max."

"You didn't tell him about Max? How in the world could he not know about Max?"

"Not my father, my son."

"Ah," said Tori. "Well, that's all right."

"But Tori . . ." Sarah caught her breath, suddenly battling away tears.

"What's wrong, honey bee?"

Sobs overtook her, unchecked phlegmy sobs that convulsed her whole body. She started laughing in the middle of it. "I wanted him to come back for me."

"Well of course you did," Tori said kindly, making Sarah wish she could crawl into that telephone and put her head on Tori's bony lap.

She inhaled, wiping her face. "I love you, Tori. How are you doing, anyway?"

"Well, you know. I'm ninety-seven. That hasn't changed." More of that dry laughter.

Sarah wished she could say something, but her throat was too tight.

"Don't you start crying again. You need to go to sleep. Make yourself some chamomile tea and get into bed."

Philip's balled-up letter, splotched with fish grease, lay atop the trash can. Sarah took the letter out and flattened it on the counter. *I've been thinking about the things you told me, or rather yelled at me, in that hole, and a hell of a lot of it was true.* She couldn't remember what she'd yelled to him underground. That part would have to get torn off before she shared it with Max.

She lifted the trash bag out of the container. If she couldn't

sleep, she might as well finish cleaning the kitchen. Outside was colder than before. It felt good, sobering. The trash bag was heavy and she held it with both hands. Around the side of the house she quietly lifted the lid of the garbage can, but it slipped from her hands and crashed upon the concrete, then wobbled on its circumference, clanging loudly. She cringed, but the lights in Mr. Walpole's bedroom did not flash on. No one yelled at her. All was silent save for the fading vibrations of the lid. The moon emerged from behind a cloud, and she saw the rake leaning against Mr. Walpole's garage.

It felt good, flexing her muscles, bracing herself against the wind. She should have done this sooner. She didn't need cigarettes or wine or godmothers; she needed good, strenuous, physical labor. Who needed sleep when you could rake? She was establishing order, making peace with her neighbors. The leaves piled up. Presumably. The moon had gone back behind a cloud, making it hard to see. Maybe she was just redistributing. She squatted and waved her hands across the ground. A shape, kind of mound-like, possibly baggable. Where were those bags? Down in the basement with the lost socks, ashtrays, and dusty art supplies. She blew on her hands, trying to warm them. She lay down. The earth, although hardened by frost, felt soft. Maybe she could freeze to death. Let Philip find her, if he came. Let him deal with the funeral.

Something rang. An alarm. No, couldn't be. She was outside. It was cold, dark; there was the moon again, and stars through black branches. She crouched, stood, sneezed. Her foot landed on something—rake tines. The rake pole swung up and smacked her in the face. Just like dodgeball. She had played dodgeball at school, her one taste of school. There had

been a caged-in lot, sticky-fingered children who grabbed her hands and made her stand still as the ball hurtled forward and smacked her in the face. She'd run, burning red, the kids howling behind her, to the school, to the stairwell, which was caged too. The whole building had been caged. The stairs had iron-mesh walls on either side, and were bisected by an iron-mesh divider that separated those going up from those going down, and even an iron-mesh roof. Up those stairs, clinging to the banister, slightly limping; she had recently broken her leg, they had just removed the cast. Up and up, dull gray light coming through the wire mesh, her breathing and footsteps abnormally loud. It was strange being in the stairwell alone; it usually burst with kids. She stopped at a barred window. Outside, there were brown leaves on the trees, and an American flag sagged at half-mast. Somebody must have died. Her face still stung from the ball. Worse than the jeers and the pain was the private humiliation. School had been her idea; no one had talked her into it. She had conned and wheedled. She had broken her leg to get out of the tour. Please, Dad, no more classes in cafés, no more mornings drinking hot chocolate, no more *Metamorphoses*. Let me play dodgeball!

Wait. Something rang again. It was the telephone. The telephone! She ran across the dark lawn, feeling in her pajama pocket for the keys. She only found cigarettes—where were the keys? She tried her bathrobe. She patted again. She slapped. Nothing. She could ring the doorbell, wake Max. No. But he'd be awake anyway. The telephone would have woken him. What if he had answered it? Everything stopped: her feet, her hands, the pain in her face. The phone rang one more time, then silence. She collapsed against the front door, then tried the knob. It opened. It hadn't been

locked. It was dark upstairs. Max would have turned on the lights if he'd gotten up. She hugged herself, trying to stop trembling.

The radiator felt good. The steam coated the outside of her pajamas, then the inside, then her skin, then below the skin to that territory of marrow and vein and tissue, the meat and bones of her that she couldn't see but accepted on faith. She sneezed. She suddenly remembered the X-ray of her leg, her fall-from-the-statue break. She used to come across it when she cleaned up her desk, a big manila envelope with a blue-and-tan string wound around the clasp, containing black, glossy celluloid and spectrally glowing bones. She'd lost the envelope in the move. Someone might have picked it up, stashed it away, reopened it, and thought that the X-ray was theirs—their leg, their shattered bone. Why not? X-rays were impersonal: no pulse, vein, tissue, life. Even if you could see the life, you couldn't tell if it was yours or someone else's. She patted her forehead, sore from where the rake had hit her. She'd cry if her bone shattered, but would her bone cry for her? It wasn't fair. What was she doing? She was drunk. She pressed her palms into her eyes, then kept pressing, harder and harder. Flashes of light swirled with the blackness inside her lids.

She climbed the stairs, still cold except for the fronts of her legs which burned when they touched the steaming cotton of her pajamas. She'd definitely get a bruise, she could feel it spreading across her forehead. *Not my husband, just a rake.* She laughed, then clutched the banister. The stairs, the walls, the house—all were moving, swaying. An earthquake? No. Impossible. Not in Connecticut. She inhaled. The house settled. Aspirin, that's what she needed. She went to the bathroom, fumbled through the cabinet, found

the pills, swore at the childproof cap, finally got it open. She leaned against the sink. She was warmer now, not so dizzy. Maybe she could get some sleep. But she couldn't leave the bathroom. It was a dump, the ceiling scabby with peeling paint, the only thing decent about it the shower curtain. She'd splurged at MoMA, bought a fancy one decorated with deadpan Magritte men, all neat and clean with their overcoats and bowler hats: don't mind us, we're just dropping from the sky.

Chapter 16

He disappears into his study and reappears with the tin cup containing Conningsby's ashes. "I'm going."

"Where?"

"To Texas." He has on his trench coat with the plaid lining. He's gotten so thin, it droops from him like he's little more than a hanger. "I never scattered him. I never dealt with it."

"Philip, you should take a shower. You look exhausted. Take a shower and a nap and we'll talk about it afterward."

He walks toward her, or rather, toward the door behind her. He doesn't see her. He hasn't seen her for months, but this not-seeing is worse. A stronger degree of blindness—though perhaps it's the same degree, and it's just hitting her full throttle. He keeps walking toward the door, his face slack, his pace slow and intractable. She steps directly into his path. She imagines him passing right through her, dark matter undisturbed by her presence, reforming himself out on the street and then continuing, clutching his tin cup, stepping into the middle of Riverside Drive, the cabs screeching, the drivers cursing him. And on, over the George Washington Bridge, onto the shoulder of the New Jersey Turnpike, a small brittle figure growing paler and lighter

with every step until the tin cup becomes more substantial than the body holding it.

"Philip!"

He bumps into her.

"Stop."

He blinks.

"Take a shower and we'll talk about this after you've had a rest."

He takes a shower, but he won't lie down. She sits him at the kitchen table, makes him eat scrambled eggs and drink a glass of water.

They leave that night, in a car from the Avis on 72nd Street. He did not invite her, but she can't allow him to drive alone; his abilities are too iffy. And there's also the pull of Tori and the land. The more she thinks about it, the more eager she is to see that land.

A block from the garage, Philip barely misses banging into a taxi. Then he sideswipes a Broadway island. "That's enough," says Sarah. "I'm taking the wheel." She gets them out of the city, onto a miraculously uncrowded New Jersey Turnpike. In the dark, it looks like an interstellar landing pad, all blinking lights and bulbous tanks and orange flames shooting out of stacks. The back of the car is filled with food—stuff he likes, or used to—crisp, tart apples, Stilton cheese, sourdough bread from Zabar's. The first day, he doesn't touch a thing. The second day, she forces him.

"Eat." She slices the bread in her lap and hands him a piece.

"Can I have a napkin?" he says.

She gives him a paper napkin from a deli. He spreads it on his lap, tears the bread into small bits, puts a piece in his

mouth, and chews for about five minutes. She places a slab of Stilton onto his napkin. He looks at it.

"You need protein."

He crumbles the cheese and eats a morsel. Eighteen-wheelers whiz by. A fine drizzle fogs up the windshield. In thirty minutes, he eats half a piece of bread and an ounce of cheese. He won't touch the knife. She gets him to eat an apple by cutting it up herself, not into quarter wedges but into skinny little pieces about the size of a thumbnail.

The third day, it's dry and sunny and the flats and mounds and rises of scrubby West Texas surround them. Sarah turns off the interstate, onto the same two-lane that Max had driven when she was nine and had never met Tori and thought of her as the glamorous lady in the art deco poster. A flat, straight road with no one on it. Safe enough for Philip to drive; she cedes the wheel. The road stretches before them, the pavement bleached almost white, with black cracks and a weather-beaten median strip. When she was a kid, it was dirt. She'd kneeled in the backseat, looking out the rear window, the dust rolling up behind them, its yellow-ness against the blueness of the Cadillac, the chrome-tipped fins looking regal and somewhat mysterious. Max had loved that car. He'd bought it from a bookie in New Jersey, and Ma was always after him to get rid of it, convinced that it would bring them bad luck.

She stares out the window, tablelands of ocotillo, lechu-guilla, yucca, creosote, faded to a dusty green. The sky is not as vast as she remembers; it's whitish and limp. The heat gets into the car, negating the effects of the air con-ditioner. She peers out the window. A cow. A tarantula. A buzzard. She plays with the radio, but there are no stations.

"When are we going to get there?" she asks.

Philip smiles, acknowledging her.

They get there in the evening, the light deep and rich, the air twenty degrees cooler. Victoria emerges from the house, tiny-limbed, blue-jeaned, spry on her cane. Sarah is out of the car before Philip cuts the engine.

"Tori! You look great."

"I don't know about great," says Tori. She has shrunk, and her skin is bunched into wrinkles and so splattered with age spots you can barely discern its original color.

"Nice boots," Sarah says.

"Thank you." Tori glances down at a pair of freshly polished cowboy boots. "They're new. They want me in those awful white things, but I need boots, something to anchor me. I've gotten so damn skinny."

"You look great."

"You said that, dear."

Philip stoops over to kiss her.

"Philip Clark," she says. "Glad to see you. You remember me?"

"Of course."

"You don't look too different. A little more haggard." Tori cackles and slaps him on the back. "How about a gin and tonic?"

They sit on the porch, sipping their drinks, looking out on Tori's tangled tomato vines. She talks about the bugs that have gotten into them, and how she can't get rid of them. Philip asks her questions about pesticides, fertilizers, irrigation.

"You going to take up gardening?" Sarah asks.

"Maybe." Philip smiles. A smile that doesn't seem forced. Sarah rests her drink on her belly and gazes at the

foothills. The land smells good in the evening, turpentine-y from the creosote.

That night in bed, she reaches for his hand under the covers. His fingers curl through hers, stronger and warmer, getting back to the right temperature. He disentangles his hand and cups her ass. "It's good we came," he murmurs.

We.

"Yes." He hasn't touched her like this since February. She had forgotten what it felt like. She had become almost as much of a shell as he.

He's asleep now, snoring. She props herself up against the pillows. Beyond the window the moon is almost full and the pale sand glimmers. On the sill is the tin cup with Conningsby's ashes. It looks better in the dark, silhouetted, so you see only the shape and not the material. She gets out of bed, pads over to the window, and fingers the cool, smooth surface of the jar. She picks it up. It feels light, too light. She becomes uneasy, imagining the ashes sucked away, leaked, or stolen. She glances at the bed. Philip's breathing remains steady. She unscrews the top. It's too dark to see anything inside. She dips her finger in, feels something gritty, probably ash, but how would she know? She hasn't handled ash before, not human ash. How could anyone tell? It might have belonged to Conningsby, or a stranger, or a dog or a cat. It could have come from a fireplace. Old Miss Merriweather could have mixed it up with sand and crumbly bits of charred steak bones, hoarded Conningsby all to herself. How would anyone ever know? She brushes the stuff off her skin, then screws the top back on. She can still feel the residue in the creases of her fingers. She wipes her hands on her nightgown, feeling guilty.

She creeps out of the room and down the stairs, careful of the rickety floorboards. In the hallway, she takes a jacket off a nail and heads outdoors. The air is sharp and cool and smells of juniper, and the bushes and dry desert weeds rustle in the breeze. She sits on a rock, hugging her knees.

This is where Conningsby had put her on his saddle and given Sarah her first horse ride. The next day, she and Max had gone to visit him at his corral. He had offered Max a horse and asked if he wanted to come get a cow and calf that had wandered from the pack. She'd been surprised. Max had never given any indication that he knew how to ride. She sat on the ledge of the horse trailer cab and proudly watched them go. Her father on a horse! Riding the range! He even had a cowboy hat, an old one of Conningsby's. They disappeared into the scrub. When they reappeared, they were four tiny dots—two horses, two cows—against the smudge of the Christmas Mountains. Max had taught her about perspective. She decided to observe it in action. As Conningsby and Max grew nearer, they moved from specks to slightly larger forms, exactly as they were supposed to. Then they became definable, Max with his beard, Conningsby with his brown half-Indian face, the cow and the skinny-legged calf. They were larger, but not quite as large as she had been expecting. Maybe if you watched perspective unfold, it didn't work as well as it should. Maybe she'd shrunk them.

Her father dismounted, groaning good-naturedly. She walked over to him, hoping he'd spurt up at the last minute. He didn't. He was at most a head taller than her, with bloodshot eyes and hair coming out of his ears.

He and Conningsby messed around with the horses' saddles. Conningsby was not as short as her father. And he looked good in his cowboy hat. Her father looked funny

in his; it didn't go with his beard. And his accent. She had to have known that he had an accent, but she hadn't really heard it until then. He pointed to a spot on the cow's throat and said, "This is where the shochet slits it."

She had left soon after they returned. Max was speaking about his childhood in a coherent, edifying way, and she had walked off. Why? Even at that age, she'd wanted to know where he came from. In that mood, he might have told her the name of the village. He might even have told her the real name of his family.

Sarah wakes, discombobulated. There's a strand of Philip's hair on the pillow, but no Philip. She hears his voice downstairs. And Tori's. She smells coffee. She stretches out, and is rewarded with a glimpse of her girlhood self, lounging in the Cadillac with her cast sticking out the window, Max at the wheel. Max wasn't used to driving in the city and didn't know the one-way streets. They'd inevitably roll up to school an hour late, but that was fine with her. Nothing she'd learned applied—no Latin, no pi, no Pythagoras. Instead: spitballs, the Pledge of Allegiance, Henry Hudson's birthday.

She gets up. She feels good. She likes the thought of Max, solo, driving around New York, brown eyes bulging, comically shaking his fist at the one-way-the-wrong-way signs. And she likes the way these pictures mingle with the smell of coffee and the tingling on her skin, an epidermal reminder that Philip had let her hold his hand, had half-held hers, had groped her ass. She checks the table. The urn with Conningsby's ashes is still there. Looking innocent and untouched. Had she really opened it and rubbed his ashes?

She puts on jeans and goes downstairs. Tori and Philip

sit at the table in the kitchen, Tori talking about local politics, Philip nodding, rolling up his shirtsleeves.

"Good morning," Sarah says.

"Morning." Philip pours her a cup of coffee, then pushes himself up from the table and peers out the window. "I'm going riding," he says. "Want to come?"

"Yes."

Tori gives them directions to a canyon where she scattered her portion of Conningsby's ashes. She's hoping Philip will scatter his there too, but she doesn't push very hard, just sends them off, saying it's a good place to have a picnic. They take her most sedate horses and start right after breakfast, before it gets too hot. Philip leads and Sarah follows, enjoying the fresh air and the unfamiliar rhythm of her horse. The sun gets higher in the sky. She takes off her hat and wipes the sweat from her forehead. Philip reins in his horse and turns toward her; his body is loose, and the easy curl of his spine fills her with pleasure. She is no longer a field of muons, and he's no longer dark matter. He smiles. A roadrunner darts through the dust, its crest bobbing.

"It's beautiful," she says.

"Yes," he says.

They continue side by side. She asks him when he learned to ride.

"When I was a kid."

"You never told me that."

"Never came up."

"Did you ride seriously?"

"What do you mean?"

"I mean, did you jump over things and wear those funny hats?"

"No, that was for girls. But I learned how to ride. Con-

ningsby and I would trot around in the woods behind the castle."

"That's funny. I always think of you two in the basement, hunched over that model."

"Well, that was the main thing we did, the lasting thing." They come to an arroyo. The horses' shoes strike against the rocks. "I was fascinated by that kid," Philip says. "The deaf-mute. Conningsby didn't talk about him often. I was always hovering, hoping he'd give me more information."

"What about the kid?"

"I suppose it was because he was all alone. No parents, ministers, coaches. Robinson Crusoe and only ten or eleven, or however old he was. I remember wondering what would happen if the North Koreans bombed Terre Haute and everyone left. I would wander around the wreckage, the only one. I loved thinking about that. What building I would live in, how I would eat. I remember almost wishing it would happen."

"Philip, you didn't pack his ashes in the saddlebag, did you?" she asks, realizing that's where their picnic is.

No, Philip says, he didn't pack them at all. Today is for scouting, not scattering. They pass an electric fence. Philip tells her the land beyond it is part of the fake silver mine that Alligator had sold to the gringos.

"That's a pretty serious fence. Maybe there was silver there after all."

"Not silver," he says. "Uranium. It was discovered well after Alligator's time."

They wind through boulders piled on top of each other and reach the mouth of the first canyon—not the one they're headed for, one that they must pass through to get there. The scrub gives way to thick cottonwood trunks and silver-

green leaves, then the trees clear and a waterfall drops from sixty feet.

"God," says Sarah, "it's gorgeous." The reflection of light and water plays on the rocks. "Why didn't Tori scatter the ashes here?"

They dismount and search for a petroglyph Tori told them about. "There it is," Philip says. A pockmarked line esses up and down, lighter than the dark sandstone. "Looks like a snake. No wonder Tori likes it."

"Did I ever tell you about when I first met her?" Sarah asks. "I was so disappointed. I thought she was going to be this art deco, snake-dancing queen—instead she was an old stick in polyester pants. But she hadn't given up the snakes, just the dancing. She had a big bull snake living under the couch in the parlor. She said it was for catching mice, but I think she kept it for company." She runs her finger along the petroglyph. "I wonder who carved it."

"An Apache, probably."

"Could be earlier," Sarah says.

"Could be."

She tells Philip about a Hopi Indian she and Maya met on some tour ages ago. He had taken them to see some petroglyphs and explained that they were the equivalent of bathroom graffiti. The sign of the beaver clan with eight lines below meant that the carver had done it with eight beaver ladies.

Philip laughs. "You've told me that story before. You love that story."

"It's true. I do."

His hand grazes her thigh. She grabs it and kisses his palm. He wanders down the trail looking at the cliff walls, the lines of red, yellow, buff rock, the sharp blue of the

sky. She leans against a cottonwood tree. It's insane how good he looks. As if he'd taken a magic pill and returned to himself. Yet she shouldn't go overboard. He's still thin. He walks cautiously.

He skips a pebble in the stream. "Three times!" he shouts. "I'm trying for four." He combs the shore for a better rock. He's lost his caution. He looks like a kid. They should have had a kid. They should have tried earlier. He would have been able to hold himself together for one. They eat their picnic there. Philip bites right into an apple and cuts healthy slabs of salami as if he's never been squeamish about food or penknives. They lie down afterward and gaze at the sky. The cliff swallows dart and swoop, and the clouds shift-shape.

"Do you still want a kid?" she asks. They haven't had sex since that terrible night.

He says nothing, then covers her hand with his. They're still looking up at the sky. He rolls over on his side, his eyes soft and thoughtful. He traces the curve of her cheek. She smiles. He kisses her on the lips. They fall into a tacit, superstitious silence, as if they'll puncture something if they talk. They wade in the stream. It's shallow but cold. They forget their solemnity and splash and shout, then sit on a warm rock, drying their feet in the sun.

"This is a good place," Philip says. "We can scatter him here. It will be our canyon."

They mount their horses, more stiffly now, the saddle leather harder under their bums. A couple miles later they get to Tori's canyon, a drier place with thinner trees and dusty bushes. They rein in their horses and stay there a few moments, feeling, to Sarah's mind at least, nothing. The emp-

tiness of ritual. But that's not exactly it—it's the inability to transfer it from person to person. The place must mean something to Tori. They turn their horses back and head out.

In the desert flat, the sun shines brighter and hotter than it did in the morning. Sarah wishes she'd brought sunglasses. It hurts just looking at the sand. She's relieved when they get to the arroyo; they're almost home. Then Philip veers off the path. "Where are you going?" she shouts, following after him.

"The ghost town."

"Huh?"

"Didn't Tori ever tell you about the ghost town?"

No. The land is dusty and flat and gets hotter with every step. In a few miles they come to a grid of wind-carved adobe walls.

"Who lived here?" she asks.

"I thought you knew. This was for the miners. Tori's father owned a big mercury mine—actually, a bunch of them—and he built the miners this town. He was an idealistic guy. It was supposed to be a workingman's paradise." Philip points out an old park. In the center is the shell of a fountain that supposedly ran with quicksilver. He's in his element; he loves playing tour guide. He walks their out-of-town guests through lower Manhattan, regaling them with tales of architect rivals, Mohawk Indians, lost subways. Now he's stopped in front of a corroded old furnace. "This is where they heated the ore," he explains. "Mercury comes in an ore called cinnabar. You fire it up, and the mercury turns into a gas. All you have to do is catch the gas and condense it. The problem is—"

"It's poisonous."

"That too. But also fuel. They burned every mesquite shrub, every cottonwood on both sides of the Rio Grande. That's why those canyons are so special. The miners didn't go there. It's the only place within hundreds of miles where you get such thick old trees."

"How do you know all this?"

"Conningsby told me. We had a couple good rides, just the two of us." Philip wets his lips. He wants to say something else.

"What?" she asks after a moment.

He puts his hands on her hips, then breaks away. "Nothing." He wanders over to the furnace, presses his hand to it, and inspects the rust on his palm.

"We ought to go back soon," she says. "You're getting a sunburn."

"We have to go to one more place."

"Where?"

"Come." He mounts his horse and sets off at a determined clip.

She follows behind, starting to worry. His shoulders look rigid. He's tightening. She closes her eyes. She hates praying; she's her father's daughter. If there are any gods, they're the old-fashioned kind, only lightly concerned with what's happening on earth. But she needs to do something. She won't be able to handle it if he goes back to that catatonic distance.

They ride over miles of burning sand until they reach a scaffold, about forty feet high. On the ground, there are rusty bits of metal and some bleached planks of wood. Philip dismounts.

"It's the opening of an old shaft," he says. "The scaffolding was for the hoist."

"I see," she responds, although she doesn't.

He puts his hands on her hips again. She smiles, trying to look encouraging. It seems like that's what he wants. His grip tightens. He is clamping her. She wiggles. He lets her go.

"Franco and I came here when we ate the peyote." He walks over to the scaffolding. "I climbed this. There was a full moon."

She follows him to the shaft opening. It's covered by planks of wood, but just barely. You can see the blackness through the cracks. Air steams out, hotter than the desert, foul-smelling. Sarah wrinkles her nose.

"Sulfur, I think. Cinnabar is made out of mercury and sulfur." He edges closer.

"Will you get back from there? You're making me nervous."

"It's covered up."

"With wood that would rot if you put a penny on it."

"It won't rot." He raps his fist against a plank. "The air's too dry." He rubs the wood, though it could give him a splinter.

"Please, Philip, let's go." She feels like she has disappointed him. "It's not that I don't like this place, it's just that it's late."

"I'm sorry, it was a stupid idea. This is where we were fighting when he kissed me," he says quietly.

A cold weight gathers in Sarah's chest and she turns away from him. The horses wait patiently, their long unkempt tails whisking at flies.

The next morning when Sarah wakes, Philip is gone. "You just missed him," Tori says. "He went for a ride."

Sarah runs back upstairs, worried that he decided to

scatter Conningsby all by himself, but the trophy is still there. She feels the phantom residue on her fingers, washes her hands and brushes her hair.

"It's better this way," says Tori. "We need to get meat for the chili, and two's better than three in that pickup." It's been decided that after they scatter the ashes, they'll have goat chili for supper. Conningsby had been famous for his goat chili.

It takes a couple of hours to get to the ranch where the meat is sold, then another hour or so listening to the rancher's daughter play piano and complimenting the rancher's wife on her lemon cookies, then two more hours bumping along the road back. It is midafternoon by the time they return. They can still scatter the ashes, but they can't dawdle. Sarah hops down from the pickup and gets the meat from the cooler in the back. She follows Tori in through the front door. Inside, Philip is sprawled on the sofa, sunburned and snoring. Tori frowns. He forgot to take off his boots; they're dusty, and her sofa is clean.

Sarah unwraps the meat and pounds as hard as she can, hoping the sound will wake him up. They can put the chili on low and ride out to the canyon and come back just as it's ready. But he doesn't stir. She chops onions and the tears run down her face.

Tori comes in and licks the spoon. "You're on the right track," she says, sniffing at the steam that comes up from the pot. "A few more hours and we'll have a blue ribbon."

He still hasn't woken up. Sarah cleans the dishes and washes the lettuce and smokes a cigarette. Tori suggests a game of Russian Bank. Fine. Tori shuffles the cards; they are soft and nicked from years of use. They each win a game and are setting the board for the tiebreaker when Philip enters, his face wrinkled with sleep.

"Smells good."

"It's too late to go to the canyon."

Philip shrugs and pours himself a Scotch. He drinks it quickly and pours another. He's drunk by the time they have dinner. Sarah doubts that he can even taste the food, although he compliments her on it.

She lies next to him as he snores, repulsed by the booze on his breath. She shakes him. "Why did you run off? You could have waited for me." He stops snoring and rolls over, his face to the wall, his back to her.

In the morning he's hungover and pale beneath his sunburn. He waves away breakfast and saddles his horse.

"What are you doing now?"

"I'm going scouting."

"What do you mean?"

"I don't know if the canyon's the best place."

"But that's what we decided. You're not going to find anything more beautiful."

"I've got to go, Sarah."

"Do you want me to come with you?"

"No."

Sarah returns to the canyon by herself. She throws pebbles at the cliff. The swallows zoom out of their holes, chattering angrily. She steps into the stream and the water magnifies her toes. She won't think about him, she'll think about her and Maya picking mint in the stream near Roncesvalles. She takes off her clothes and wades into the deepest part, gasping at the cold. She submerges herself. The water is crystal clear. Above, a ribbon of sunlight floats on the surface. She reaches up, and the ribbon breaks into fragments.

* * *

The next day Philip again goes scouting, and again she returns to the canyon, this time with her camera. She takes pictures of the water, the reflections of the ripples on the rock, the petroglyph. She shoots two rolls. When she gets back, he still hasn't returned. Tori tells her not to worry; Conningsby had his moments too.

"This isn't a moment. It's been going on forever."

"He doesn't seem that bad. He was talking nicely this morning."

"To you."

"To you too."

"He didn't say anything. He said good morning."

"Some women would find that loquacious. You let him be. You've got your own business to attend to."

"What business?"

Simon Perez had called while she was taking pictures. He wants her to call back. Sarah sighs. She's supposed to feel something; she's been waiting for this call for months, and it's a good sign that he called her out here—it means she'll probably get the show at the Galley. But Philip isn't here. He'd make her feel excited. Without him, all that hoping and wishing seems absurd. What is a show other than hanging your paintings in a different room than they're usually in? Still, she calls him back.

"Sarah!" Simon is exuberant. He launches into a tale about last night's party, a bepimpled stallion in a shower cap, some joke that Sarah doesn't get, but she laughs anyway, a little bit of her waking up to Simon's charm and the pleasures of the art world. It's not that bad, hanging your stuff in a room. There's nothing wrong with it. Yet gazing out the window and hearing Simon yammer away, she thinks the sky out here would crush him. It's so vast. It would crush

almost the entire scene—the art and the artists and the critics and the collectors, they're all dependent on the smaller scale of Manhattan. There you compare yourself to a building, here you are up against the earth, the mountains, the fucking galaxy. Maybe that's why Philip wanted to come. He's an insect out here, he's nothing. Maybe he won't go back to the canyon because once he scatters the ashes, he'll have to leave and become something again.

"Baby, are you going to do it?"

"What?"

"My love map, ding-dong, I want you to paint my love map. How many times do I have to say it?"

She claps her hand over her mouth, suppressing a groan. So much for pooh-poohing shows, she can feel the disappointment rising. What happened to the big Texas sky and its enforced perspective? These fucking love maps. She's sick of making them. Their appeal has to do with the exact way the subway map is replicated, the curve of the green line, the circles and squares of the red line, just the right shade of purple for the 7, so painting them means executing the same strokes, mixing the same colors, over and over again. The only things that change are the locations of fucking and splitting, the number of dots, the distribution and promiscuity. They'll be like her scale paintings, annoyingly popular, while the stuff she cares about gets ignored. But she can't say no. Philip hasn't worked for months, and who knows if he ever will again?

"The mystic's map," Simon is saying. "That big bang on the Lower East Side, what's that about?"

"He said it was a physical union with god. He didn't come, but he was drenched in sweat and trembling like when he was first with his wife."

"Some kind of god," Simon says. "Give him my number."

Sarah smiles politely even though, of course, Simon can't see her. Outside, Tori pushes a wheelbarrow out to the stables. "I should go," she says. "It looks like Tori needs help."

"When are you getting back?" Simon asks. "I want you to do a show in December."

"More love maps?"

"No. Whatever you want."

Sarah circles around the house. Where is Philip? He has to know right now, this instant. He'd always said she'd get a solo by the time she was forty. He'd been more confident than she. He'd even offered to bet, but she hadn't thought it was a good idea to bet against herself. He would have won, although only by a hair, seeing as she was turning forty-one in a minute.

She shivers, not from the evening air but from the realization that it's actually happening. She hugs herself. It's pathetic. She knows it's pathetic. The sky is laughing at her and poor Philip is riding around, demented, alone, who knows where? A show won't make her happy and it means nothing in the long run, but in the short run, damn it, it feels sweet. Where is he? She climbs onto the rock.

Tori appears in front of her. "Do you see him?"

"Maybe." There's a blurry shape on the horizon. Could be a horse, could be a man.

"Well, I'm popping the champagne—Coors, that is," says Tori. "We can't wait forever."

Chapter 17

Connecticut, October 1997

A shower. That's what she needed. She was a disaster of sweat, booze, tobacco, leaf mulch. She pulled back the curtain and turned on the faucet. Ah, hot water, better than raking. She washed her stomach, her navel, her C-section scar. She started to hum an old song of Maya's. She wrapped herself in a towel and dripped downstairs. The wine bottle seemed to have disappeared. She poured a nip of Scotch and pretended to be Max Sr., stirring it with his finger, smacking his lips. She opened the record cabinet. The needle jumped over some dust, hit on a groove, and there was her voice.

Sarah lay on the couch, gazing at the picture of Maya's back, the glimmer of her skin in the blackness of the stage. The house started rolling again, lurching and keening. Her stomach churned. She tore upstairs, grabbed at the rim of the toilet, and vomited. The lurching stopped. She flushed, shuddering with disgust, and splashed water on her face. Downstairs, Maya's voice swelled. Philip had accused Sarah of wanting to have lunch with Maya, dinner with himself, as if it were horrible to want both. Maybe he had been right, but how could she not want both?

She remembered a fiberglass cow, white with black

spots, its hooves shockingly pink. It had been in a super-market, somewhere on the road, when she was a little girl. Ma had gaped, appalled.

"It's just a cow, Ma."

"What's the meaning?"

"It's a decoration."

"It's not a cow. It's got no udders. Not a bull either."

"It's pointing out the dairy, that's all." Sarah was Max's age, and matter-of-fact. What is, is. An udderless cow, why protest? But she understood now. Ma had been appalled at the willful erasure, the falseness and stupidity. How can you understand anything if you erase sex?

Sarah shivered. She had to get dressed. But what should she wear? How could she make these decisions? What time was it? She sneezed. She needed some clothes; she was too naked. She put on an Irish sweater and some old jeans and lit another cigarette. The telephone rang. She choked on the smoke. It rang again.

Chapter 18

West Texas, October 1989

Philip is in his hole, that's what Sarah's calling it. It's not really a hole, it's that putrid mine shaft, but it's easier if she thinks of it as a hole in the ground.

"Maybe he's looking for something," Tori had said.

A meager hope. Buried treasure? Quicksilver drippings?

They are in the truck, Sarah and Tori. Tori picked her up from the Fort Stockton airstrip, and they're driving southward, on the now-familiar two-lane highway, her suitcase sliding and scraping in the pickup bed. She has no idea what's in there. She remembers throwing in some jeans and a jar of marmalade that has probably cracked open. She wasn't thinking straight; she had just gotten Tori's message.

She shouldn't have gone back to New York. She knows that. Tori does too. The air in the pickup is thick with it. You go off to paint pictures and leave your husband piling empty tequila bottles in my garden? But Tori had urged her to go: get back to your studio, prepare. And she'd insisted that Philip stay. Sarah suspects that this was because he still hadn't scattered the ashes, and Tori wanted them in the house or nearby, didn't want Philip leaving with his trophy still intact. He hadn't been drinking then. That began after Sarah left. She shouldn't have left. You don't leave when

things are going to hell. But things had been going to hell for so long. She stares at the dashboard, the old-fashioned knobs, the dried flowers in the ashtray, Tori's fragile, weathered hand.

"Do you want me to drive, Tori?"

"No. Am I weaving?"

"No. I just thought you might be tired."

"You're the one who looks tired."

"When did he start drinking?"

"About ten days ago. I told him if he planned to carry on like that, he couldn't stay at my house. So he left. Got a room at the Kiva Hotel."

"There's a hotel out here?"

"Down by the Rio Grande. From the seventies, some optimist's dream of a Wild West tourist trap." Tori laughs. "The optimist left, but the Kiva stayed. They get dope-runners, herpetologists, I suppose some river rafters." Sarah clears her throat. "Anyway," Tori continues, "they called when Philip disappeared. He owes them about a thousand bucks in margaritas. He was drinking pitchers for breakfast."

"He's never done anything like this before."

Tori whistles. "Look at the horns on that one," she says, eyeing a longhaired bull.

"That's great, Tori."

"There used to be thousands of cattle out here. When I was a kid, we'd take the stage up to Marfa. You should have seen it then. Miles and miles of gama grass, no fences, huge herds of cattle and sheep, and every few hours a lonely cowpoke ogling my mother. The animals overgrazed. When I came back from Europe, it was a different place, pretty much like you see now: barren fields, barbed wire."

Sarah leans against the window, tired of Tori's subject-jumping. Maybe Philip isn't in that shaft. Maybe it's all in Tori's head. She's singing now, Ma's old circus song: "*Divine Serpentine, you are yours and I am mine* . . ." There's no question that she's acting erratic. Well . . . she's over ninety; she's got the right. Sarah cheers inwardly. Maybe they'll get there and Philip will come out of Tori's house, sane and sober, mildly puzzled. "I thought you had to prepare for that show." "Well, yes, darling, but I missed you." Then what? She and Philip go back to New York and leave a Tori-gone-bonkers alone in the desert? Well, yes—she wants to stay here. That's clear enough. No pills. No placements. No machines.

"Tori?" Sarah says. Tori finishes her song before glancing over. "How do you know that Philip is in the shaft?"

"Because I rode out there and yelled for him to come up, and he yelled back, *No*."

"But how did you know to go out there?"

"Oh, I just had a suspicion."

"Why?"

"He and Franco used to go out there before."

"Was he thinking of scattering the ashes there?"

"Oh gosh, I hope we have enough gas."

"The tank's full, Tori. Don't you remember? We filled it in Fort Stockton."

"Oh yes, so we did."

"You sure you don't want me to drive?"

"I'm fine, Sarah. Men like smelly holes. My father was particularly fond of Shaft 8, and you've never smelled anything worse—cordite, sweat, and piss. Philip's is more sulfurous."

"It smelled like rotting metal."

"My father called it the smell of life. He believed that chaos gave birth to order, rot to growth, that sort of thing. He died in a mine. Did you know that? Surrounded by elementals and muck and rubble. My mother said that's what you want: to die from what you love."

"Philip can't die in a mine shaft. He doesn't love mining."

"That's why you've got to get him out. He's been down there for two days, and all he has is a bottle of tequila."

"I thought you said you dropped down some water."

"Oh yes, you're right. That was smart of me."

Sarah rubs her eyes. "You sure about this, Tori?"

"Rojo."

"Huh?"

"I just remembered, the guy who drove the stage when I was a kid, his name was Rojo."

"Great. I need a cigarette. I hope you don't mind."

"No. Go ahead. My father didn't like tobacco, but the doctor did."

They turn off the highway and head southeast along the bumpy road that leads to Tori's house. Behind them, the sun sinks, and the sky and land become an inscrutable haze of gray and purple. The shape of Tori's house comes into view. She slows down and peers over the steering wheel.

"No light in the windows," Tori says. "Doesn't look like he's come back."

"Maybe he's taking a nap," Sarah says.

Tori shakes her head and continues driving. "He's in the shaft, Sarah. He's not coming out anytime soon."

Sarah twists her head, watching the retreating house. The sky gets blacker, and the road becomes more rutted, then peters out completely. Tori shifts into first, and they bump over small rocks and bushes. Moths flutter in the

glow of the headlights and ping off the windshield. They hear coyotes and owls, and some high-pitched cricket or grasshopper. Tori stops the car. The headlights shine on the scaffolding, and the planks of wood, piled in a haphazard heap, glimmer palely. Sarah jumps out of the truck and heads toward the shaft.

"Careful!" shouts Tori. "He took off the planks. The ground around the lip is loose."

Sarah stops a few feet from the mouth of the shaft. "Philip!" she calls out as Tori wobbles over with a flashlight. "It's me. Are you down there? Philip?!" She inches toward the rim. The air is steamy and sulfuric and adheres to her skin, leeching out a thick, greasy layer of sweat. "Please answer! Are you in there?"

A muffled yell rises up out of the hole, his voice distorted by the tunnel echo. "Go away!" or "Okay!" She can't tell what he's saying, only knows that the smell is making her gag.

"Tell him we've got more tequila up here," Tori says.

"I don't want tequila!" he yells. "I'm fine! Leave me alone!"

"Sweetheart, please!"

Everything is still, except for the moths, their wings shining and translucent, spinning in the headlights. A coyote yelps.

"Philip . . . come on up! You can see the Milky Way! Come up or I'm coming down!"

He doesn't answer. She hopes Tori will try to stop her. Instead, Tori hands her a Maglite.

Sarah flashes the light around the rim of the shaft and finds a metal rung. "All right! I'm coming down." No comment from Philip. She looks at Tori. "Do you think it will hold?"

"It held him, didn't it?"

Sarah clamps the Maglite between her teeth, grabs the top rung, lowers a foot. She groans as the smell gets worse, almost losing the light. Slowly she descends, feeling the way with her feet and hands. She doesn't know why she cares so much about the Mag; it is tiny and ineffectual in the tight, inky darkness. The only lights that mean anything are the stars in the sky. Everything is quiet except for her breathing and the slip of her soles on the iron rungs. She keeps going down; the sky hole gets smaller. She stops to wipe the sweat off her palms. It's awful not being able to see. She steadies her breathing. She gets closer; she can hear him raggedly gasping. Why won't he say anything? She slips on a rung. Then her foot finally touches something solid. She steps off the ladder, shines the light around. A few feet away lies Philip, curled up like a pill bug. She starts toward him, realizing midway that they're on a platform. Over the edge is a blackness that makes her shudder. Philip's teeth chatter. She puts her hand on his shoulder and the bone shoots through the skin.

"Philip," she says softly. "Come on, honey. What are you doing? We've got to get out of here."

He squints, pained by her Maglite. "Leave me alone."

She sits beside him and strokes his hair which is oily and tangled. "It's all right, baby."

"I can't go back up there."

"You have to, Philip. Tori's waiting. She's old. She needs to go to bed."

"I don't care."

"Well . . . I can't leave you down here."

"Why not?"

"I'm your wife."

Philip wheezes, then chuckles.

"What's so funny?"

"Matrimony."

Sarah laughs too. But the smell is awful. "Come on. It's not far to the top."

"No, I'm staying here."

"Philip," Sarah says sternly.

"Tell Maya that she won. Maybe that will make her happy."

"Pull yourself together. You fucked up. People fuck up. Do you think you're the first person in the world to have killed a man?"

He rises, unsettling her. She'd been thinking he might not have the strength to stand on his own two feet, but in an instant he's up, pushing past her, dangerously close to the edge. "He smiled at me, Sarah. He was that sure I wouldn't. And so I did. He was surprised, that was all."

She pulls him toward the ladder and he twists out of her grip. But she won't stop, tugging now at his shirt. He pushes her away. He pushes hard. She loses her balance and falls. Her forehead cracks against something; her brain seems to be vibrating.

"God," he says. "Sarah? Are you all right?" He cups her shoulders with his hands. "Forgive me," he whispers.

"Take me up," she says.

Now it's morning. Her forehead is swollen and discolored, tender to touch, but the aspirin has done away with most of the throbbing. She studies the raised lump in the mirror, the dark purple blots under the skin. She can't remember ever having had a bruise on her face before. It strikes her that she's had an easy life.

Tori's in the kitchen making breakfast, and Philip's on the couch, safe, breathing regularly. They gave him a shower, then a bath last night, but his hair is still thick with grease and dust. She pulls the sheet up around his shoulders. He stirs, but doesn't wake.

Sarah goes into kitchen. Tori hovers by the stove, attending to her coffeemaker, a double-orbed glass thing that she got in Italy. The water starts clear on the bottom then bubbles up, getting murky and brown as it rises. Sarah remembers being fascinated by it when she was a kid.

Tori sees her and whistles at her bruise. "You got a beaut there."

It is afternoon. Sarah's in her room, on a stained quilt, an unread book in her lap. Philip opens the door, his face gray and taut. He winces at her bruise.

"It's okay," she says. "Just ugly. It doesn't hurt anymore." She stretches out an arm, grabs his pajama sleeve, pulls him onto the bed. He lies beside her, his fingers clasped over his nonexistent belly, his eyes fixed on the ceiling.

"I can't go back to New York, Sar. My business is over."

"No it's not."

"Haupt won't pay."

"He's got to."

"You sue him for breach of contract if you want. I'm done with lawyers."

She looks at him reproachfully. He rubs his eyes.

"I don't want to. I have no desire to—what do they say, pick up the pieces and put them back together? I'm done with it."

They stare up at the ceiling, side by side. Sarah can't really blame him.

"We could go somewhere else," she says, "find a whole new city."

It's a new thought. She had never considered not living in New York, but why not? The possibility floats there between them.

Outside, the wind blows. He curls toward her and gently touches her cheek. "You couldn't live without her."

She understands that even to speak Maya's name would puncture this thing, this tiny bubble. "I could," she says softly.

He regards her with a quiet gaze that she tries to return, but her insides are quivering. Downstairs Tori sings to herself, and the wind mounts up again. Sarah feels shy, almost afraid to kiss him. The sharp lines of his face have a certain logic, but they were not so sharp before. His normal scent is mingled with the stench of the shaft. She puts her lips on his, and he kisses her back. This part works. He is there again, his veined arm, the roughness of his cheek. His skinniness is alarming, and yet he is as strong as he has always been. He grips her, and she is in motion, propelled by him, biting her lips to keep quiet, aware of Tori in the room below, the shooting ache of him inside of her, his weight and fury, his breath in her ear. She squeezes her legs around him with all her might.

A few days later they are in the car, Philip at the wheel, driving north on Route 118. His skin looks new, smooth, like it's growing back. Sarah imagines she is getting a glimpse of the man he was twenty years ago, driving these same Western highways. His shoulders slope down at a relaxed angle. His eyes, though red-rimmed and baggy, rest more easily on things. She tamps down the urge to touch him. She's been

touching him too much, grasping onto him, as if to prove he is really there. A brown and gray bird swoops above the road before them.

"I don't recognize any of the birds out here," Sarah says. "Except for hummingbirds and vultures."

Philip smiles at her. The car veers into the opposite lane.

"Philip. Watch the road."

"There's no one coming. I can see for miles." He slows the car to a crawl.

"What about that tarantula?" It is a few yards ahead, its body as big as an egg, black and furry. It moves across the bleached pavement with a carefree step, oblivious to danger. Philip swerves, avoiding it. She gazes at the rolls of distant mountains, the layers of purple and mustard, longingly. They are en route to El Paso. He is to drop her off at the airport before driving to Terre Haute, and then Chicago. A friend from graduate school has a firm out there. He might be able to get Philip a job.

She lights a cigarette. "I could go to Chicago with you."

"You've got to paint. You can't shrug off that show."

"I can reschedule it." They both know how unlikely this would be. Eddie Kiebbler could reschedule a show, not Sarah.

"Don't worm out of it. We need that money."

They arrive at the airport seven hours later, cramped and dry-mouthed from too much time in the car. He walks her to her gate, holding her carry-on.

"Don't look so glum."

"How can I not?"

"I'll be back for your show, even if I haven't found a job. I'm not going to miss that. I want to strut around, proud of my wife." Unspoken is the likelihood that Maya will be there too.

Philip kisses her on the lips, not the kisses of the past couple nights, but a hard kiss, like a strong handshake. Then he turns and walks down the carpeted corridor, a tall, slim man in jeans and a checked shirt, looking not too different from the other men who walk past him and before and behind him. Men with tan faces and cowboy hats and briefcases. Men with suits talking to business partners. Men in sweatshirts with women and children. Men alone. There is a lightness in his step, as if he just took off a heavy backpack.

LaGuardia Airport, New York. A crowd waits at the end of the terminal, its members jostling for the best position to spot incoming relatives and friends. Sarah drags her suitcase through people embracing, crying, whooping, half expecting Maya to pop out from the crowd, though she hadn't told her of her arrival. Bored, suited limo drivers hold paper signs over their chests, the names of their passengers-to-be inked in black. She should have called Maya. She would have gotten her a car. But Tori's house is too small—Philip would have known who she was talking to, and she hadn't liked the idea of surreptitiously dialing the moment he took a shower. The taxi line snakes down the sidewalk, shuffling, pausing, shuffling. She joins its staggered movements, watching the lucky people at the front, a woman in white fur and her beleaguered husband grandly wheeling matching suitcases. The cabbie lifts the bags and stows them in his trunk. Over and over the scene repeats itself with different bundles and baggages, different dents on the cabs, but the fundamental action remains the same, a moving of things from place to place: Out of the trunk into the closet. Out of the closet and onto the body. Off the body and into the

laundry. Out of him and into her. Out of her and into him. On and on, in and out, from pile to pile and place to place, until the last trip, when it finally settles. But it doesn't. It keeps moving—but now it's in pieces, echoes for the current, fingernails for the fish.

Someone taps her shoulder. The line has moved. The cabbie doffs his baseball cap. "Yusef Mustaba. Pleased to meet you."

"Manhattan," Sarah says. "Franklin Street."

The cabbie likes Franklin Street because, he says, it is named after Benjamin Franklin, his favorite American. She's grateful for his talk and listens intently, diligently, trying to forget everything else. They jump over potholes, and he lectures her on the discovery of electricity. Her head bumps the ceiling. "Excuse me," he says. "My shock absorbers have rubbed off. People say, including my wife, that I should get new ones, but I believe it's better to feel the road. All this cushioning, it's not good for you. I love this country, I love this city, and I love Franklin, but I do not love these shock absorbers. They make you soft. Take the bicyclists. The bicycle riders in America—you must have seen them—wear *helmets*." They hit another pothole and Sarah ducks. "If Franklin had been soft— Hey, are you all right?"

"I'm fine."

"You look upset. Would you like to see my children? They are beautiful." He hands her his wallet.

"You shouldn't just hand your wallet to people."

"Look at them. They'll cheer you up. A man is not happy unless he has children. It's the truth. I used to be a mathematician, but that's in the head—with children you multiply and they are there, in front of you! Do you have children?"

"No."

"Oh. You must, really. And you should do it soon. There is always a way, they have medicines, specialists. My wife, bless her, had our youngest at forty-eight. A wonderful woman, how to explain?" His hand sinks gently. "She flies kites, but not like Franklin. She enters the competitions and slashes her opponents to bits. They are all young men, and at that age they are foolish. They see a respectable lady and they think, *Pah, nothing!* But she's got special razors on her tail and *yaah*, she tears them to shreds, wins every time."

They swerve through Queens. The headlights, street-lights, flashing bar lights blur into each other. They twist up a ramp and Manhattan appears. The skyline is beautiful and ungainly, glowing with an awkward hope. Sarah inhales, as if to breathe the city into herself. She leans forward as the cabbie slows for a red. "How long have you and your wife been married?" she asks.

He looks at her through the rearview mirror. "An eternity."

Chapter 19

Connecticut, October 1997

Flings were more civilized than matrimony. If she could have kept herself to a fling, then she'd be thinking of Philip fondly, and not like a piece of shrapnel embedded in her heart. But then she wouldn't have had Max. She scooped him up carefully, sixty pounds breathing trustfully in her arms. The stairs were long and steep but they held steady and she made it down without a hitch. Max opened his eyes as she kicked open the front door. "Shhh," she said, catching her balance. She rattled the Buick's handle. "I made you a bed in the backseat." The Buick looked better this way, the holey upholstery hidden by sleeping bags and a couple of pillows. "Cozy, huh?" Max, still half asleep, crawled in. She fastened her seat belt. She'd countered the Scotch with a dose of coffee and no-drowse flu medicine. She felt fine, and besides, no one would be on the road at this hour. It would be like driving in the desert. People were allowed to drive a little tipsily in the desert; they stored six-packs of beer in the backseat so they wouldn't get dehydrated.

She put the key in the ignition. The engine sputtered and died. She tried again. A wheezing chug, a hesitation, a collapse. She squeezed her eyes shut. She'd had the car

for three years—an unexpected gift from the father of one of her favorite students, Milo, Milo Pére, Buick-donor. He owned the used parts and body shop, and when Milo told him she was the only teacher who had to rely on the public bus system, he drove it to school and tossed her the keys. "It ain't much to look at, but the engine works fine." And so far, it had. She got out and checked under the hood. It was dark and she didn't really know what she was doing, but there seemed to be oil, water. She kicked the tires. They felt full. She got back in and took a breath. If the car didn't work, she always had Plan B: pack Max off to school, go the train station, suffer the humiliation of Philip not showing. And if he did show? Well, that was a big if, better not to go there, better to just leave it be.

She breathed on the key. Come on, baby. The engine chugged . . . chugged . . . caught. Thank god. She opened her eyes and backed out of the driveway. Goodbye, house. She'd been smart, turned off the lights, checked the oven. I won't miss you. She had her art supplies in the trunk, a credit card that still worked, the dented beige Buick. Max breathed softly. They'd be okay. They'd be better than before. She should have never moved to Connecticut. She'd morphed into a bitter old hag.

She hadn't left in eight years. Correction: there had been the day trips to New York—hurried, nervous afternoons with her collar up and her hat pulled low, trying not to bump into anyone. Eight years. They hadn't gone on vacation once, impossible on an auxiliary teacher's salary. Maya had tried in the beginning, practically accused her of child abuse when Sarah sent back the ripped-up tickets. But she couldn't have Maya mothering Max. That part Sarah had gotten right. She tapped her pockets. Where were

her cigarettes? Oh yes, no cigarettes, she'd thrown the pack away. That's not how she would start over. She whooped, overcome with pleasure at the dark intersection, the yellow light, the welcoming emptiness of the road ahead. She felt unburdened, euphoric. She felt like herself. As if she had been trapped in someone else's life, and now the cracks had appeared and she'd stepped back into her own. It was simple: a road trip. The steering wheel vibrated against her hands. She gave it a squeeze. Not a Caddy, but not bad, a sweet Buick with half a tank of gas.

Plan A was to drive up to Maine, find Gus, see if she could get the job cooking at the artist colony. Granted, the offer had been made a couple years ago, but if that didn't work out, Gus might still be able to help her. Just to be somewhere else, to be back with people making things. God, she couldn't wait to see Gus! She thirsted for him! All these Connecticut people, she wouldn't miss one of them, except for Carlos. He was different, he understood, even though he only knew a part, a sliver. Carlos and she, they were like people drawn to each other on a train, people who stay up all night groping, murmuring, who love each other in a fervent way but whose real lives are elsewhere.

She sneezed again, feeling a cold coming on. But she was in control, the lines of the shadows were razor sharp, as if the booze had backfired and rendered her lucid. Here was the highway, already! They were on their way! Maine! Remember the Maine! Maine was north, follow the North Star to freedom. She craned her neck over the steering wheel, squinting at the stars. Which one was the North Star? The brightest lights were satellites. But maybe that one, so shiny, blurring like a beacon. She pressed on the accelerator, sitting straighter and prouder as the car sped up. She saw him

in the airport terminal walking away from her, that light-ness in his step. He must have known even then. All those words said and unsaid were just padding. Well, she forgave him. Why not let him be? Why this constant clawing of each other? She curved around a cloverleaf, wiping away a tear. The North Star! Follow the North Star! There were only a few other cars on the highway, cherry-red taillights essing ahead of her. The needle on her gas gauge now hovered just below half a tank. They wouldn't have to refill until after Hartford. They could get out of Connecticut all together, not stop once in the state.

Max stirred. She popped a Life Saver in her mouth, cleansing the booze and coffee from her breath. He pushed himself into the space between the driver's seat and the passenger's. His hair, charged with static electricity, tickled her neck and cheek.

"Your Grandpa Max used to get static in his beard," she said. "It would lift up and point toward Ma. She said it was proof that his love was true."

"Where are we going?" asked Max.

"We're on a road trip," she said. "Which means that while we have a destination, the trip is just as important. Doesn't it feel good to be driving?"

"Feels like it always does. Except it's dark."

"It's getting lighter. The sun will rise in a moment, then you'll be able to see."

"Where are we going?"

"Maine."

"Maine?"

"Yes."

Max cocked his finger and aimed at the headlights on the opposite side of the highway. "Bang! Bang! Bang!"

"You're not angry, are you?"

"No."

"Upset that we're going?"

"No, I'm just shooting the bad guys, that's all." He blew the smoke off his finger. "Good riddance to bad rubbish." He paused. "What about school?"

"What about it?"

"I'm going to miss it."

"Yes. But you can miss some school. I never went to any, and I'm literate."

"Really?" he said. "I'm really not going to school?"

"You got it."

"Stellar."

"Glad you feel that way, Max. We're going to have a great time." She took another curve, the accelerator vibrating cheerfully under the sole of her lace-up boot. "We'll live right by the ocean, listen to the roar of the surf. It's like the train, but constant and much better."

"What about karate?"

"You can do karate on the beach."

"But Sensei—"

"You remember what Sensei says. You have to have self-discipline."

Up ahead, a police cruiser pulled a car over. She slowed down and felt for the coffee she had brought along.

"Remember the first people who did karate, the peasants in Okinawa. They didn't have dojos or senseis giving them homework, they did it on their own."

"Did you remember my gi?"

"Yes," she said, although she didn't actually remember packing it; she remembered sleeping bags, coffee cans of paint, a canvas stretcher clenched in her teeth. "We'll comb

the beach and make driftwood fires and write messages and stuff them in bottles, then throw them to the waves." She pulled at the steering wheel. Could she actually live there, facing the ocean, day after day? She'd never liked the ocean since Ma and Max's plane dove into it.

The shadowy form of a station wagon passed them. "Bang! Bang!" shouted Max.

She accelerated. They gained on the station wagon, passed it, left it in the dust. Max cheered. Something opened in her chest, a sweet coolness. Yes. Tori had talked about this ages ago, chiding her about how she ought to go out to the beach, throw a flower . . . She had been so scornful—an empty gesture, Tor, grossly sentimental, they're gone, no cosmic splash is bringing them back. But the point wasn't bringing them back, it was going to the ocean.

The sun, huge and orange, appeared from behind a bank of steely blue clouds. Up and up, big and impossibly full. "Can you believe it? Look, Max, how beautiful." The sky glowed pink behind the charcoal silhouettes of abandoned smokestacks, and above, more clouds, horizontal slivers of forget-me-not blue and violet and, wavering in the midst, a strange kind of corkscrew cloud, white, spiraling up at a perfect vertical. "It's officially day. You can see out the window."

"Could before too," said Max. "Even in the dark. Bang! Bang-bang-bang!"

Chapter 20

New York City, November 1989

Sarah hates going to the doctor, and this kind of doctor, with the torn family magazines on the table, the watermelon-bellied women, the escaped toddler throwing a shoe down the hall—she wants to run from the building screaming. She digs in her bag for the *New York Times* and stares at the print, unable to make meaning out of the words but comforted by the familiar font. The kid sitting next to her snuffles, a glob of yellow-green mucus suspended from his nostril. His mother sees this also, searches for a tissue, and, not finding any, wipes the kid's snot away with her finger.

"Gross, isn't it? The things you get used to." The woman wipes her hand on her jeans, a snail trail darkening the fabric.

Sarah grins, imagining Philip's reaction. But what does she know? Maybe he wouldn't be disgusted. He's a fisherman. What's a little snot compared to fish guts?

She pees in a cup. The kid with the runny nose whines. His mother reads him a story, a thick cardboard-paged book about a dog in a dress. The snail trail on her jeans has almost faded away. It strikes Sarah that this woman, this utter stranger, knows something about her that no one else

knows. She hasn't told anyone about the purple line on her home pregnancy test, not Philip, not Maya, not Gus. She's pretty sure it was a false alarm. Yes, she's exhausted, but it's late November, the days are short, she's been working hard. It feels more like the flu. Or early menopause. It was just a dime-store test.

"Congratulations, Mrs. Marker, your results are positive."

She stares at the nurse, a sad-looking woman with orange rouge and pale, apologetic eyes. A numb panic. "Really?" she hears herself saying, as if she were responding to a piece of mildly interesting gossip.

The subway platform is packed. A horrible guy in a smelly sweatshirt presses into her. She pushes through the crowd, trying to get away from him, and steps on something that collapses under her. It's the side of an open violin case, an old one with faded blue lining and moldy pennies among the quarters and bills. The musician, deep into Paganini, has fingerless gloves and very sharp cheekbones. Listening to him, her breath catches, the fall of the notes agonizing and beautiful. The subway arrives and she squeezes on, shielding her belly, still at this point flat as a pancake. The train jerks forward, and she stumbles back on an old woman in a purple shawl. "We neva gonna get outta here," the old woman says. "Neva gonna, neva, neva, neva." Sarah presses her lips together. She feels sick. It's probably psychosomatic, although Ma always said that she started vomiting the day after conception.

The old woman gets out at Lincoln Center, still mumbling, "Neva neva." The train becomes quiet and the passengers thin out and Sarah stares at the subway map. Her love map without the dots. Philip's telephone number is on a Chinese takeout menu, but where is that menu? She'd

been annoyed the last time she talked to him. He hadn't gotten the job in Chicago, and instead of looking elsewhere he'd checked himself into a fishing lodge in the Idaho mountains. Rocking chairs on the porch, pine trees, run by a family named McHenry or something like that. He had scattered Conningsby's ashes in the trout stream there.

"Why there?" she had asked.

"It's beautiful. It's like the canyon," he said.

"But it's not the canyon. It has nothing to do with Conningsby."

"I'd carried them around long enough."

"So you toss his ashes in the first stream you see?" Her voice was so shrill, she could almost feel Philip retract. How is it you can feel a silent retraction over a telephone? She should have apologized. But it had been a betrayal. Idaho? Idaho had nothing to do with any of them.

Maybe that's why she hadn't told him about the drugstore pregnancy test, so annoyed at that.

She searches through the kitchen for the menu. The dishes are piled high in the sink. The newspapers take over the table. There are crumbs, drips of marmalade, open boxes of cereal. There is a picture of him, and her too, on the bulletin board. They are wearing paper hats, jumping from a couch. It was New Year's Eve a few years back. They were supposed to have their feet off the ground, light and free, at the stroke of midnight. For good luck.

She finds the Chinese menu under a vase of sagging flowers. His number is scrawled in the margin by the moo shu pork. She dials, her fingers gaining confidence with each push of the button. Usually their conversations are good. The modulations of his voice, his hesitations, his intelligence soothe her, remind her that he is he, not some mon-

ster of his own making. And this, this will further catapult them out from that.

The man at the lodge who answers the phone sounds like he has a wad of chewing tobacco squirreled away in his cheek.

"Philip Clark, please."

"Wait a second." Shuffling. Silence. "Ah. He checked out a couple days ago, ma'am."

"Do you know where he went?"

"No ma'am."

"He didn't leave any forwarding information?"

"No ma'am."

"That can't be."

"Nothing here, ma'am."

She cleans the kitchen. She throws away her cigarettes. She thinks of calling Maya, then Gus, then Wendy Flanders, the only person she knows well who actually has children. But it feels wrong to tell them before she tells Philip. She could call someone anyway, talk about something else. But she doesn't want to talk about anything else. She could meet someone for a drink. She's not of the school that believes a little bit of alcohol will destroy a fetus. But the way she feels right now, one drink won't be enough. She won't be able to stop. She curls up, a fetus herself, on the rarely used couch, and gazes out at the Hudson, the lights of the boats blurry in a low-lying mist, the windows of New Jersey glowing yellow against the leaden sky.

Days pass. She paints. She avoids people. She waits for Philip to tell her where he is. She gets home from the studio feeling beat. Breathing is an effort. Blinking is an effort. She reads a book that says this sort of exhaustion is normal. It takes a

lot of energy making a placenta. Three or four nights after the trip to the doctor, the phone rings while she's in the shower. She sprints down the hall.

"Hi, Sarah."

"What's going on? Where are you? I tried calling you in Idaho." She should have grabbed a towel. She's dripping all over the hall.

"I had to leave quickly, I got a last-minute interview in Georgia."

"Georgia?"

"Yes. There's a Habitat for Humanity project down here. They are building houses out of scrap materials, stuff that otherwise would be clogging landfills. It's a pretty great project."

"Wait just a sec." She runs back for a towel.

"How's the painting going?" he asks upon her return. Then, because he remembers how she hates that question: "Did you know there's a Quetzalcoatl Association in Atlanta?"

She laughs. "An association of sun gods? Or are they making them?"

"My thoughts exactly," says Philip. She can feel him smiling on the other end. "It's all very mysterious," he continues. "A plain metal plaque on an office door I passed by on my way to the interview. It made me feel as if you were here with me. Send me an invitation to your show and I'll slip it under their door."

"I'm thinking that my Quetzalcoatl would not look Quetzalcoatl enough for an association of aficionados."

"What do they look like?"

"You'll see them soon."

A silence follows, the kind of silence filled with unsaid

things. "They've offered me a job," he says finally. "The pay is ridiculous, but they can give me a camper to stay in. It's just for a few months, until the project's done. It will give me time to think and do something useful while I'm at it."

"Well . . . that sounds good."

"I can't go back to designing second houses for rich people."

"Understandable."

"I can't go back. I mean, even for an instant. "

"Are you trying to say you're not coming to my show?"

A pause. "Yeah."

"You promised, Philip. You said you were going to strut around, proud of your wife."

"I'm sorry." The sorrow of his voice sinks deep into her, a heavier sorrow than their immediate conversation merits. She cannot speak, the phone cold in her hand.

"Should I go to Georgia?" she asks softly.

"You need to stay there and work on your paintings."

"For the show you're not coming to."

"You'd hate it here."

A sound, a sound she cannot bear to hear, rises in her throat. She hangs up, not wanting it to come out, not even saying goodbye.

Her Quetzalcoatls become more detailed and palpable. When she works on them she forgets her exhaustion and discomfort, intrigued by the knives and Cheshire cats and glorious tumescences popping up out of bushes and fields of color. She is not angry when she paints, though it floods back into her when she leaves the studio. When she paints she is suspended in a strange peace. It's all right that Philip is living in a camper in Georgia. She is not altogether sorry.

His absence allows her to explore things she wouldn't have dared were he here.

She tries something new—crude oil, not paint. She wants monochrome. She wants basic ingredients. Oil, sand, ash. Painting with crude oil is more like drawing than painting. There is no depth, only line. And it is more like calligraphy than drawing. There is no erasure. Once the lines are down, they are down. She works in a kind of trance, holding the brush in her hand for great chunks of time, not knowing what's coming until all of a sudden it happens. A quiet process interrupted by claps of laughter. She draws a plumed serpent coiled around the Empire State Building, à la King Kong. Its enormous jaws are open. Its tongue extends. Next comes a helicopter. Then a sacrifice, a man in a loincloth being fed into the snake by a man in a suit. Then, because this man in the suit feeds the snake midair, she attaches him to cables strapped to the legs of the helicopter. Then the wind, associated with Quetzalcoatl, whipping him, making his job more difficult. She has to draw the wind over what she had already drawn, half obscuring the figures. Then she understands that the helicopter must have a pilot. A high priestess, half Egyptian, half Aztec, with Maya's profile and her regal neck.

Maya has sung in Biarritz. She has sold a building in London. She is organizing the first North American Fado Festival in San Francisco. It amazes Sarah how unscathed she is. Perhaps it shouldn't. Perhaps her reaction is more normal than Philip's.

On a rainy day in November, Bambi and Gus dry off by the studio's steamiest radiator, surrounded by a multitude of soaked and disintegrating shopping bags, puddles of water,

socks and shoes. Sarah hasn't seen Bambi since Eric's funeral. She is pale. Sarah wraps her up in a big hug. "Look at your hair! What have you done? It looks amazing."

"I went to a salon," Bambi declares grandly. "I got a permanent. If I'm going to be spending my life visiting dying people, I'm going to at least look fabulous doing it."

"Who wants to be visited by a dowdy old hen?" offers Gus. He lifts a purple expanse of drapes and shoulder pads from one of the bags and eyes it with a bit of masculine discomfort.

"Eric would have loved it," says Bambi. Then, as if all the energy was suddenly sucked out of her, she sits down, small and quiet.

"Where's that tea we brought?" Gus says, fussing around before finding it.

"Did you hear that Eric's friend Asa is also sick?" Bambi asks Sarah. "He's looking for someone to replace him. Do you know anyone who wants to teach art out in Connecticut? It's one of those private places, you don't have to be certified."

"I'll ask around," says Sarah.

"Where's your ashtray?" asks Bambi, dangling a cigarette. "You didn't stop smoking, did you?"

"It's just a temporary thing." Sarah hands her a saucer. "You can use this." She's tempted to tell her about the pregnancy, but it's still so early. Gus's eyes twinkle, pleased to be the only one who knows.

Maya comes back from London a couple days after the Berlin Wall falls, bearing a chunk of it in her suitcase. She presents it to Sarah the night of her arrival, the two of them perched on barstools at a café near Sarah's studio. A rough hunk of

concrete with a splash of maroon spray paint on one side. Sarah holds it reverently. "How did you get it?" She and Gus were at the studio when they heard the news—one of Gus's crazy aunts had called. They didn't have a television; they'd huddled around the radio, as if it were the 1940s, listening to a euphoric reporter, the excitement of the crowd, gazing at each other with blank, wondering faces.

"One of my business partners was in Berlin the day it fell. There are going to be incredible opportunities, Sarah."

Sarah focuses on the concrete, overcome by a wave of repulsion. Maya motions to the bartender. "Shall we have champagne?"

"I'll get ginger ale. I'm into ginger ale these days."

"One champagne and one ginger ale," says Maya.

"To new beginnings," says Sarah when the drinks arrive. They clink glasses.

Maya's face lights up. "You *are* pregnant!"

There's no point in denying it. Sarah grins, embarrassed, happy. Maya clasps her in an old-fashioned, full-throttled hug, then holds her at arm's length, beaming and shaking her head.

"It's just a baby," Sarah protests, as if the two of them are continuously popping out babies, when in fact, strangely, neither have ever before gotten pregnant.

Maya signals for the bill and ushers Sarah out of the bar, practically pushing her to the front door, eyeing the smokers sternly, although she had snuffed out a Camel only minutes before. On the sidewalk, their breath rises in thin white plumes. It's the first really cold night of November.

"Where should we go?" Maya asks. "What do people do? Look at you, you're shivering. Let me take you home. I'll give you a bath. I'll make you tea."

"Wait!" says Sarah. She'd left her piece of the Berlin Wall on the bar.

"I'll get it for you. You're not going back in there. Why did you ever suggest it? You're not still using turpentine, are you?" Maya doesn't wait for an answer and heads back inside to collect the concrete.

"Thanks," says Sarah when she returns, eager to show it to Gus.

"How are you feeling?"

"I'm fine."

"Thank goodness. Have you seen a doctor?" Maya steps into the street to hail a cab. "I'll draw you a bath at your own place if you won't come to mine."

"What is it with baths? Do I smell?"

"No, darling, I just want you to be comfortable."

"I'm not uncomfortable."

"Good. How do you feel?" Maya catches herself starting babble and laughs. She helps Sarah into the cab, then scoots in beside her, their knees touching, Maya's hands fluttering with excitement. "Do you know if it's a boy or a girl? Do you have a feeling? Ma said she knew, both times, with us. I know an obstetrician who is apparently very good. I can get you an appointment if you'd like."

"I already have an obstetrician."

"Is he qualified?"

"*She*. She's fine."

"Oh, your poor ears, they're red. Here's my scarf. Well, if it turns out you want another one, I recommend Jerome. Jerome Rosenfeld. I don't think he takes insurance but I'd be happy to pay. Oh, darling, can you even believe it?"

At the apartment, Maya kneels in front of Philip and Sarah's

claw-foot bathtub, tending to the faucet, an unreliable old spout whose waters gush out in wildly varying temperatures. Sarah sits on the closed lid of the toilet, blowing on her fingers, remembering the tub on 155th. You had to turn the faucets with a wrench, which you could never find.

"Have you been able to eat? Do you want pickles or something?"

"Tea would be nice," Sarah says, hoping to redirect Maya to the kitchen. She wants to get undressed alone.

Maya runs her fingers though the water, her forehead wrinkled in thought, still fiddling with the temperature. The bathroom bulb glares down on her, a merciless light that Sarah has meant for years to replace. It shines on Maya's skin, rendering it thin and translucent, revealing the bones underneath, giving Sarah a glimpse of that age that Maya has been complaining about recently. Maya looks at her expectantly.

"Some tea would be nice," Sarah repeats.

"What kind would you like?" Maya asks, now standing upright, brushing the dust off her knees.

"Anything herbal is fine." Sarah slips into the bath. It does feel good. Wonderfully good. She dips her face under the water and blows bubbles, the warmth enveloping her, her face thawing along with her toes and fingers.

Maya returns; Sarah adjusts the curtain so that only her face is visible.

"Chamomile," says Maya. "You can't go wrong with that."

"I've never seen you like this. I swear, you're fussing around like Ma."

"Am I?" Maya sounds pleased. "Well, I've never seen you like this either."

"You're not seeing me. I'm not showing you my belly. It's a squishy mess."

"You know, you could come over and visit me in London. If you have the baby there, it would have dual citizenship."

She wakes the next morning with a churning stomach, and runs to the bathroom. Vomits all over the place. She mops it up, weeping, then calls Philip.

"Hello." He sounds stiff and formal.

"I'm buying a ticket to Georgia. I wanted to check with you when would be a good time."

A crackly silence. The kind of silence that makes her want to scream.

"Sarah," he says gently, "I'm not sure how much longer I'm going to be here. I met an interesting woman from Oxfam—"

"An interesting woman from Oxfam?"

"Oh, come on. It's not like that . . . There may be a way for me to get involved in some of their development projects. I'm flying to London next week."

"I'm surprised you dare. Maya lives almost full-time in London." The name reverberates long after she speaks it. She leans her forehead against the cold glass of the window.

"Well, I guess I'll have to buck up now, won't I?" There's a nastiness in his voice that makes her shudder.

She mixes a palette of reds and jabs at a new painting, a depiction of Quetzalcoatl's fiery breath, only his breath. She considers having an abortion.

Gus dribbles his ball over. "Jeez, Sarah."

"What?"

"It's not as, ah, playful as most of your work. It's a little scary."

"Good. I want to be scary." She can't have an abortion. The thought makes her sick. Gus keeps bouncing his ball. "Can't you bounce that thing somewhere else? Or throw it out the window?"

Gus continues to slap his ball up and down, up and down. "Do you want me to tell him?"

She considers it, but what would be the point? "Just stop bouncing that thing. That's all I want."

"It's a free country," Gus replies. He dribbles it back to his side of the studio and, as if to punish her further, practices his jump shot.

Simon selects six paintings for the show, all large and violent. *The Plumed Serpent in Manhattan* (oil, sand, and ash on paper), his favorite, hangs near the entrance. Maya knows about it, although she has not seen it in person, and she doesn't know how similar her profile is to that of the priestess piloting the helicopter. She and Sarah arrive at the opening together, late, having had trouble with Sarah's dress. There are so many people there, the paintings are barely visible. They enter the throng, the heat of bodies, the plastic glasses of wine sloshing, the smoke curling in lonely towers that mass together in a cloud at the ceiling. Sarah doesn't know very many of these people. Some of them are terribly young, girls tottering in black spiky heels, boys slouching moodily. She imagines that Falk might be here, though she heard he started some skateboard project in Detroit. She scans the room and sees a boyfriend from even further back, his ponytail now quite straggly, gesticulating to a circle of onlookers.

Maya and Simon embrace. A stranger grabs Sarah and tells her she's a genius. Simon tugs at her, eager to intro-

duce her to a skinny kid with glasses who is somebody's nephew. Through the crowd and the chatter Sarah glimpses Maya's white shoulders, her voluptuous back. She is once again ageless, whether from the lighting or the makeup or the pleasure of the deal. She is set on selling every one of Sarah's paintings—"For the baby, we'll open it a new bank account, we just need a name." She is mad about baby names, frequently calling Sarah up with new inspirations. Hudson? June?

A man with a Dalí-esque mustache insinuates himself between Sarah and the nephew, shaking his head in disappointment. "Sand," his voice a thin protest. "It's abrasive. I'm trying to get away from abrasion."

Sarah nods, her mouth forming words she is barely aware of, her focus suddenly centered on Maya who is wandering toward *The Plumed Serpent in Manhattan*. She stands before it, alone. The mustached man speaks, but Sarah doesn't hear a word, studying Maya's bun, her slender neck, the cock of her hips, wishing she would turn so she could see her face. They have only had one conversation about what happened—a brief exchange, months ago.

"You shouldn't have asked me to be friends with Philip."

"I never asked. You volunteered."

"It was expected of me." As if what happened were Sarah's fault.

A friend of theirs from Paris, finely scented, swoops her into a hug. "You look wonderful, darling—*et ta jupe!* Where did you find it?"

"My dress? Oh, yes, it's from Maya. She had her dressmaker design it especially for tonight."

Maya comes up from behind, kissing them both on the cheek. "What a fabulous show!" If she is angry at the *Plumed*

Serpent, there is no sign of it. She is glowing and proud. "These are the best she's ever done, don't you think, Mimi?"

"I wouldn't say that," says Mimi. "I love that circus over my mantle."

Maya squeezes Sarah's arm. "There's Claude. He's going to buy one."

"You think so?"

"Bet you fifty bucks."

Maya swoops over to a white-haired banker in plaid pants as Bambi and her date, a professor of philosophy who Sarah has met many times but whose name forever escapes her, appear before her.

"Sarah!" cries Bambi, raising her arms to hug her, forgetting her glass. "Oh shit, I'm sorry." Wine spills everywhere. "At least it's white. You can barely see it."

"Can I get you some water?" asks the professor.

"No, please, I must repair to the powder room. I'll be back, my loves."

"Poor Bambi. She's had a hell of a year," says the professor, watching her stumble to the bathroom. Sarah, wanting to help her, nods miserably. She asks the professor some question that leads him into Diderot and determinism in the radical enlightenment.

"Determinism?" murmurs Sarah. Over the professor's shoulder, Maya beams at the banker, her fingers light and playful on his sleeve. He whispers in her ear and Maya throws back her head, her neck still gorgeous, gleaming white. She has won. Philip was right. She has gotten rid of him and she will, through love or money, get his child.

"Sarah?" The professor gently taps her shoulder. "Are you all right?"

"Sorry, I lost my footing there. I think I need to get some

air." She fetches her coat and slips from the building.

Men and women, flushed and laughing, have spilled out onto the iron steps and nearby sidewalk. Their gazes fall on her, slight sparks of curiosity that easily pass to other things as she walks away. By the next block, she is no longer the artist, just a woman alone on the sidewalk in the dark.

The next day she takes the subway to Central Park. Space. Staunch forms of life. Ice forming on the puddles, melting and reforming, crumpled leaves clinging to the branches. She walks and walks and walks. Past Cleopatra's Needle, around the reservoir, to the northern end, the weed-choked pond. The weeds are desolate and gray and no one is there besides her. She climbs a gray-trunked, brown-leafed hill. She isn't following a path, just scrambling by boulders and bushes through slippery mud. She gets to a cave with a charcoal pit and a grimy sleeping bag. She squats, examining the soot-blackened ceiling, wondering who lives there. It seems to be somebody sympathetic. A wrinkled, unflappable, all-forgiving hermit. If the sleeping bag were cleaner, she'd crawl in and take a nap. The hermit would understand; he'd welcome her. She wants to stay there. It is quiet and peaceful. She does not want to go back to her apartment, the telephone ringing, the answering machine beeping, voices asking if she's all right, Maya chiding her ferociously. She sold three paintings! How could she run off like that? Outside, sleet skitters against the rocks. It's getting dark. She walks back to the southern end of the park, empty except for a couple of bundled-up nannies pushing babies in plastic-wrapped strollers. She holds her stomach with cold-fingered hands, wishing she hadn't left the cave. She'll never be able to find it again. Through the windows

of bars, TVs broadcast the American bombing campaign and people cheer as missiles drop through the night air and unseen, untelevised houses explode and blood leaks out of the skulls of goats and grandmothers and anyone unfortunate enough to be in their path.

A man stumbles onto the sidewalk. "Whoa, miss," he says, blearily groping at her. "Pretty miss."

"Behave yourself," she says.

"Why?" he calls after her, laughing.

Chapter 21

"How long till we get there?" Max asked.

"A long time. Maine is far away."

"I'm hungry."

"Well, we'll stop when we find a good diner."

"I'm hungry now."

"Don't be difficult. I want to get out of Connecticut first, make some progress."

"I'm not being difficult. I'm hungry."

"Here's a box of Cheerios. Munch on these."

"I don't want Cheerios. I want donuts."

"You are being difficult."

"Why are we going to Maine?"

"So we can live by the ocean and Mom can paint and you can collect fossils and horseshoe crabs."

"Live? We're going to live there?"

"Well, no, not necessarily. We'll see. For now, we're taking a vacation."

"Everyone else takes a vacation in the summer. Why do we have to do it in the fall?"

"Look at the sun. The rosy fingers of dawn! Where's your sense of adventure?"

A car honked. Sarah scowled at the rearview mirror and

saw, a couple of cars back, a police car. She braked a tad abruptly, jerking them forward.

"You okay, Max?"

"Yeah."

What were all these cars doing? Why was everyone going to Maine? The North Star had disappeared, all the stars had disappeared. The sky turned from pink to yellow and the cars multiplied. She swerved through the traffic, undaunted. She'd get there first. The road seemed to expand, all sorts of cars slowing and speeding in concert, caught up in an invisible current; an asphalt river, pulling them along—she barely had to steer, the Buick moved by its own volition, the river's volition. Max had fallen silent. She glanced at the rearview mirror. He'd zipped up one of the sleeping bags and crawled into it. A giant orange caterpillar with a tousled blond head.

"Why don't you be a caterpillar for Halloween? You'd be the cutest caterpillar."

"I don't want to be cute."

"I'll make you the costume. Do caterpillars have antennae? We'll have to stay until Halloween. Everyone will have cool costumes. It's an artists' colony, they don't do prefab plastic superheroes. I could make beautiful antennae with copper wire."

"You can't see caterpillar antennae. They're too small."

"Fine," she said, "no antennae. Cool makeup though."

"Yech."

The Buick strayed, edging into the other lane. Whoa! Where the hell are you going? She returned her attention to the yellow lines, the motion, the zooming bumpers and car antennae. That good swooping feeling came back. She was at one with the traffic, curving around interstate es-

ses, whizzing past tarry-roofed row houses and the ruins of paintings on brick warehouse walls, faded advertisements for fried chicken and chewing tobacco—she thought again of her absent cigarettes. No. Max. It was just as well. She didn't need a cigarette; she needed nothing except the vinyl-wrapped wheel quivering under her palms, the light getting brighter, the traffic never quite bogging down, just becoming more intricate. She sneezed and sniffled, but all this nose business was clarifying, energizing, making her see the lovely geometry of the overhead ramps, the railroad bridges, the skyscrapers.

"You know what caterpillars got?" Max said.

"What?"

"Anal claspers!" Max guffawed. "You can make me anal claspers."

"Very funny," she said, passing a sign for the George Washington Bridge. "Why not be George Washington? I'll make you a wig and wooden teeth." Wait. How had that sign gotten there? That couldn't be the George Washington Bridge. Another sign came up: *Last Exit before the G.W. Bridge*. Holy shit. What had she done? Of course she was in New York, she'd been admiring the skyline a second ago. That's why the traffic was so heavy, she was in fucking New York, about to be George Washington'd into New Jersey.

"Hold on, Max!" She shot across the lanes. A chorus of horns and screeching brakes rose up behind them. Sweat chilled her pores. She was drunk, undeniably drunk, and Max was in the backseat. What the fuck was she doing? The sweat poured out, freezing cold. Her palms dripped on the wheel. "Please," she whispered through clenched teeth. "Oh god, I'm sorry." They made it to the exit ramp, a twisty tunnel that delivered the Buick from the echo of still-angry

horns and turned it out onto the relative calm of the Henry Hudson Parkway.

"I could be Henry Hudson," said Max softly, thoughtfully, as if trying to make up for the mess they'd left behind them. "He discovered New York Harbor."

She nodded, too terrified to speak. How much had she had to drink? She clutched the wheel. She had to get off the parkway, onto some safer, slower, quieter road. The Cloisters were coming up. Yes, that was perfect. She could sober up and Max could wander around the old castle, yes, perfect—sarcophagi, swords, suits of armor. On a proper road trip, you did this sort of thing. And there'd be a phone. She could call Gus, warn him that they were coming. He had to be there. Who'd give up a gig like that? Sculptor-in-residence. You simply did your work, and the bills would get paid. All right, you might have to smile for a pamphlet, go to a fundraiser, sleep with a donor, but that's nothing compared to the PTA. She sighed, feeling better. They hadn't crashed. There hadn't been an accident, just a fury of horns.

"You're going to love Gus, sweetie."

"Who's Gus?"

"I never told you about Gus? He's a friend of mine, an artist. You'll like his sculptures. They're made out of old car parts."

"Weird."

"Where did this *weird* come from? Everything's weird these days."

Max pressed his face against the window. "I don't know."

The cars were zooming, zooming, hogging the lane for the Cloisters exit, not letting the Buick in. Okay, no Clois-

ters. She sighed as she passed the exit. Immediately afterward, a space appeared in the right lane. She dove in before it was swallowed up. The next exit sign appeared: *155th Street*. This one she made, curving off the parkway into a once-familiar corner of northern Manhattan. She sucked in her breath as they drove past the Cervantes statue, the old Indian museum, the park that used to be fancy but was now blurred with dull graffiti, paper coffee cups, needles, if she cared to get out of the car and look. But the streets—they weren't that different; the ratio of house to road, the narrowness and shabbiness. It had been shabby then too.

"Max." Her voice trembled. "This is my old neighborhood."

"I thought we were going to Maine."

"We are. But Maine's north. We're doing a detour."

"Red light, Mom."

She braked, the sweat pouring out again, but she'd only gone a couple of feet over the line; it was the kind of mistake anyone could make, and there were no other cars. She backed up and waited for the green. "Your seat belt's on, honey?"

"Yes, I told you."

"How can it be with that sleeping bag?"

"It goes over, see?"

She checked the mirror. Indeed, the belt stretched over the sleeping bag. He was a strapped-in caterpillar. The light turned green. She passed a parking spot to her left, but she couldn't bring herself to stop. The Buick was pulling her deeper into the neighborhood.

"Who are we going to write messages in a bottle to?" Max asked.

"Huh?"

"You said when we got to Maine, we could write messages and stuff them in bottles and send them out to sea. Who are we going to write them to?"

"What about Grandpa Max and Grandma Grace?"

"They're dead. Dead people can't read."

"Since when did you get so sensible?"

"I've always been sensible. Just like Dad."

"Oh, for god's sake. Who ever said your father was sensible?"

"You."

"A sensible person respects the senses, doesn't run away, doesn't sacrifice everything for some skewed idea of holy fucking perfection."

"You said he was sensible. You said he was the three S's: square, straight, and sensible."

"No I didn't. I said he's a hero and he's wandering the planet."

"Square, straight, and sensible. *Sss*—the snake in the garden."

She had said something like that, but not to him, to Carlos. He must have been listening. "No way," she said. "If I ever said something like that, I was wrong. If you're too sensible, you become insensible. You can't understand anything that doesn't make sense."

The streets were too narrow for this. Concentrate. She edged the Buick between double-parked cars. The left tires rose up on the curb. A woman standing on her stoop eyed her warily. Yo gringa, whatcha doing here? Yo yourself, I'm no gringa. I'm a displaced homegirl, and where's the el? She had taken Philip here years ago, the year they'd crisscrossed Manhattan, exploring Philip's architectural marvels and her childhood places. He'd hardly said anything, eyeing the

grit-encrusted mortar, the crumbling wedding cake plaster-work, the broken windows, the sagging staircases, the sod-den coupons in oily puddles. He'd felt sorry for her. It had made her furious. She'd been trying to show him something that she'd loved.

She stopped at an intersection, and the kids on the cor-ner, down-jacketed and smoking, sussed her out. What's the score, lady, what d'you want? She didn't know. All she knew was that she had to keep going and she had to be careful. Her kid was in the backseat. The telephone wires sagged and a man raised the gates of a bodega. She winced at the clattering metal. Too loud, everything was too loud. The air buzzed. She tried to turn left, but the street was blocked by orange and white sawhorses. A Con Ed chimney puffed great clouds of smoke. She wiped her forehead and turned the other way. At the next intersection, an old man dragged a poodle by a leash. She rubbed her eyes, so out of place the man looked. He was terribly proper, with a trim gray mustache and a feather in his tweed hat. The poodle stopped to pee at the curb, and the man glanced up at the sky, as if to disassociate himself from something so base. Sarah wanted to shout an obscenity. She rolled down her window but then stopped herself.

"Listen, Max, I have something to tell you. We're all animals. That's how we were made. Only an idiot's embar-rassed by it."

The car behind her honked. She jerked forward then penitently braked. There was a lesson she'd taught when she substituted for the history teacher. A sermon given by one of the early Puritans that defined love as a ligament, what bound the parts together, toe to foot, rich to poor, high and eminent to mean and in submission. Not some

painful, ungraspable mystery. A bond, that's all. Elmer's Glue. She'd been lecturing the class, maybe a little smugly, you silly kids with your crushes and your bubble gum lyrics, it's not what you think, you're already bound up in it, there's no escape. Then Milo had raised his hand.

"Yeah, but if it's just a bond, why does he say, *For to love and live beloved is the soul's paradise?*"

The class had stretched out in front of her, the students at their desks, Milo with his stringy hair, white light coming in through the bar of windows.

A film of water pooled on her eyes, more and more of it. She could barely see. She pulled over, gasping, tears cascading. Philip. Why had she been so hard on him? She clutched her knees, her shins pressed firmly against the steering wheel. She was shaking so hard that the Buick trembled with her.

"Mom?"

She gasped for air.

"Mom?"

Max's hand hooked over the seat and rested on her shoulder. Its warmth brought on a fresh attack of tears.

When her eyes finally cleared, she saw the building across the street. This was what she'd been searching for. Sooty bricks. Lopsided stoop. A banged-up metal door with a porthole window. It was the apartment she'd lived in as a little girl, where the el used to go by, although there was no el anymore. They'd dismantled the tracks. Outside what would have been her parents' bedroom window, someone had hung a threadbare beach towel on the fire escape to dry.

"Sweetheart," she said, wiping the snot from her nose. "Look up here, in front of us, this is where I grew up."

He glanced at the building. "I like our place better."

She nodded, too hollow and exhausted to speak.

"Mom," he said, shaking her shoulder, "right down the block there's a donut shop."

There had been a donut shop. She used to go there Sunday mornings when they weren't on tour, bring back a dozen in a waxpaper-lined box. She twisted around in her seat. It didn't look much different, the windows decorated with a checkerboard band, the neon shaky. The *u* had gone out completely, making the sign read *Don t* instead of *Donut*. "We could see if they're open," she said, cutting the engine. A crumpled sheet of coupons skittered at her and clung to her calf. Max ran ahead, open-jacketed, down the sparkling sidewalk.

A bell tinkled wanly when she opened the door. Max was pressed to the counter, eyeing the trays, while the woman who worked there talked to him. "You must be his mother," she said, nodding at Sarah. "I was just telling him, lucky for you all I opened early. Used to be I opened even earlier. People would come around before work. Six, six thirty. Five thirty sometimes. They knew how to work back then . . . Now they roll in, nine, ten, slump over, leave their napkins on the floor. The neighborhood's on the skids. But I'm glad to see some folks still got it together."

"I don't know about that," said Sarah.

"How many can we get?" asked Max.

Sarah joined him at the counter. The donuts seemed to go on forever. "I don't know, sweetie, what about six? We can have a couple here, and take the rest on the road. The woman unfolded a box and looked at her expectantly. "Two plain cakes," Sarah said, "and some coffee. He can choose the rest."

Max paced along the counter, considering his decision.

The woman poured Sarah's coffee. "Milk?" she said. Sarah nodded. The woman leaned to open the refrigerator, then stood up, rubbing her back. "Tell you the truth, that's why I opened early. This damn back. Couldn't get any sleep. Took some Tylenol and this bark that my neighbor told me about, you soak it in milk. But it didn't work, neither of them. So I said to myself, *Listen, H.T.—*" She looked at Max. "H.T. You know who that stands for?" Max peered up from a tray of chocolate-glazed and the woman repeated her question. "Harriet Tubman," she said. "Do you know who that was?"

"Yes," said Max. "She worked on the Underground Railroad."

"Good." The woman handed him a Boston cream. "This one's on the house." She turned back to Sarah. "Anyways, I said to myself, *Listen, H.T., you might as well get out of bed. Better to stand up and mind your business than lie on your back moaning.*"

Sarah nodded. Max scooped a glob of yellow cream onto his finger and held it out to her. "Do you want a taste? Hey! What happened to your forehead?"

Sarah tapped the bruise gently. It was swollen and tender. "It's all right. I was just raking." She licked the cream off Max's finger. "Thanks, sweetie. It's delicious." If she had told Philip about Max, Max might have grown up on the road as she did—but sleeping in refugee camps instead of roadside motels. Why hadn't she told him? She couldn't remember anymore. Out of spite? Had she been that mad? The secondhand on the wall clock turned around. It seemed to be moving in slow motion. It was an ancient clock with an aquamarine border and a sticker supporting an old Caesar Chavez grape boycott. Philip, if he were going through with it, would be on a train pulling into Grand Central at this very moment.

"Ma'am? You don't look so good. You want to sit down?" The woman came around the counter and guided her to a chair. "Here, now, you have this coffee. Maybe you got up too early. Maybe we should all sleep more."

"Thank you," Sarah mumbled, and lowered her face to the coffee steam. She groaned. Right before leaving, she had stuffed the Gilgamesh papers in the dishwasher. What was she doing? *Home is the place that you run away from.* Her father had said that when she'd asked him the name of his shtetl. But he had said it with unspeakable sadness. It was not a directive; it was his greatest regret.

She reared up. The box of donuts waited on the counter. It was too small. She ordered six more, three white-frosted, three chocolate-frosted.

"You take care of yourself," the woman said, handing her the boxes.

"Thank you. You've been very kind." Sarah took another look at the clock. Outside the wind had stopped and the sky was clear. Max gazed at a string of sneakers dangling from a telephone pole. "Come on, sweetie. We've got to get going."

"Why are we in such a rush?"

"I've made a terrible mistake," she said.

She fastened his seat belt, then double-checked it. She was still in no condition to drive, but it couldn't be helped. The train would get in at 10:23. She didn't realize until they'd left the neighborhood that she hadn't even taken a final glimpse at her old building. Well, she could always go back. But she didn't think she would. She drove over the bridge, blocking everything out but the grim lines of the road, the distance between her and the other cars. An accident had stopped incoming traffic, but the outbound side moved swiftly. They passed Pelham Park and Co-op City,

the reedy wetlands, the drawbridge. She didn't take 95 this time. She took the Hutch to the Merritt. The Merritt exited nearer to the train station. It was jammed up around Greenwich. She gave Max another donut and crossed her fingers. It was ten o'clock, on the dot. If they didn't make it to the station, he'd probably take a cab to her house, be greeted by the Batman welcome mat, not know if he was in the right place. She gunned the engine.

"I guess I could be a caterpillar," Max said, wiping a crumb from his mouth. "Did you know that Salima Carpenter has a butterfly collection?"

"No," Sarah said, eyeing a cop on the other side of the parkway. She couldn't slow down. 10:06. They rose over the crest of a hill, and in spite of her concentration and hurry, she was struck by the beauty of the trees, the sunlight hitting the leaves, the vitality of the colors, so flagrant they were almost obscene. How do you paint that? For the first time in years, not just her mind but her fingers tingled with an old-fashioned urge.

"You can make me antennae," Max said.

"What?"

"For my Halloween costume."

She knew she'd won a point, but she couldn't remember what the point was. "Great," she said nervously.

10:10.

"Max, we're not going to Maine, not today."

"But what about the horseshoe crabs?"

"What?"

"You said that we would pick up horseshoe crabs on the beach."

"We will. Only not right now."

Max sighed. The water tower, which was only a mile

or so from the station, rose up beyond the trees. Sarah held her forearm to her nose, hoping the smell of alcohol wasn't seeping out of her pores.

"Does this mean I have to go to school?"

"I don't know what it means." She exited the parkway and accelerated up the last hill. The whistle blew and the long gray snake of the train pulled out of the station. She zoomed down to the parking lot and curved around to the side of the platform. He was there, on the platform. He was there. He was there.

She stopped the car. His hair was bright white, his body slim. He held his hand against the sun and scanned the parking lot.

"Holy fuck."

"Mom! What are we doing?"

She didn't have lipstick. She didn't have powder. Her bruise was purple in the rearview mirror. "Your father's here." She tried to make her voice gentle. "I'm sorry I didn't warn you earlier. I wasn't sure he'd really come." Half a dozen passengers moved toward the steps, Philip trailing them. Sarah got out of the car. "Come on, Max." Max looked pale, frozen. She undid his safety belt for him. "Come on. Don't you want to say hi?" She pulled at his arm. He shook her off and stepped onto the pavement himself.

Philip saw them. His hand shot up, an assertive signal that made her stand straighter. He came toward them, his eyes on Max. She could tell from his expression that Max was not a surprise. She had been right. He had not come back for her or anything she might have said in that hole. Damn. She held Max in front of her, her fingers clamped into his skinny shoulders. Philip stopped at a respectful distance. His eyes moved up to Sarah, those same eyes, grave

and steady. She looked back, aware of the cold air on her cheek, the quiver in Max's shoulder.

"Hi," she said.

"Hi, Sarah." It felt strange not touching him, but Max was in the way, and even if he hadn't been, she might not have had the courage.

"You must be Max."

"Say hi, sweetie." She nudged him toward Philip. Max stumbled and she felt badly, but he caught his footing. Philip nodded, just like Conningsby would have, a perfect Western nod, barely noticeable but there. Max nodded back, mimicking him.

"Pleased to meet you," Philip said, holding out his hand. Max shook it.

"You were in Africa?" asked Max.

"Yes," said Philip.

"Did you see any gorillas?"

"No. Just people."

A gust of wind shook the trees. Bright colors flew through the sky and leaves skittered along the pavement. An orange maple leaf with splotches of red and yellow landed at her feet. She picked it up, twisting the stem between her fingers.

"Here," she said, offering it to Philip.

He took it from her, their fingers finally touching. "Nice," he said. He showed it to Max, who made a show of scientifically examining it. "Thanks for picking me up."

"No problem," said Sarah.

"So . . ." said Philip. "Pancakes?"

"No!" Max shouted with a spasm of excitement, and ran to the Buick. "We brought donuts!"

They ate them there, leaning on the hood of the car,

the trees arching above them. The engine was hot from the drive, and it felt good, the warm metal against the cool air surrounding them. The last of the other cars drove away and the pavement stretched out with its clean white lines.

Max brushed the crumbs from his face and ran out to claim all that space. "Look!" he cried. "Look at me!"

"We are!" said Sarah.

He began his kata. His first punches were wobbly and Sarah realized with a pang how nervous he was. As if he were auditioning. Philip watched him with a quiet attentiveness. Max recovered, his next punch confident and level.

"Don't applaud," said Sarah. "He hates that."

"He's beautiful," Philip said. Sarah nodded warily, but Philip seemed pleased. He gestured to her bruise. "You okay?"

"It's nothing."

He shook his head, and there was his old crooked grin. She felt herself responding, a smile overtaking her face, a warmth inside.

He leaned toward her, gently. "What were you thinking?" he whispered.

"I don't know," she said, suddenly buoyant.

"Kaia!" shouted Max. He had become immersed in the ancient moves and no longer seemed aware of them. With a knife-hand fist he sliced through the brisk blue air and ended with a perfect double kick.

Acknowledgments

So much gratitude and appreciation to everyone who has read, encouraged, and guided this book through its many, many-year gestation. Starting at the beginning: Susan Carlile, Jen Currin, Christine LeClerc, Ron Carlson, Melissa Pritchard, Jewell Parker Rhodes, Maureen Langloss, David Lefer, Helen Atkinson, Martha Witt, Sofi Nevakivi, Joseph Caldwell, Shannon Welch, Dayna Lorentz, George Prochnik, Amanda Stern, and all the great people at Akashic: Johnny Temple, Johanna Ingalls, Susannah Lawrence, Aaron Petrovich, and Ibrahim Ahmad, the genius behind proper letter placement. And Jason, always.